creative life

BOB OSTERTAG

creative life

MUSIC
POLITICS
PEOPLE
AND
MACHINES

UNIVERSITY OF ILLINOIS PRESS

Urbana and Chicago

Library of Congress Cataloging-in-Publication Data
Ostertag, Bob, 1957–
 Creative life : music, politics, people, and machines /
Bob Ostertag.
 p. cm.
Includes bibliographical references and index.
ISBN 978-0-252-03451-0 (cloth : alk. paper)
ISBN 978-0-252-07646-6 (pbk. : alk. paper)
1. Music—Political aspects. 2. Music—Social aspects. I. Title.
ML3916.O77 2009
780.92—dc22 2009009437
[B]

for my father

All of the music discussed in this book can be downloaded

for free from **www.bobostertag.com**

contents

acknowledgments

I have so many people to thank it would take another chapter to do so, but a few include Katie Ostertag Miles, Sara Miles, Richard Board, Jim Magee, Ali Janka, Andy Bichlbaum, and Ryan Nguyen. Thanks to Anthony Braxton, Fred Frith, Mark Dresser, Gerry Hemingway, Phil Minton, and Jon Rose for sharing my musical path; to Fred and John Zorn for generous encouragement and support when my self-confidence was faltering; to Hank Wilson and Jane McAlevey for being true comrades; to Jonathan Scott Lee for initially encouraging me to write this book; to Susan Meiselas for a long and rich friendship and also for the generous use of her beautiful photographs of Central America; to Mark Lutwak for helping me sort out my memories of my early New York City years; and to Michael Ulrich for invaluable assistance with editing and shaping the final manuscript. Much of this book was developed through detailed exchange with Pierre Hébert and as a result is far stronger than it would have otherwise been.

introduction

The pursuits to which I have dedicated myself thus far follow no conventional career path or unbroken thread immediately obvious to others. Nevertheless, my own experience of them is of a continuous flow. In conventional terms I have been a composer, an instrument builder, an improviser, a filmmaker, a journalist, a historian, a political organizer, a media prankster, a student and a teacher, a gay man partnered with a lesbian woman, and a father. Yet these identities have very little to do with my own experience of these activities. The way I see it, I have simply pursued the task at hand and tried to do so creatively. By this I mean keeping an open mind both as to what was required at the moment and what the next step might be. I see myself as dedicated not to a particular career but a creative life—life because I have tried to apply this approach to all my pursuits: art (music), politics (relations between large groups of people), friendship and intimacy (relations with small groups and individuals). The "next step" has always been there staring me in the face upon completion of any project, its logic revealed by the experience just completed. The range of possible "next steps" in life paths is, I believe, determined by the creativity one has applied to the last step. Or to put it another way: I have learned that it is always best to focus one's work on whatever one finds to be genuinely most interesting at the time. If its precise connection with the previous step is not immediately obvious, get to work and the connection will soon become apparent. In this regard, three rules of thumb have proven useful: always be open to new ways of understanding what it is you are doing, always be open to reassessing whatever you just completed, and try not to repeat yourself.

If this has the ring of empty platitude now, hopefully it will acquire substance as the reader progresses through the book.

Art and Politics after September 11

The thoughts that occupy the pages of this book begin in Manhattan, where I moved in 1978 at the age of twenty-one to play music. And here they end, in a coffee shop down the block from the downtown loft where I used to live. My old doorway is now as close as one can get to the site of the crumbled World Trade Center without special ID. Soldiers in camouflage fill the sidewalk out front. Many wear masks over their mouths, and though I have no mask myself, the toxic stench in the air suggests a mask might be a prudent idea.

In the subway down below, as was often the case when I lived upstairs, an African American man is playing soprano sax. The sound ricochets off the tile walls and concrete floors to the steel girders overhead and finally fills the station, caressing the frayed and fraught New Yorkers waiting for their noisy trains. He has a sweet tone and a nice sense of melodic ornamentation. But instead of playing NYC subway standards like "Take the 'A' Train" or a Coltrane-inspired "My Favorite Things," he is playing "Onward Christian Soldiers," and hearing it is sending cold chills down my spine.

Up above ground, American flags flutter everywhere. I hate the American flag. The sight of it sickens me, brings me back to El Salvador during the civil war years where I see it atop the American embassy in San Salvador, lurking behind a huge gray security wall like some Martian rodent in a 1950s sci-fi B movie. Bureaucrats, spooks, death squad killers, military goons, secretaries, and janitors crawl in and out of the giant rodent's mouth, feeding the war that killed so many friends and acquaintances.

My friend Marilyn disagrees. I have known Marilyn for twenty years. We met when we were both consumed with trying to end U.S. support for the regime in El Salvador during the civil war there. As exhaustion, defeat, death and destruction, betrayal, and the general ugliness of people sinking rather than rising to the occasion led many of our comrades to drift away from the Salvadoran revolution, Marilyn and I hung in there. Through the onset of the calamity when the regime's hit men gunned down the country's Catholic archbishop while he said mass, sending a clear message that no one was safe from the bloodbath that would ensue. Through Secretary of State Alexander Haig suggesting that the soldiers who raped, tortured, and murdered four American nuns delivering aid to refugees were "communist agents" running guns. Through the Reagan administration "certifying" to Congress again and again that "human-rights progress" was being made, even as the massacres became larger and more frequent. Through the arrival in El Salvador of U.S. military advisors, then U.S. combat helicopters, then U.S. gunships, then

surveillance flights piloted by American pilots, and much more. Through the four billion dollars in U.S. aid that propped up a decrepit regime that bore down ever more brutally on its five million people. Marilyn had staying power, a passionate woman with a deep rage which sustained her in that political whirlwind. Sometimes she would startle me with the intensity of her hatred of what the Americans were doing, and I would feel that next to her my commitment to social justice was insufficient. And now Marilyn is happy to see American flags all over Manhattan. She wants to wave one herself. She feels she has been attacked and sees the flags as reclaiming her home. For me the flags in New York mean just what they meant in Central America: symbols of arrogance, greed, and now mindless eye-for-an-eye patriotism, which is now pervading a city I had imagined was immune to such sentiments. Speaking with Marilyn is one of the most unsettling things I have experienced since September 11.

A few blocks to the north, Ali Janka is in residence at an art gallery in Soho. Ali is part of Gelitin, a four-man Austrian art group that makes fantastically quirky art installations. He is also one of a few men I am in love with.

In the summer of 2000, Gelitin was invited to do an installation on the ninety-first floor of the World Trade Center, and they came up with a characteristically brilliant idea. Very early one Sunday morning, when they were certain they would be alone in the gallery, they took out a window, and the fresh air of the New York harbor a thousand feet up in the sky rushed in. Ali and his co-conspirators then pushed a handmade balcony through the opening and went out to enjoy the view and sunbathe while a helicopter flew by filming them. They then retracted their precarious platform and resealed the window. No one from the gallery, the World Trade Center, or anywhere else knew anything about it. The only trace of their presence they left was a piece of gum they stuck on the outside wall of the tower next to the window.

Fearing legal consequences, Ali and the rest of Gelitin kept the deed a secret for more than a year before finally scheduling an exhibition of photos of the action at an art gallery in Lower Manhattan. Incredibly, the opening was set for September 11, 2001. Ali was there that morning to hang the photos and watched the towers fall with tears streaming down his face.

The balcony photos are now shocking to behold. Astounding images of sleek white modernist lines against blue sky and water. Of human specks dwarfed by towering steel. Of fun and innocence. Of daring and danger. Of fleeting moments and impermanence.[1]

I love these images. And the fact that Ali had a hand in them makes me love him all the more. When I look at Ali now I see these images in his eyes,

and when I look at the pictures I see his eyes. But there is one photo that is unnerving. Taken from the window of a nearby building, it shows the tower, the balcony visible near the top, and the helicopter flying by to film. I keep seeing the helicopter crashing into one of the buildings.

When Ali and his friends made their balcony, this was not "political art." In fact, Gelitin could not be less interested in politics. Yet by timing and coincidence, their images have acquired a political significance that would be all but impossible to create by design. They are uncertain about this unwanted boon. Making political art is not what they set out to do. Their photos sold out immediately and that's it, they will make no more. It is as if their favorite project has somehow combusted and covered them with something icky, something very much like the dust that has covered Lower Manhattan, even covered the members of Gelitin who were nearby when the towers came down, and they are hoping that by selling the images and sending them far away they can get clean.

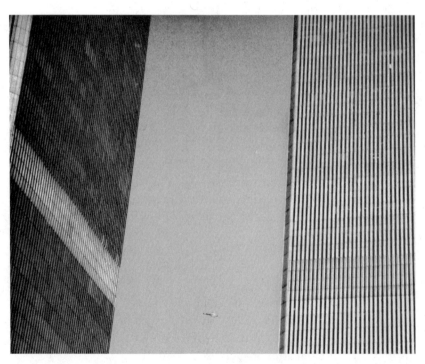

Gelitin's balcony off the World Trade Center. Courtesy of Gelitin.

It's astonishing, really. The towers collapsed, and art that was innocent and light and about immediate sensual experience is now heavy with import and intent, shouldering the weight of thousands of tons of wrecked association, while art that seemed so important the day before now goes searching for meaning. My musician friends I have been visiting in New York speak of "going through the motions"—doing rehearsals and concerts and benefits not because they want to or because they believe in them, but because they cannot *not* do them; not making music but going through the affect of making music, a mime that somehow produces sound but is an imitation nonetheless. The catastrophe seems to have sucked the wind from the imagination.

Even the megalomaniac German composer Karlheinz Stockhausen was at a loss. The murder of thousands in the World Trade Center, he explained, "is the greatest work of art for the whole cosmos . . . I could not do that. Against that, we composers are nothing."

What Stockhausen expressed with the grandiosity and lack of grace that have been his trademarks was articulated ten years earlier (years before the World Trade Center catastrophe) by Don DeLillo, in a passage from his novel *Mao II* that was stunning in its prescience:

> For some time now I've had the feeling that novelists and terrorists are playing a zero-sum game . . . What terrorists gain, novelists lose. The degree to which they influence mass consciousness is the extent of our decline as shapers of sensibility and thought. The danger they represent equals our own failure to be dangerous. And the more clearly we see terror, the less impact we feel from art . . . The major work [now] involves midair explosions and crumbled buildings. This is the new tragic narrative.[2]

■ ■ ■

Since arriving in this city I have spent my life pursuing politics and music as if they were two sides of the same coin, as if the two pursuits were actually one. Now it seems that politics has made art impossible.

But the downtown scene of which I was a part was never able to encompass politics and art at the same time, which is why I left it long ago. When I showed up in Manhattan at the end of the 1970s, the tone and sensibility of the downtown art scene was dominated by a group of people in Soho whose skin was white, who dressed in white, put on shows in lofts painted white, where they drank white wine and told white lies and affected the airs and mannerisms of multimillionaires. Snobbishness was next to artiness.

My generation dressed way down, lived in squatted derelict buildings, rode

bicycles (I worked a day job as a bike messenger, long before messenger bags became a fashion statement), played unruly, cacophonous music, and made common cause with punk rockers—yet still could not put politics and music together. Or at least, could not do so in a way I found meaningful. The other musicians with whom I played (with the notable exception of Fred Frith) were completely uninterested. Critics had a similar attitude. My perception of the apathy of the cultural scene was no doubt made much more acute by my own experience of the difficulty of becoming increasingly engaged with revolutionary movements whose dynamics were rooted in countries other than my own, and the fact that I could not articulate—even to myself—the integration of art and politics that I was intuitively grasping for and even now struggle to put down on paper.

Political art of a high caliber generally emerges from a time and place of extraordinary political ferment. *Nueva canción,* for example, emerged in the Chilean social upheaval leading up to and during the Allende era, then outlasted that political moment for an extended run as concert music with a broadly international audience. The music of Charles Mingus and Bob Dylan in the 1960s; the plays of Tony Kushner at the peak of AIDS activism in the United States; Picasso's *Guernica* during the Spanish civil war: all of these extraordinary works were more shaped by the upheaval surrounding them than they were shapers of those events.

At the end of the 1970s and into the next decade, I was straddling two cultural worlds: one in Central America in the midst of social revolution, and another in the United States during the final decline of 1960s radical-ism and the rise of the Republican right. There are times and places when an accumulation of social pressures results in political eruptions that tear a social fabric so deeply that even those with little affinity for political action drop their daily routine and take extraordinary risks for a common cause. Central America was going through such a time. And then there are times of such generalized complacency that foregoing one's personal pleasures and pursuits in order to work to right an injustice others see as remote can actually isolate you from your own culture. The United States was going through such a period. This is a catch-22 situation, because the only way to effectively organize is to immerse oneself in one's culture, not run from it. All the Americans working to change American policy in Central America were acutely aware of this disjunction and at times felt like this discrepancy would drive them crazy. I think this experience was particularly acute for me, as my political imagination was fired by events in Central America, while my

artistic imagination remained rooted in the urban avant-garde of America during the Reagan revolution.

One result was that I lost all sense of urgency about music. What was the point of another little show at an obscure underground venue for a handful of in-the-know hipsters when death squads in El Salvador were murdering over two hundred people a day, American aid to the regime was ramping up, the revolutionary movement was gaining momentum by the day, and there was simply no time to lose? If the choice was between music and politics, it was a no-brainer. After spending a few years in New York swimming upstream and increasingly feeling like the culture of art was making meaningful politics impossible, I left musical pursuits altogether and dove headfirst into the political culture of the Central American revolutions of the 1980s.

After ten years I returned to music older and wiser, with a more nuanced understanding of the politics of human culture, and willing to be a little more patient feeling my way forward in finding a way to integrate the different creative impulses that motivate me.

And now here I am come full circle, once again a musician and again in New York, only to find that where before art seemed to make politics impossible, now politics seems to have made art impossible. Which raises the question: what have I been doing the last thirty years? Why should political events like terrorism and war make art so irrelevant? Why not the opposite? Why does political calamity not make art all the more urgent and necessary? Why do connections that so motivate me seem opaque to my contemporaries? These questions will, in one way or another, occupy the remainder of this book.

■ ■ ■

In this life we are enmeshed in an infinitely dense grid of social and physical relations. Art is what happens when we try to interact with this web in a particular creative way. Make it better? Maybe. But also make it prettier, uglier, louder, quieter, more organized, and more chaotic. Art is making things that are useful. Art is making things that are useless. Art is making things that excite the mind. Art is making things that quiet the mind. Art is inventing systems. Art is breaking rules.

Is this all we can say about art, that art is about creating? No. Entrepreneurs are creative, inventing new business methods, product lines, and markets. In fact, the capitalist system is relentlessly creative, yet we do not think of its functioning as art. The question is one of intention. Entrepreneurs create in order to make profit. Scientists create in search of falsifiable knowledge.

Athletes create in order to win games. Military leaders create in order to destroy the enemy.

I think an artist is someone who creates in order to transcend, to rise above the particular and reach for the universal. Words like *transcendence* and *universality* are quite unfashionable in our postmodern intellectual milieu and come loaded with a heavy baggage that today is generally seen as conservative. But I use them here in a way that is quite specific to my argument, so I ask the reader to suspend judgment for at least a few paragraphs and hear me out.

Much of my art is focused on the tension between humans and their technology, between body and machine. This theme will occupy quite a few of the pages of this book. The problematic relation between bodies and machines is more typically the domain of science or engineering (biotech, robotics, medicine, artificial intelligence, and so on). But science seeks to explain problems, while engineering seeks to solve them. The tension between the human body and the machine poses a complex set of problems that is clearly not ready to be "explained" or "solved" yet intrudes into our lives in many profound and unavoidable ways. This makes it a natural habitat for art, which seeks neither to explain nor solve but to illuminate.

A work of art seeks to illuminate some nexus in the dense web of physical and social relations in which we live, illuminate it so brightly and clearly that we can see it as if from a new angle, can for at least a moment become unstuck from our unique spot in the grid and see things from a new perspective. This coming unstuck is what I mean by *transcendence.* And the possibility of seeing potentially any other location on the grid illuminated and clear of the filter imposed by our own little node is what I mean by *universality.*

The approach to the universal can take many routes, and most art employs more than one. But every route must pass through the body, this one thing we all have in common, which mediates our every perception and experience with the great web beyond. We live in these bodies every day, we experience the same joys and frustrations with them. We all know the hurt of physical pain, the exaltation of sex, the feel of a cool breeze caressing our face, the nuance of taste. We all know the joy of learning to do a magical new thing with our body, like riding a bike or swimming or kicking a ball and seeing it go where we intended. And we also know the frustration of failing, of realizing that no matter how much we practice, we may not be cut out to be a great violinist, that we may never run as fast as we would like, that our injured shoulder will never regain its full range of motion, and that age will inevitably take its toll. If composing music for dancing is art, it is

because humans universally find beauty in moving their bodies in rhythm with sound. If composing a fugue or exploring a raga is art, it is because humans universally find beauty in sounds arriving at their nervous systems at frequencies that are arranged in mathematically coherent ways. Music and dance are universal because they are written into our bodies, and virtuosity in anything has a universal appeal. Thus the notion of virtuosity, the ability to be transcendently creative with one's body, will receive a fair amount of attention in these pages.

Consider the following spectrum: at one end is art that is "abstract" in that its cultural references are relatively open-ended, or at least implicit and unspecified. At the far other end of the spectrum lies deeply personal work about the experiences of one's own life, family, tribe, and so forth. Such works may even be made with the explicit intention of appealing only to others who share those immediate experiences, the members of one's own tribe. But even the most explicitly personal works carry the potential that, if done well enough, they will illuminate an aspect of human experience deeper than the details of experience specific to any one group and thus be profoundly appealing to all. This is the realm of art we consider "classics."

Artists often state that they make their art only for themselves. I have said something like this myself. But what I mean is: when I make music, I make it the way I think it should be. I do not imagine how others might hear it, then tailor my work to these imagined tastes. I create uncompromisingly for myself. I trust that there is enough common ground between our different lives that if I make something that resonates with me at a profound level, there will be others who will hear it as profound, as well. And I suspect that if instead I tried to make music by imagining what others wish to hear, the result would be perceived by all as superficial.

So yes, I make music for myself, but that is very different from saying I do not want anyone to hear my music. Of course I do. That is the only reason to make it, to create some bond between people. I have never met an artist from any discipline who did not share this objective. This does not imply that a bigger audience is better. Take Jim Magee, an extraordinary artist whose work is the subject of a chapter in this book. When Jim decided to dedicate his life to making art, he decided that the best way to do so was to get as far away from the art world as he possibly could. His intuition was that isolating himself off from the social noise of the art world would not only permit him to pursue the sort of work he was interested in, but would allow his work the best possibility of being truly "seen," even if only by a very few who travel to El Paso, Texas, and then ride with him in his beat-up old pickup one hundred

miles out into the desert. Though he is in a sense an artistic recluse, he goes to greater lengths to show his work than any artist I know.

In the case of my own work, when I created my multimedia work *Yugoslavia Suite,* which dealt with the civil wars in what was formerly Yugoslavia, I did not give a second thought as to whether performances of the work would be attended by large or small audiences, but I was willing to go to great lengths to make sure it was performed in the Balkans, even if only for a handful of people. (*Yugoslavia Suite* is the subject of Chapter 2.)

I can imagine an artist who would be satisfied if only *one* person saw his or her work and was truly illuminated by it, but I cannot imagine an artist who did not care if *no one* ever saw it.

I have the deepest respect for musicians who create amazing music for years in isolation from any significant audience, musicians such as Conlon Nancarrow and Cecil Taylor. But their dedication to their craft does not indicate any lack of interest in an audience, but rather the conviction that their work would find its audience in due time.

Any serious artist approaches each new work with the intention of making something with universal appeal. This is the fundamental motivation behind artistic endeavor: to provide a door through which we can become unstuck from our unique little point on the web in which our lives are entangled. Our efforts fall short in all kinds of ways, but every work begins with the possibility of becoming a masterpiece. It is this allure that motivates us to make art. Here lies the answer to why an act such as occurred on September 11, 2001, can make artistic endeavor seem so pointless, for it reveals schisms in the human experience so profound that the possibility of creating anything that speaks to everyone seems completely futile, even ridiculous. If we cannot at least *try* to transcend this web in which we are ensnared, what is the point of art? Thus the going-through-the-motions-but-running-on-empty feeling of my musician friends in New York in the wake of September 11.

The web of our relations with the human and physical worlds has grown increasingly complex, dense, and extended in recent years. Afghanistan is one of the poorest countries in the world, the United States one of the richest. The two countries are situated on nearly exactly opposite sides of the planet. If people sitting in caves in Afghanistan can create mass murder in Manhattan, then we can say that *everyone* on earth stands in some relation to everyone else. Of course, people in the poorer parts of the world who have been the targets of American expeditionary forces or cruise missiles or subsidized corn exports have known this for some time. But a relationship implies a two-way street, and the World Trade Center attack signaled

the arrival of the return mail. I am a gay atheist living in San Francisco, yet somehow I must share a common social, political, and cultural space with people in Afghanistan whose religious police walk the streets with rubber whips with which to punish men whose beards are too short, who banned almost the entire vast and rich heritage of Muslim music from being heard, and who hate me and others like me so much that they can patiently plan and execute the murder of thousands of us at a time. What could possibly bridge this gap?

■ ■ ■

Within this web of relationships of which I am speaking, let us say that *power* is the degree to which any relationship is tilted in favor of the person or party on one side of the relationship being more likely to obey the commands of the person or party on the other side than vice versa. *Commands* is used here in the broadest sense: not only "stay off my property," or "work for a low wage in my factory," or "fight in my army," but also "trust in my wisdom," "desire the sexual pleasures I wish for you," "dream dreams that reinforce my authority," and so on. Since no relationship is exactly equal, power is expressed in every relationship, from that of two close friends all the way to, say, that of the world's Christian and Muslim communities. Every relationship between people, from the individual to the national, the trivial to the profound, has some degree of imbalance, and when I use the word *power* this is specifically what I mean.

People who are at the hub of many relationships skewed in their favor are powerful people. Strands of the web can solidify into well-worn channels that defy easy change—that is institutional power. Institutions relate unequally to other institutions all the way from nuclear families right on up to grand structures like the Group of Seven (or Eight) or the North Atlantic Treaty Organization. But even at this grand scale, power is not a thing one accumulates like poker chips or bullets, but is always a relationship that can be traced back to relationships between real people—strands between nodes in the web.

Politics refers to actions that attempt to change a balance of power in the strands between nodes, to tilt the balance differently, to shrink one strand and strengthen another, to cut a strand here and make a new connection over there. When feminists declared "the personal is political," they meant that the power imbalances in relations between individuals (and in particular between individual men and women) merited sustained analysis and struggle for change. Politics in the more conventional sense concerns struggles over

balances of power involving large nodes in the web of human relationships with strands running out in all directions, nodes like states, transnational corporations, and so on. Maintaining a semblance of democracy in an era of "globalization" implies the need for some way of addressing the balance of power at the scale of the entire web, and it is not at all clear how this might develop.

Of course, a lot of political activity involves people who occupy strong nodes in the web seeking to defend their position, or other people trying to push those occupants of the strong nodes out of place so that they themselves can enjoy the privileges of that real estate. But there is another kind of politics that seeks to restructure the web itself so that power is distributed more evenly. Let us call this *insurgent* politics. Insurgent politics is necessarily experimental, unruly, and disruptive. It examines, tests, expands, breaks, and restructures the strands between the nodes in the web. It always centers on struggle.

This is so close to my artistic aesthetic that in this light it is hard for me to even discern the line demarcating art and politics at all. For all my work is in some sense about struggling with the limits of the social and physical world: testing, examining, expanding, breaking, and restructuring. Seeking possibility where before there was none, making new connections and rupturing old ones. It is fundamentally about struggle—struggle with and within the social and physical world. Others can make peaceful, sonorous music about beauty and symmetry and celebrate the world as it is. For me, struggle is the root, the source.

Yet despite seeing art and politics flowing from the same spring, I am not blind to the fact that farther downstream they diverge according to differences in intention. *Politics is about restructuring the web in which we live. Art is about coming unstuck from it—transcending it, if only for a moment.* Insurgent politics is about seeking to draw together a collection of weaker nodes in the web in such a way that the web itself can be restructured to their benefit. This requires focusing on the commonalities that define the collective. It does not imply erasing the individual except in its most totalitarian manifestation, but it does imply, at the least, deemphasizing the individual. Art requires an uncompromising truthfulness to oneself, forgoing any intentional appeal to an audience in exchange for a potentially universal appeal to all. Politics, in the end, is about winning, a concept that is meaningless to art.

It is these discrepancies that make so much of what is referred to as "political art" so bad. For art made with the intention of contributing to a specific political struggle is necessarily made from a perspective of trying to teach,

convince, motivate, or manipulate its audience, which leads straight into the thicket of clichés that plague "political art": predictable, preachy, pedantic, overbearing—in a word, boring. It may be a political tool of limited but nevertheless real use, usually in the sense of offering people engaged in a struggle a moment of respite where they can celebrate their common commitment. But rarely does such work have an appeal beyond its immediate circumstances, and it is usually forgotten as soon as the social battle lines that produced it fade and new ones are drawn.[3]

This is not only why people whose primary intent is political often make bad art, but also why so many artists make such bad political insurgents. Their predilection toward personal expression gives them an inflated sense of the importance of their own perspective to a common struggle, and instead of participating in the struggle in a way that honors a willingness to immerse oneself in a common cause, they insist that their private vision will offer some unique inspiration to everyone else, a stance that is not just self-important but ultimately selfish and leads to an "art politics" that suffers from the same clichés as "political art": a politics that is predictable, preachy, pedantic, overbearing, and, most importantly, is not about winning anything.

I have tried to find another way. I try to avoid the downstream areas where art and politics have become so divergent with their differing intentions that they can only be forced back together artificially and selfishly, and to situate myself upstream, closer to the creative source, where the waters are mixed and the demarcation is still blurred. My music is often described as "political," yet it is never about trying to convince anyone of anything, not about getting anyone to think like me, not about moving anyone to march on anything. I try to avoid preaching to the choir by not preaching at all.

But I do use "political" elements: a recording of a Salvadoran boy burying his father (*Sooner or Later*), images of war (*Special Forces* and *Yugoslavia Suite*), memoirs of friends who died of AIDS (*Spiral*), letters to heads of state (*Dear Prime Minister*), audio from a queer riot (*All the Rage, Burns Like Fire*), and others. I do not use these with the intention of achieving a political result, but simply because they are what move me. They are my life, which has been lived in Central America, New York City, San Francisco during the AIDS epidemic, and the United States during a particularly bellicose time in its superpower reign. I use them because it would be unimaginable for me not to. Everyone who spends a life making art has a particular affinity with certain particulars of their craft. Some painters are drawn to color, others to form. Some musicians have an instinctual affinity with harmony, others with melody. For me, the social relations within which I live and make

music have always been the materials to which I am naturally drawn, the elements my curiosity returns to every time I sit down to work. I use them as my materials because I need to, just like any other artist uses the materials he or she must. If my music and films motivate anyone to sympathize more with political causes that are dear to me, that is wonderful, but my work is not made with that intention, and I am more than skeptical that my music (or anyone else's) could be in any substantial way successful in this regard.

Just as importantly, I have devoted a substantial amount of my energies to more directly political pursuits. I don't do this as someone who thinks his art might make a special contribution or play a special political role. I have comrades from years of political struggle who do not even know I play music. I do it because political struggle is endlessly creative and engaging in itself.

I don't see myself as swerving back and forth between art and politics but engaging in a creative endeavor of struggle against the constraints of the web of social and physical relations in which we live. Farther downstream, this endeavor forks into politics (which seeks to win) and art (which seeks to illuminate), but upstream it is just the creative impulse that ultimately gives life meaning.

This is what I think of when I think of a creative life, a life whose center of gravity lies upstream, where everything—profession and livelihood, location, even gender and identity—is up for grabs and we ride the tiger even when it takes blind turns and detours to destinations unknown. This is the realm where the impulse to create leads people to reinvent themselves: where John Cage's musical curiosity led him to reinvent himself as a Zen Buddhist, where Jim Magee of New York became Jim Magee and Annabel Livermore of the desert, where Anthony Braxton reinvents himself as reed genius, composer, chess master, and philosopher, and where Justin Bond continually reinvents himself as Justin Bond. (You will meet them all later in this book.) It is the realm in which the best of the Central American revolutionaries reinvented their revolutions in small ways every day, reinventing themselves to the task at hand in ways that created masterpieces of politics equal in every way to masterpieces of art. This is the life to which I aspire, and it is why I do what I do.

—*Winter 2001*

Early Years

In 1976 I left my hometown in Colorado to study at Oberlin College and Conservatory in Ohio. I spent the first year in ecstasy over escaping from small-town Colorado and finding a community of others my age with similar interests. I spent the second year banging my head against the wall. Everything I learned there I learned from other students or just one teacher, Dary John Mizelle, a wonderful composer who was denied tenure my second year.

In the spring, Anthony Braxton visited the school. Braxton was the superstar of the jazz avant-garde of the day, and the arrival of the radical black saxophonist and composer to the conservative white institution was a huge deal for the few students who were interested. He ran an improvisation workshop for a couple of days, in which I participated with my hand-assembled Serge synthesizer: a box of knobs and buttons and tangled wires—and no keyboard.[4] I was enrolled in the conservatory's music-improvisation class, an utterly pointless endeavor. Anthony's workshop was a revelation. While most professors at the conservatory were highly adept at conveying their sense of boredom with their own classes, from the minute Anthony walked into his workshop there was an electricity to it wholly alien to everything else I had experienced at school. I learned more in the first hour with him than I had in two years of classes. The most startling thing was how seriously he took his encounter with students. It was immediately clear that he expected great music to be made, right there and then. His demeanor would have been no different if he was in a room of world-class virtuosos instead of struggling students. We had no choice but to reciprocate, and for a brilliant moment a classroom became an actual site of learning.

I learned essentially the same thing from both Anthony and Dary John: what it means to be a committed musician. How to center your life on it. How music must absorb you. How you must enter each musical situation with the expectation that it will be transcendent. And how to share a sense of this kind of engagement with those around you. Thirty years later, it is only a slight exaggeration for me to say that this is all I think anyone can learn about music from a teacher. The rest you have to work out for yourself.

On the second day of the workshop Anthony asked if I would join his ensemble for a concert tour of Europe. I was stunned. Just a few weeks later, I found myself in New York City rehearsing with a fourteen-piece big band featuring virtuosos such as George Lewis, Kenny Wheeler, Marilyn Crispell, and many more. For a kid from a small town in Colorado, just being in New York was a full-on sensory assault. But the rush of traffic and people and noise

and hustle out on the street was outdone by the whirlwind of chaos in the rehearsal studio. There was not nearly enough time to properly rehearse the material, which was exceedingly difficult. Much of the material wasn't even written—Anthony was staying up all night writing the parts for the next day's rehearsals. At the time I assumed this must have been an aberration, that somehow someone must have promised Anthony more time or resources and then pulled the rug out from under him.

When I arrived on the first day of rehearsal, Anthony welcomed me in, handed me my parts, and then turned away to deal with the hubbub enveloping him: someone couldn't read Anthony's notation, someone couldn't tell if his part was transposed, someone had been promised a place to stay that had not materialized, someone was not showing up, someone had called from Europe to cancel a concert, or demand an additional concert, and so on. I stared at the charts Anthony had given me and my heart sank. Keyboard parts! I didn't know how to play keyboard. My synthesizer didn't even *have* a keyboard. In fact, it didn't even have anything you could hit to bang out a particular rhythm or pitch. It was an automatic music box. You played it by using colored wires to connect inputs and outputs in different patterns, listening to the sounds that resulted, and then responding to the result by changing the automated parameters with knobs.

What was I ever going to do? I was absolutely convinced that I should not be there. A country boy in the city. A kid among adults (I had turned twenty-one the week before). A white in a room full of blacks. A student among teachers. And most importantly: with the wrong instrument! I flashed back to the improvisation workshop at Oberlin and it hit me: Anthony had spent the whole workshop listening intently—*with his eyes closed*. He hadn't actually seen me "play" my synthesizer. He had hired me thinking I played keyboard! With my heart in my mouth and a terrible feeling in the pit of my stomach, I timidly followed Anthony around the rehearsal space trying to find an appropriate time to break the news.

"Ummmm, Anthony, these are keyboard parts."

"And?"

"I don't play keyboard."

[Pause.]

"What?"

"I don't even have a keyboard."

[Blank stare for about ten seconds.]

"Ostertag, I don't have time to deal with this. *Figure it out.*" And he was

off to deal with the next ten crises, leaving me staring at the notes and stems and clefs and key signatures on the staff paper in complete confusion.

To make matters worse, the group was playing a suite of marches and big-band music Anthony had composed—music about as idiomatically remote from what was generally done on a synthesizer like mine as could be imagined. What was a white kid with an automatic music box that made electronic bleeps and bloops in no particular rhythm or key going to do onstage with a collection of jazz greats *getting down* with some highly deconstructed yet totally foot-stomping big-band charts?

A few days later we were in Köln, Germany. Köln was an imperial capital of the twentieth-century avant-garde, home to a storied electronic music studio where John Cage and Karlheinz Stockhausen had done seminal work, and home to WDR Radio, which commissioned major works by composers considered cutting edge and in whose vast concert hall our opening show was booked. Our concerts alternated Anthony's compositions with improvisations that Anthony conducted with hand signals. We finished the opening composition, and as we segued into improvisation, Anthony's first signal was for everyone to stop and for me to play an unaccompanied solo. I nearly froze with terror. An old man in the front row stood up and started yelling. I did not speak German, but I had a pretty clear sense of what he was trying to convey.

■ ■ ■

I have since learned that my experience with Anthony was not an anomaly, and that a sink-or-swim sensibility is central to Anthony's music. He spelled this out in his introduction to his *Catalog of Works,* written ten years after our tour: "Don't misuse this material to have only 'correct' performances without spirit or risk . . . Don't view this material as only a technical or emotional noose that can be used to suppress creativity. If the music is played too correctly it was probably played wrong . . . I recommend as few rehearsals as possible so that everyone will be slightly nervous."[5]

My time with Anthony was short, but the experience was formative. And now I can explain why it was an exaggeration when I said there was only one thing you could learn from a teacher about music, because Anthony taught me about how to incorporate a sense of struggle into music. Struggle permeates all his work—struggle with graciousness and a sense of humor: his entire sense of creativity, his extraordinary virtuosity, his impossible parts, the frenetic energy of the music, his insistence on projects that demand more

resources than he can garner, his delight in putting his players in situations where nothing is easy and the outcome uncertain. One could consider Anthony's music "indeterminate," but this is not the kind of indeterminacy that comes from a privileged white upbringing. This is indeterminacy African American style. No throwing the *I Ching* here, but rather recognizing life's impossible odds and taking delight in the creative ways we come up short. Frederick Douglass famously said, "If there is no struggle, there can be no progress." For Anthony, if there is no struggle, there can be no music. For my part, I can say that if there is a sense of struggle and commitment in my work, I learned this in part from Anthony, and I have tried to apply this teaching to everything I have done since.

Of course, Anthony Braxton's music is about much, much more than this. The scale of Anthony's vision is stunning, encompassing novel compositional and improvisational forms, a unique synthesis of many disparate musical traditions, a deep sense of world history, and a philosophical and mystical system all his own. When you add it all up, Anthony's life project has been the creation of an alternative world based in equal parts on musical mastery, philosophical rigor, and mysticism. There are few precedents for what Braxton has accomplished. Karlheinz Stockhausen is often mentioned in this regard, though he lacked the instrumental virtuosity on which the entire edifice of Braxton's world is built. Sun Ra may be better fit, especially given the way in which Sun Ra's poverty and continual struggle to keep his Arkestra afloat informed his overall esthetic. But Sun Ra traded on his own wackiness in a way that Braxton would never do. To my mind, the closest precedent to Braxton was set by Harry Partch, the only other composer I know of to match the scale of Braxton's will to create his own musical world from the ground up. But here again, Partch didn't have Braxton's instrumental virtuosity, and his actual music was nowhere near as compelling. In the end, I think there is no precedent for Anthony Braxton. He is a true original. I was fortunate beyond words to have had the opportunity to work with him at such a young age.[6]

■ ■ ■

After the European tour, returning to school was simply not an option. Most of the members of the Braxton ensemble lived in New York City, so soon I found myself in the East Village of Manhattan, where I quickly fell in with a group of young musicians with whom I became very close, some of whom, like John Zorn and Fred Frith, became lifelong friends. This was a wonderful time. Everyone lived within a few blocks of each other. We could walk to

each other's places in minutes, and often we could walk to our "gigs," such as they were. The first time I met John, he was playing a "gig" in his girlfriend's apartment, which "sold out" with an audience of five. Since no real venue would have us, we set up a space of our own in the basement of a pet store.[7] It was dark and dirty and cramped, and when the music stopped you could hear crickets chirping (escaped snake food from the pet store above). In other words, it was perfect. Playing CBGB's, a local punk rock dive, was about as respectable as we got.

We had no money, no grants, no institutional support, and little critical attention, but we had the one crucial ingredient an insurgent cultural scene needs in order to flower: cheap rent. Cheap rent, I learned, is far more important to fostering a vital art scene than grants, galleries, and so on. We lived on nothing, played in nothing spaces, and were not accountable to boards, power brokers, or granting agencies. We didn't write any proposals, didn't justify our activities to anyone—we just did it. Wonderful. The violinist Jim Katzin and I had two storefronts, living in one and rehearsing in the other, and paid $275 a month for the pair. John Zorn lives to this day in a building in the East Village that he and some friends bought from the city for one dollar.

Much later we would be seen in hindsight as the initial nucleus of what became known as the "downtown" music scene, but at the time we were not even on the map. Back then what was known as the downtown scene was a group of musicians gathered around a venue in Soho called The Kitchen, with whom we had little contact. In fact, when the New Music, New York Festival was organized in 1979 (what went on to become the yearly New Music America Festival until it shut down in 1989), supposedly representing the breadth of the New York scene, not one of us was invited. Instead, Zorn and Eugene Chadbourne organized a counterfestival of our own that included three days of small-group performances culminating in a "big band" performance of Chadbourne's *The English Channel* and Zorn's *Archery*. Few people came, and no one wrote about it. At this point the only mention that John had received in the press was in a *Village Voice* review of a duo concert he had done with Eugene, which did not even mention their names, but rather used their performance as an anonymous example of all that was allegedly bad and amateurish in music in New York.

Oddly enough, my work seemed to be getting more traction than that of my friends. By 1980, I had done a couple of gigs at The Kitchen and had a couple of very positive *New York Times* reviews. The Squat Theater was a venue on Twenty-third Street run by a Hungarian guy named Janush. Fred Frith and I played a duo gig there that Janush was ecstatic about. He was organizing

a twelve-hour music marathon of all his favorite acts, and he invited me to bring any group I chose and have the prime time slot at midnight. I organized a trio with John Zorn and Polly Bradfield, a violinist we often played with and who lived in John's one-dollar building. But John absolutely refused to do the midnight slot we were slated for, insisting that there would be "too many" people in the audience, which would "ruin the music." Janush was incredulous that we were turning down the top bill and instead wanted to play when the marathon first began at 2:00 P.M., but he consented. We played our afternoon set to a nearly empty house. When we finished, Janush was again effusive in his praise and insisted that we come back and play again at midnight when the place would be packed. It was a coveted spot and the schedule was booked solid, but somehow he would get us the time. Just as adamantly, John refused. He was emphatic that an audience of ten was the most he would be willing to play for!

■ ■ ■

In the meantime I had become increasingly involved in the anti–nuclear power movement that had emerged in the wake of the near-meltdown of the Three Mile Island nuclear power plant in 1979. One of these was in Seabrook, New Hampshire, where a series of occupations of the construction site had brought thousands of protestors. I worked organizing these events and was designated the spokesman for the New York State contingent in the campfire discussions during the final occupation. The Seabrook occupations were followed by a huge demonstration in Lower Manhattan against funding new plants, where we effectively shut down the New York Stock Exchange. Next came a campaign against the Shoreham plant under construction on Long Island. This was an incredibly vibrant movement, absorbing much of the remaining "back-to-the-land" counterculture of the 1970s while incorporating many like myself who were too young to have really participated in the 1960s. Three Mile Island had pushed the issue to the forefront of the public imagination of the day and infused the movement with a strong sense of urgency. Just as importantly, the mode of protest—occupations of construction sites—made the work fun and exciting. We got to camp out in the woods with hundreds and even thousands of others. We got to confront state power, put our bodies on the line. We got to learn fun stuff like how to protect yourself from tear gas and shield yourself from police batons. Everyone felt great. Everyone fell in love. Everyone had a blast. And then it all fell apart in a morass of sectarian splits, ideological rigidity, and police dirty tricks.

It was about that same time that the Sandinista movement overthrew the Somoza dictatorship in Nicaragua. The Sandinistas cut an enormously appealing profile. They were young. They were less ideologically rigid than previous generations of Latin American revolutionaries. They were obviously hugely popular in Nicaragua. They counted writers and poets among their top leadership. And they had *won* outright against a U.S.-supported dictator. As a result, the Sandinistas captured the imaginations of politically minded young people all over the world, on a scale far out of proportion to what would have seemed possible for a movement in a poor country with less than three million inhabitants.

Fred Frith and I had been running a little record label called Rift, and I decided to go to Nicaragua with the intention of recording some Nicaraguan music for the label to release. Nicaragua in the wake of the fall of Somoza was an incredible place to be. A national literacy campaign was under way, with students leaving university and even high school to go to the countryside and teach *campesinos* to read. Similar campaigns for health and land reform were in the works. There was an outburst of grassroots creative endeavor. The whole country seemed to be engaged in a giant love affair. But what hit me more than anything was the sense of optimism that pervaded everything and everybody. The horizon of the possible seemed to have suddenly shifted. In one of the hemisphere's poorest countries, reasonable people everywhere acted as if the sky was the limit.

If you were a gringo in Nicaragua at that time and asked what you could do to help, you were told without exception to find some way to help the struggle in neighboring El Salvador, where another revolutionary movement was threatening another repressive U.S. client state, and where the incoming Reagan administration was "drawing a line in the sand" against democratic upheaval in Latin America.

So I went back to New York and did exactly that, splitting my time between music and working with the rapidly growing population of refugees fleeing the Salvadoran war. I tried to fuse these activities into one. I wrote a piece called *Hospital General,* a collage of media stories about the soap opera *General Hospital* and reports of torture in Central America. I arranged a gig at the *Taller LatinoAmericano,* a cultural center of Latino leftists. For my group I roped in John Zorn, Polly Bradfield, and percussionist Charles K. Noyes. I remember actually having to *push* John out of the dressing room and onto the stage. He was convinced they were going to throw chairs at us. In fact, they very nearly did.

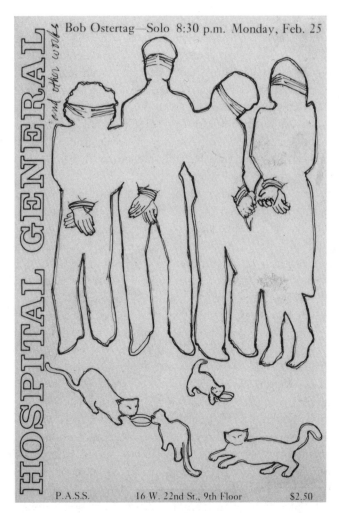

Concert announcement for 1981 premiere of *Hospital General* at the Public Access Synthesizer Studio, New York City.

With the exception of Fred, I could find no one in New York supportive of these efforts. In the New York art world of the day, anything to do with politics was just *not cool*. Appearing to be passionate about political issues was a way to instantly ruin your street cred. In the 1990s, after two terms of the Reagan administration cutting arts funding, this attitude would change a bit. But that would be later; this was now. No one, not even my closest friends, shared these passions. And I myself could not articulate them all that well

(something that I am finally attempting with the present book, thirty years later). John and I would often ride our bicycles through the Wall Street area in the wee morning hours after gigs, speeding through the empty streets as a way of coming down off the high of the music. I remember trying, and utterly failing, to interest him in the politics of the day on these rides. I might as well have been speaking Chinese.

Torn between the worlds of the New York music underground and the Central American revolutions, I chose the latter. Compared to the insurrection against death-squad rule in El Salvador, my little world of marginal musicians just didn't seem that important. Without me making any conscious decision on the matter, gigs and rehearsals soon disappeared from my datebook and I was up to my ears in Central American politics.

■ ■ ■

A decade later, I returned to music and was more than startled to discover that John had become a famous, influential composer. And I am still surprised today when I hear the activities of my little circle of musical friends referred to as "seminal." It certainly did not feel seminal at the time. It was fun, I had a great time, and perhaps we even made some good music, but I was sure it would never amount to anything.

The antinuclear struggles in which I participated can be viewed in the same light. In spite of the fact that the organizing died out in despair when it became clear that we would not immediately stop the construction of the next round of nuclear plants, the Shoreham plant never went on line and was finally decommissioned in 1994 without ever producing a single kilowatt of electricity. More importantly, no new plants have been licensed since. Our "failed" movement was one of the most successful in U.S. history.

central america

When I returned from Nicaragua I began raising money, showing films, and doing public speaking on behalf of the community of Salvadoran refugees in the New York area. As the war in El Salvador escalated and Ronald Reagan drew his infamous "line in the sand" against radical social change in that poor country, I switched from working with Salvadoran refugees to organizing Americans to oppose Reagan's support for the Salvadoran regime, first locally in New York City, then regionally in the Northeast, then nationally. At some point along the way it was discovered that I could write, and writing became a bigger and bigger part of my work. Eventually I withdrew from direct organizing and worked in Central America as a journalist, though a very politically engaged one. As time passed and the war ground on, my own political views became more sophisticated and I became more confident of them. I found myself increasingly at odds with the direction of the revolutionary movements in Central America, and finally in 1988 I left Central America for good and returned to music.

El Salvador, 1988: Absolute Diabolical Terror

Being less conjunctural than most of my writing from El Salvador, this piece is perhaps of more interest to a reader today than the more analytical pieces I typically wrote. It is coauthored by Sara Miles, my partner in politics and just about every other aspect of life in this period. It was originally published in the April 1989 issue of Mother Jones.

. . .

As the helicopter carries us up in a cloud of dust, the door gunner straps in behind the sights of the M60 machine gun and breaks into a wide grin. "War is beautiful," he cries. We scream north, skimming the treetops to San Francisco Gotera, the last government outpost in the toughest guerrilla stronghold in El Salvador. Tumbling out of the chopper along with crates of ammo and medicines, warily inspected by the exhausted soldiers guarding the landing strip, we're loaded into a pickup that winds its way past women selling tamales, shouting kids, pigs and chickens, depositing us at the garrison where troops, tanks, and informers are endlessly going and coming and the smell of gunpowder is in the air.

And there it is, stuck on a jeep parked in front of the room in which Colonel Juan Carlos Carrillo Schlenker, the beer-bellied base commander, is having breakfast while watching loud U.S. rock videos. A large blue and white bumper sticker from New Age California tells us, in English, to VISUALIZE PEACE.

The bumper sticker isn't really out of place. In fact, its complete inappropriateness makes it fit right in in this tiny country that is both at war with and overwhelmed by U.S. culture. It is certainly no more surprising than the handsome young man encountered in the steaming cotton fields of the coast who, before becoming a guerrilla commander, had waited tables at Tavern on the Green, an expensive Manhattan restaurant. Or the head of the clandestine urban front who passed us documents stuffed inside a well-worn copy of a Jimi Hendrix album. Or the campesino kids at the demonstration who danced happily down the street to James Brown's "Living in America" blaring from a CBS TV truck, all the while chanting, "Death to the Yankee Invaders!"

Peace is hard to visualize in Gotera, or anywhere else in El Salvador. It's easier to VISUALIZE FEAR, a fear that chokes El Salvador like a cloud of smog on a never-ending muggy summer day.

Rubén Zamora is an expert on fear: a leftist politician, he remembers how his brother (at the time the country's attorney general) was assaulted at a party in the early part of 1980 by a death squad that dragged him into the bathroom and blew his brains out.

"Begin from the following," he says. "Fear is part of our soul. It's like the sexual impulse. In the face of fear you cannot have an absolute attitude, you cannot demonize fear. When the Catholic Church tried to demonize the sexual impulse it was a disaster, it produced schizophrenics or psychopaths.

"So the first thing to do with fear is recognize it as an objective part of the reality in which we live. But second, you must rationalize it. In the sense of trying to situate it so that it allows you to survive, helps you to survive, but

does not dominate you. When fear dominates you it's the same as if the sexual instinct dominates you. Totally. You become irrational. So you act bad. You make mistakes."

Zamora shrugs. "Fear is a very complicated thing in this country. We tend to simplify it too much." Then he lights another cigarette, takes a draw from the fifth of Johnny Walker Black we have been working on for the last two hours, and speaks very deliberately. "We have the right to be afraid. We have a rational basis for being afraid. But we do not have the right to live in fear, or to be slaves of fear."

■ ■ ■

Zamora is himself a complicated man, who conveys convincing honesty, political savvy, and a genuine sense of humor. He is the most dynamic of the social democratic politicians who fled the country in 1980, allied themselves with the guerrillas of the Farabundo Martí National Liberation Front (FMLN), and returned last year to reenter electoral politics.

Much has changed in the past eight years. The civil war has torn the society to shreds: more than sixty thousand dead, roughly one-third of the population displaced, the economy in a shambles. President José Napoleón Duarte—in the 1970s a persecuted reformist, then the front man for a bloody military junta, and finally the U.S.-anointed symbol of "democratization"—is dying of cancer. The FMLN has grown into the most capable guerrilla army in Latin American history, moving freely beyond its traditional mountain "zones of control" into the cities. A new ragged and militant mass movement— unions, squatters, refugees, cooperatives—has grown from the remnants of the social tidal wave that swept the country in the late 1970s before it was thoroughly dismembered by right-wing terror. The new movement has yet to find its own rhythm, but it keeps pushing, constantly testing its limits.

The right has also changed. The army, with all the U.S. aid it could absorb and then some, has grown from a force of 12,000 to over 56,000. The ultra-right ARENA party has grown from a loose collection of coffee oligarchs and death-squad thugs into a well-oiled political machine, still run by the thugs, that is close to consolidating its hold on the presidency and the legislature.

There is continuity, as well. Officers with death-squad links still hold some key army commands. The disappearances and killings, after dropping sharply for a few years, have begun to increase. The United States keeps pouring money into the regime—nearly $2 million a day goes to a country of five million inhabitants—and keeps talking about democracy. The war keeps piling up the dead.

But all the changes of the last eight years may pale in comparison with those soon to come. The March 1989 presidential elections, combined with an expected guerrilla offensive, could irrevocably alter the political landscape in a test of will and force that may shatter the rotting edifice the State Department's "nation builders" have struggled to patch together. Duarte, alive or dead, will be removed from the scene. His Christian Democrats will face ARENA in a critical electoral battle neither can afford to lose; the army will face its most intense challenge, and the Salvadoran people will face an even more difficult struggle for daily survival. So the fear of tomorrow is added to today's, leaving El Salvador suspended in almost surreal tension.

■ ■ ■

The fear is photographed, documented, cataloged, and published by the various human-rights organizations that try to keep score. A few entries from the spring of 1988 in one recent catalog:

> Felix Antonio Rivera, 25, and Mario Cruz Rivera, 16, Tepemechin, Morazan. Captured by soldiers. Both bodies found with their ears and noses cut off, as well as their thumbs and ring fingers. Gerardo Hernandez Torres, 27, Mariona Prison, San Salvador. Died of heart failure after being transferred to Mariona from the custody of the National Police. Other captives heard Hernandez crying and asking soldiers to kill him rather than keep torturing him.

> Nicolasa Rivera Palacios, 77, and her son, Juan Hector Villanueva Rivera, 45. She was taken to her son's workplace at night by uniformed soldiers. Both were found shot dead; the mother had apparently been raped as well.

> Unknown male, approximately 27 years old, San Salvador. Neighbors saw three armed men in civilian clothes take the man out of a pickup with dark windows and throw him on the ground, his thumbs tied behind him. The men shot him in the head and kicked him into the ravine.

> Unknown male, approximately 25 years old, on the road to Ilopango Lake. Body found naked, with genitals destroyed, thumbs and hands tied behind back.

A few of the movies (almost all of them made in the United States) playing in San Salvador during one week of the fall of 1988: *Armed Response, Absolute Diabolical Terror, Diabolical Gangs, Diabolical Nymphs, Girl Prisoners of War, Rapists of Virgin Girls, Carnal Torture, Mercenaries of Hate, Squads That Kill,* and *Savage Dogs* I, II, and III, a series featuring oversized Dobermans tearing undressed women limb from limb.

■ ■ ■

El Salvador is sick, and the guerrillas of the FMLN think they can cure it. The war is a giant social experiment in homeopathy, as they attempt to purge the disease by adding their own traumatic dose of violence to that already in the body politic.

Though, officially speaking, the guerrillas are no longer "guerrillas." The army press officer calls the journalists in to announce the change. Reading the incorrect names, it pains the colonel to note that journalists still use these terms to describe the FMLN: "insurgents," "rebels," "guerrillas," and so forth. All wrong. He reads the proper names to be used by the responsible press: "delinquent terrorists," or the more familiar "DTs."

When you run into the DTs—the combatants in the mountains or their sympathizers in the cities—they can appear almost as incongruous as the admonition to VISUALIZE PEACE. This is because they are "organized," meaning they have joined a revolutionary organization, they have been "formed" as cadres, they believe in the strength of their organization, they believe in the revolution. And because, with these beliefs, the organized learn to deal with their fear.

■ ■ ■

At the construction site, a ragged crew is grouped around a short, skinny woman, in sneakers, purple jeans, dark shades, and a baseball cap pulled low over her face, who's taking charge. "Comrades, we are in a state of emergency."

Cecilia explains that they have been striking for nineteen days, camping out behind makeshift fences, defying the owners, their goons, and the cops. She is the only woman at the site, and obviously not a construction worker. An older man, huge by Salvadoran standards, with a square jaw and a crooked smile, beams down at her. He looks and talks like a Wobbly from the turn of the century. "We've been under this yoke for a long time," he says, "this wage slavery."

Cecilia spits at the mention of the special riot police who are circulating through the surrounding streets in pickups, armed with tear gas, clubs, and M60 machine guns. "No one invited them here." Like most of the other workers, she is carrying a lead pipe filled with cement; a few have wooden sticks.

"Listen," Cecilia says, sticking out her jaw. "We're not afraid. If they have balls, well, so do I. We're not afraid."

Back at the union, Cecilia explains that the office is her home; she doesn't

want to bring heat on her parents by staying at their house. Twenty-three years old, a single mother with a seriously sick baby, she recently came back to El Salvador after eight years of exile to work in the union again: "To fight," she says, "until the triumph." In a country with a combined under- and unemployment rate approaching three quarters of the population, labor struggles generally win nothing but joblessness for the participants. A commitment to the union essentially means, as they say in El Salvador, "demonstrating our combativeness."

"The bourgeoisie doesn't give us schools or education," Cecilia sneers. "They want useful idiots. They say we don't know anything, but our useful idiots are smarter than theirs."

■　■　■

Ads for soap, the one commodity even the poorest slum dweller will buy, are omnipresent in the media. The two major brands, People and Victory, engage in perpetual psychological warfare over the airwaves. Housewives march across the tube with banners for their favorite soap, chanting "People! Peo-ple!" Among the hovels of refugees who have fled to the city from the war without end in the countryside, a triumphant radio voice blares day and night, "I have Victory in my hands!"

■　■　■

In the squatter shantytowns that ring the capital, El Salvador's poorest slum dwellers seize power every day. Working with practical genius, the residents break into electricity and water lines, taking the services they need. Leonardo, the head of one squatter association, talks about defying landowners and the municipal authorities, as the squatters rip up the road to find cables and water mains. "Nothing's ever done in El Salvador without pressure," he says, grinning happily. His neighbors live in huts of mud and cardboard, held together with improvised walls of shower curtains and garbage bags, now illuminated by stolen lightbulbs glowing with stolen electricity.

■　■　■

In the United States, electric lighting is so omnipresent that there is no emotional difference between, say, three in the afternoon and seven in the evening. Here, there's no such illusion. There is a complete pitch-black that always lurks in Central America just beyond the range of the tiny, fragile lights.

At night, the campus of the National University resembles more than ever

what its enemies on the right charge it with being: a training camp for guer-rillas. Some buildings, battered when the army invaded in 1980 and further smashed by the earthquake of 1986, stand empty, with revolutionary slogans and vines covering the crumbling walls. Others, almost in ruins, have one lit window. Dense bushes and overgrowth give way to small clearings, where open-air huts have been built and food is served. There are paths through the darkness, past campfires, where small groups of people stand in the shadows talking, and a voice quietly sings.

By day, there are more explicit signs of the university's sympathies. Dur-ing one interminable speech at a women's conference, three hooded FMLN urban commandos, with blue shirts over obvious breasts and two short Uzi machine guns, burst into the room to wild applause. With the voice of a very young woman, one reads a statement ("Greetings from the FMLN!"), which is interrupted by everyone leaping to their feet and screaming in delight and cheering and waving their fists in the air.

Not that the university is a reliably liberated zone. Raúl Escamilla, a jani-tor briefly detained last year by the National Police, is in the main cafeteria the following week when two men in civilian clothes saunter in and shoot his head off.

The tensions of fear and hope were wound especially tight in Reina, a po-litical prisoner in the Ilopango prison for women. Reina was what in other circumstances you might call petite: perhaps five feet tall and skinny as a toothpick. Like most political prisoners, she had been raped upon capture. Yet Reina was walking around the yard of the political section in a black beret and tight jeans, receiving visitors with the same air with which army commanders welcome correspondents into their garrisons.

Reina had led the prisoners in an extended uprising against their male guards. They had occupied the central prison office, taking four kitchen staff hostage. At the age of nineteen, surrounded by sharpshooters with their sights trained on her tiny frame, Reina had negotiated for the lives of her comrades with the minister of justice.

But now the riot was over and the inmates were alone again with the guards they had humiliated. Reina would survive to be released some years later, but this day she could not know that. Reina was asked if she was afraid that her keepers would exact their revenge. For a moment, and only a moment, her commanding air evaporated. "No!" she and a friend shouted in unison. Just as quickly Reina regrouped. "We are not *afraid*. We are *concerned*."

■ ■ ■

A few miles away from the prison, at their headquarters, ARENA members are busy VISUALIZING POWER. With a party machine whose efficiency rivals the clandestine structures of the FMLN, ARENA is run with fanatic attention to detail.

Most of the detail, and a good deal of the fanaticism, comes from Major Roberto D'Aubuisson, the man universally referred to by the ARENA cadre as "our maximal leader." D'Aubuisson is better known as the godfather of the death squads, accused of masterminding the wave of rightist terror in the early 1980s and even plotting to kill a U.S. ambassador. His notoriety makes the Americans extremely nervous about the major's high profile in the party they expect to be in power soon. In fact, D'Aubuisson runs the show, wisecracking incessantly, talking nonstop slang, looking everywhere, taking it all in, bending down to listen, in command. At a party meeting following an election rally he was all smiles and jokes, with his usual endless stream of street humor. But when the meeting began, the major meant business. "Okay, now we're going to have criticism and self-criticism," he snapped.

D'Aubuisson reviewed the rally, almost word for word, with pointed comments for everyone. "First," he began, addressing the rally's emcee, "you began by saying how ARENA would save this country. We are nationalists. We *never* say 'this country.' We always say '*our* country.'" The lesson continued.

Twenty minutes later, D'Aubuisson offered another kind of lesson. He flagged down a VW bus piloted by current ARENA presidential candidate and "moderate" front man Alfredo "Freddy" Cristiani and announced that he had a present for the journalist accompanying Cristiani. Another van load of campesinos from a nearby town, summoned to make an audience, watched giggling as the major presented the journalist with two clay pistols, the barrels of which were larger than life-size, full-color, grotesquely detailed erect penises.

The giggling turned to laughter. Cristiani stared at the ground. "Major," the journalist asked, "have you killed many *subversivos* with these?"

"No," shot back D'Aubuisson, "but yes, we have killed many *subversivas*. They like it. They go: 'Ooh, oooh, ow.'" The major writhed in mock pain and pleasure. The campesinos howled. Cristiani, beet red, managed a smile.

■ ■ ■

Freddy Cristiani is very good at his job. That job, as the front man for an ultraright party confident it will soon win power but worried that the U.S. life-support system will be unplugged as a result, is to have as little as possible of substance to say.

In his suit and perfectly polished loafers, standing beside his pretty, perfect

politician's wife, making small talk in perfect English, Cristiani is an image maker's dream candidate. To every question he has a long, charming nonanswer; to every angry attack he has a long, soothing nonresponse. He looks modern. He looks respectable. He looks, in short, American. The problem is that he's here, in El Salvador.

Cristiani is giving a speech one night at the Jesuit-run University of Central America, a school viewed by ARENA as a hotbed of communism. The crowd overflows the auditorium, sitting outside on the grass in the dark and looking in through the windows as if they are watching television.

As Cristiani talks gracefully on, there is a series of explosions, muffled but not terribly distant, as the FMLN goes about its nightly urban sabotage. Cristiani remarks how sad it is that political parties in this country argue, instead of working together for the patriotic values they all share. About half the crowd—some students, and ARENA members who've come early, proud of their candidate on the campaign trail—cheers loudly. Cristiani praises peace and says that of course his party has always believed in peace, as well as in liberty and justice. And then the lights go out.

There is an instant of shocked silence. In the dark, the sudden waiting, the radios of Cristiani's bodyguards crackle, and the bodies of the nuns standing at the windows tense, and the students sitting on the grass freeze, half crouching. And then the other applause starts.

In the United States, and in the El Salvador Freddy Cristiani pretends so well is a real country, there is a respectable right wing, and it welcomes its candidates with applause and cheers the images it can see. But the hidden El Salvador watches, and waits, and disbelieves the images.

It is the other side, cheering what cannot be seen.

■ ■ ■

VISUALIZE WAR. When the no-longer-afraid meet the powerful; when the terrorized meet the terrorists; when the lines are drawn. Sometimes the power and fear equation is hidden and subtle, ultimately decipherable only by Salvadorans. Sometimes all that can be visualized is more war.

■ ■ ■

At the Estética Laura, an inconspicuous whorehouse in a residential section of town, the only topic of conversation is the bomb that exploded there the night before. Since the whorehouse belongs to a military man, and many clients are soldiers and policemen, the "girls" are convinced the guerrillas were responsible—a fact confirmed later by the clandestine rebel radio.

"Sure, we're *really* scared," sneers one girl, wearing a skintight yellow miniskirt. "We're *dying* of fear." But at eleven in the morning, most of the girls do seem a bit spooked, their nerves probably not helped by their breakfast of cake and Coca-Cola.

"It's really very good for us," offers another hopefully. "The bombing was on every TV station. Now we are the most famous brothel in San Salvador, and everyone will come." In fact, nobody is coming. With no customers, the application of more and more makeup becomes obsessive. Kits get closed up and put up, only to get pulled out and reopened in a few minutes. There is a complaint that the bombing has created family problems for some: until the TV news, a few of the girls' mothers thought their daughters worked as masseuses in health spas.

A large woman in a purple blouse and purple makeup stands up. "Many clients come uniformed and all," she says. "You never know who's a soldier, who's a cop, who's a guerrilla. So better if they would come as civilians. Uniforms just attract trouble."

■ ■ ■

This is really a matriarchy, says the U.S. official, dressed in a neat blue button-down shirt he probably has not ironed himself. "Women really have all the power here," he continues, leaning back in his armchair and rolling over an office floor he definitely has not scrubbed.

■ ■ ■

You can tell who's who at the exhumation by what they're wearing to shield themselves from the unbelievably horrible smell. At the bottom of the list are the actual grave diggers: small, skinny, barefoot men wearing nothing but looks of pure misery on their faces. They've been fed a good deal of firewater by an official from the local judge's office, who stands back from the mass grave in the cornfield, calling encouragement to the drunks from behind a surgical mask.

Fancier masks, with black rubber and screens, are used by the representatives of the attorney general, the government human-rights commission, and some unidentified men carrying large multicolored USAID (U.S. Agency for International Development) binders.

Most of the rest of the bystanders—journalists, independent human-rights observers, and drivers—have pulled bandannas over their noses. Salvadoran television crews film it all, as one by one the rotting corpses are pulled up.

"You look like a guerrilla," they tell each other. "Hey, look at Fito in that bandanna, he looks like a guerrilla."

Ten people were killed here. About forty villagers watched the victims, seven men and three women, as they were selected by soldiers of the Jiboa Battalion and taken away blindfolded. Explosions were heard, followed by gunfire. The villagers found the bodies in a single spot on the road; they say the soldiers tied them up, threw a grenade, and then shot the victims through the head.

The army claimed that the campesinos were victims of a DT ambush: killed by DT mines, DT bombs, or DT rifle fire, according to various army press releases. The murder was so flagrant that the usually terrified judiciary ordered the exhumation of the bodies to verify the cause of death.

At the scene of the crime, a short walk away, a sweet-faced boy of twenty-two is pointed out as the son of one victim. He describes uniformed soldiers taking his father from his home on the morning of the massacre. "They said they were going to give him an educational talk," he says. On what, he's asked. The boy looks straight ahead. "I don't know. Death, maybe."

Back at the gravesite, the corpses lie askew; one by one villagers are taken over to identify their relatives. One woman, sitting on a rock being interviewed by two reporters and a government representative, answers all questions in a polite, almost inaudible monotone. She leans away from her questioners suddenly and vomits, then clears her throat and turns her blank, dry-eyed face back to them.

The smell is overwhelming. A doctor, gas mask dangling from his neck, stands in front of reporters, announcing that seven of the nine bodies exhumed have been shot through the head at a range of ten to fifteen centimeters.

The soldiers of the Jiboa Battalion are present, thoughtfully providing security for the event. Noticeably absent is the new Salvadoran high-tech criminal forensic unit the Americans had set up to investigate political crimes. There is, however, a human-rights officer from the U.S. Embassy. After a thorough investigation of the site, he announces, for the record, that the ambassador is "very interested" in the case but that judicial proof of army wrongdoing would be almost impossible to obtain. "There's lots of evidence," he says, smiling patiently, "but evidence ain't proof."

■ ■ ■

There is not a lot of proof about how the FMLN gets its supplies. What the Americans claim in their press releases—support from international com-

munism, arms from Nicaragua and Cuba, money from Libya—may be true or false, in whole or in part, but is almost irrelevant. In a country this small, any part of which can be easily reached in a morning's drive, and where most of the people know or are related to each other, the mystery of logistics is more subtle.

"I'll tell you a story," a man says with a laugh. "No names." It was in a poor barrio, he says, crowded with people scrambling to get by. And they received a message that eight hundred pairs of shoes were coming through, eight hundred desperately needed pairs of shoes for the front. At dawn the shoes arrived and, by the afternoon, needed to be delivered to the next stop on the long route to the mountains.

The problem, he explains, is that the distance to the drop-off point, while not far, involved crossing a highway directly in front of a local army post. How to carry eight hundred pairs of shoes, when the entire population is carefully watched for signs of subversion? "They decided to wear them," he says, "and so all morning there were men, women, kids, walking back and forth, looking like just another busy day." But worried that the shiny new shoes would tip off the army, each person walked through a puddle of mud before crossing the road.

Everything arrived without incident. And all afternoon a group of volunteers huddled at the drop-off point to receive the shoes, pair by pair, carefully wiping off the mud with a rag. "Eight hundred pairs of shoes," the man says, "and people wanted to make sure they'd look nice when they got to the mountains."

■ ■ ■

The night is late and the whiskey is almost gone when Rubén Zamora describes the war: "The battle is really between hope and fear. When you speak with some people you see how much fear predominates. But as they gain consciousness, hope becomes stronger, until in some cases it becomes certainty. But for the majority, the battle is still on." VISUALIZE HOPE. Zamora is asked what would be the most positive outcome of the next few months, what's the most optimistic scenario. He lets go a sad laugh. "That is the hardest question you've asked all night."

Zamora rubs his eyes. "Our struggle at this time is against fear. Because given the objective conditions of the country, we can't propose great social transformations. Now is not the moment for great transformations. Later, yes. Our task now is much more primordial."

■ ■ ■

What happened here? Up a hot, rough road, a dirt path, to the spread-out grouping of six or ten shacks with a name: the "village" of Three Trees, Saint Francis, or, maybe, Sweet Name of Mary. Beautiful green vistas, scraggly cornfields, skinny horses, dirty river. Very quiet, very still, very hot; some turkey buzzards overhead in the blue sky. A long walk in.

What happened here? "*Algo muy feo*"—"Something very ugly"—mumbles the man you hail on the path, looking down, not wanting to talk. You arrive. There will be bodies: laid out stiff on the ground, or in coffins lit by flickering candles in dark, mud-walled huts, or buried already, just heaps of dirt where someone cut down the brush with a machete and made a small clearing.

There will be relatives. One or two, maybe, will have the story clear and will tell it over and over. The sister or wife of another victim, young, very pretty, will be nursing her youngest child, sitting on a rock. She will be vague, polite, open-mouthed, and not altogether there. Her name will be Magdalene, or Glory, or Miracles. She'll be asked about her husband, her brother, his age, where he lived, and she'll answer it all in the present tense. He lives over there, she'll

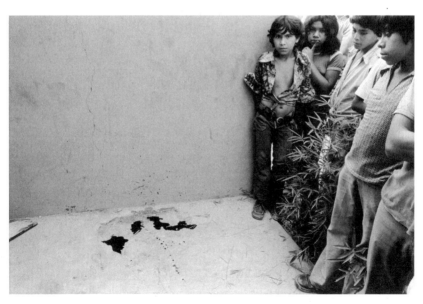

El Salvador, 1980. Blood of student slain while handing out political leaflets. Courtesy of Susan Meiselas/Magnum Photos.

say, gesturing away from the bodies laid out in the sun, away from the coffins inside, away from the small pile of dirt in the clearing. Over there, away.

What happened here?

These dusty lives go on, in all the little villages, day and night and day, and then without warning something big and sudden and ugly happens. And there's all of this commotion, completely out of the ordinary: you can see it in the little kids running around hyper and overexcited. Visitors! Television! People from outside with trucks and pens asking us questions! And then after a while the outsiders leave, and the commotion subsides, and there are just the dusty lives left, the chickens, not enough firewood, the long, still afternoons. And Miracles with nobody left to talk to at night, all of her family shoveled so quickly underneath the heap of dirt with no trace left and she's not ready, it was so ugly and suddenly over.

Sooner or Later

Sooner or Later *was the first work I composed upon returning to music after the El Salvador years. Perhaps more than anything, it was a way of trying to sum up the complexity and tragedy of that experience for myself. It is also one of a number of works I have done that fall under the general rubric of* musique concrète *(others being* Burns Like Fire, All the Rage, Say Your Angels, *and, in a different way, all of my work with* Living Cinema*). With the explosion of digital technology in music and everywhere else in the 1990s and into the new century, people tend to think of these works as "sampling" pieces. I prefer* musique concrète, *however. What unifies them as a body of work is the use of recorded sound taken from daily life. In this sense they are direct descendants of the earliest days of electronic music, when composers used spliced magnetic tape to create sound collages. Sampling technology allows the manipulation of recorded sound in more elastic ways than tape recorders did, but this is a question of degree, not kind. The fundamental innovation was the introduction of recorded sound into music composition, which will soon be a century old.*

What follows are the original Sooner or Later *program notes.*

■ ■ ■

The sounds in this piece come from a recording of a young Salvadoran boy burying his father, who had been killed by El Salvador's National Guard. There is the sound of the boy's voice, a fly buzzing nearby, and the shovel striking dirt and rock as the grave is being dug. In Part Two there are additional sounds from a twenty-second sample of the guitar playing of Fred Frith.

Each section of the piece began as an improvisation on a digital sampling keyboard, to which refinements were then made. For the most part, the original recording is played back at more or less its original speed, with little electronic alteration or "processing." Rather, the music is made by breaking the original recording into very small events, and stringing these events into musical structures, creating shapes different from the originals. To use a film analogy, it is as if the frames of a film were reordered so that the characters do altogether different actions—in effect reanimated. Or you might imagine the source sounds as physical objects viewed from different angles. I have placed you not only at different positions around the object, but have made windows of different sizes through which you look, and have occasionally curved the glass into lenses of various types.

As spatial location of sound is such an important aspect of this piece, listening with headphones, or at least sitting the same distance from both speakers, is highly recommended.

The choice of sound source is not incidental but results from the last ten years of my life, much of which was spent working in or around El Salvador. During that time I saw a lot of death. And in that culture, which is both Catholic and highly politicized, death gets surrounded with all kinds of trappings that are intended to make it purposeful. Death is explained as God's will, or else as irrelevant, since the victims "live on in the struggle." It is all glorious and heroic.

But some seventy thousand people have died there. Most died because they were in the wrong place at the wrong time. They didn't want to. There was no plan. There was no glory.

There are many Salvadorans who did die heroically, fighting a brutal regime against overwhelming odds. But even for the heroes there is a starker, more immediate side to their death.

Sooner or Later is about that side. There is a boy, and his father is dead. And no angels sang, and no one was better because of it, and all that is left is this kid and the shovel digging the grave and the fly buzzing in the air. If there is beauty, we must find it in what is really there: the boy, the shovel, the fly. If we look closely, despite the unbearable sadness, we will discover it.

Papito chulo. ¡Malditos! Viendo a mi padre, siento como que en el corazón tengo la bala, compañeros. Prefiero mejor morirme por uno lucha justa, compañeros, y no quedar abandonado compañeros. Mi padre decia . . . el combatia . . . era un cambatiente de este pueblo. Me decia que yo no fuera tan despijo. Que yo fuera . . . tuviera una creatividad y valor, para llegar al final de un

triunfo de los compañeros que queden or que quedemos. Ay, compañeros, yo deseo esta sangre, tarde o temprano la voy a vengar.

Sweet Papa. Bastards! Seeing my father, I feel like I have the bullet in my own heart, *compañeros*. I'd rather die for a just cause than be left abandoned. My father told me . . . he was a fighter . . . a fighter for our people. He told me not to be a good-for-nothing, that I should be creative and brave until the final victory of those who survive. Ay, *compañeros,* sooner or later I will avenge his blood.

Thanks to Sara Miles, Katie Ostertag Miles, Fred Frith, Pierre Hébert, J. A. Deanne, and all the Salvadoran *compañeros y compañeras.*

—San Francisco, January 1990

Nicaragua 1990: Power Outage

This is another piece I wrote with Sara Miles. While more conjunctural than the El Salvador piece, it nevertheless deals with issues of movement and power that are developed throughout this book.

The Sandinista guerrillas overthrew the Somoza dictatorship in 1979, leading one of the most authentically "mass" movements in Latin American history. Their years in power, however, were difficult. Only six months after the fall of the dictator, the Reagan administration took power in the United States and soon was funding a not-so-secret war against the Sandinista government. The Sandinistas, meanwhile, were having a hard time making the transition from insurgency to government. Somoza had been so hated at the end that the relatively small but well-organized Sandinista movement was able to trigger a mass uprising of thousands of Nicaraguans who had no substantial contact with movement cadre. When Somoza looted the state and fled, the Sandinistas had to quickly build a state essentially from scratch, and there was no alternative to filling many positions with "instant Sandinistas." Corruption, military necessity, and honest mistakes due to inexperience all began to feed off each other. As a result the war, which began as a straightforward mercenary endeavor funded by a foreign power (the United States) against an overwhelmingly popular government, came to acquire more and more the character of an actual civil war.

After ten years, elections were held in 1990 and, to nearly everyone's surprise, the Sandinistas lost. A center-right government ensued and negotiated an end to the war. The Sandinista party continued on as a shell of its former self, and

as the personal political tool of Daniel Ortega, the former Sandinista head of state. Sixteen years later, in 2006, Ortega was reelected president of the country, but by this time there was virtually nothing left of the egalitarian ideals of the original Sandinista movement in the corrupt circle around him. Much of the original promise of the Sandinista revolution went tragically unfulfilled.

For all the shortcomings of the Sandinista leadership, it must nevertheless be said that the Sandinistas were democrats. The U.S. government took credit for "forcing" the government to hold the 1990 elections, but in fact the Sandinistas had said from the moment they took power that they would hold elections in ten years. The post-Somoza constitution specified presidential elections every five years, and the Sandinistas argued that after leading the insurrection that overthrew the dictatorship and confronting the difficult task of putting the country back together, they should get two terms. After ten years in power, they held the elections precisely on schedule. And despite having total control of the state and the military, they respected the electoral results when they lost, leading to the first peaceful democratic transfer of power in the history of the country. No previous Nicaraguan government, all of which had been allies of Washington, had yielded power democratically. To my knowledge, the Sandinistas are the only modern revolutionary movement in the world that came to power through force of arms and left through democratic elections. The Sandinistas wanted to educate the illiterate, give land to the landless, and build an equitable health-care system. Not nearly enough of that happened, but as recent decades have shown, building stable democracies in countries where none has existed is no simple matter. At least the Sandinistas gave that to their poor country.

The article was originally published in the October/November 1990 issue of Mother Jones.

■ ■ ■

You're not asking much, but it's so hard, and you see the cruelty of the world. Here, in a little country, people tried to make some happiness. And if all we achieve is the faint memory of a failed experiment, I think it will have been worth it.
—Sofia Montenegro

The union hall sits not far from the shores of Lake Managua, near the rubble of the ruined downtown. Over the past decade, we have walked and driven past it hundreds of times—late at night, in sudden rainstorms, on our way to meet people, buy groceries, go to funerals and rallies. Like so many places in Nicaragua, this shabby, graffiti-covered corner is saturated with personal and political history. We've seen it in the first heady months after the Sandinista

victory, through the grueling years of the contra war, and during the last period of exhaustion and economic collapse. The smell of smoke and garbage and jasmine filling the evening air last May was familiar, as was the noise of motorcycles tearing across the big hole in the road, and the soft glow from sidewalk stands where women sell tortillas. But the scene inside the union hall was a mixture of the past and the totally new.

The hall was packed with anxious people, sweating in the oppressive heat beneath large portraits of Sandino, Marx, and Lenin. A cracked sound system pounded out tapes of Chilean songs from twenty years ago. Luis Enrique Godoy, balladeer of the Nicaraguan revolution, led the crowd in chants and songs from the insurrection of 1979.

In February elections, the Frente Sandinista had suffered a stunning defeat, and in April the victorious right-wing UNO coalition of Violeta de Chamorro took power. Tomás Borge, the only surviving founder of the Frente Sandinista and a member of the party's National Directorate, stepped onstage to give the first public speech on political strategy by a Sandinista leader since the electoral disaster. He is a small man, and when he waved at the crowd, you could see that his hands were almost as big as his head. He turned to Godoy, who started to sing "La Consigna," the old marching song of the guerrillas in their mountain days. And Borge, dressed all in black, began to cry.

"The Frente is still crying over its defeat," spat out an angry Sandinista activist. "But there is never time to cry in Nicaragua. That's why every now and then you have to take a long vacation, to go somewhere and cry." The activist had no patience. "The Frente doesn't know what it's doing," she declared. "It has its pants down and its ass in the wind."

The crowd at the union hall had come to find out what to do.

"DIRECCION NACIONAL—ORDENE!" they shouted. (National Directorate—Give Us Your Orders!) But the slogan, like the songs they had sung, was a relic from years gone by, and it fell into a surreal void. For Borge wiped his eyes, stepped up to the microphone, and told his followers that he had no orders to give. In fact, he continued, the leadership had no program, no strategy, no tactics. Borge said all this "must be the fruit of a collective reflection" within the movement. The Sandinistas, in short, must think for themselves. And fast.

■ ■ ■

There was little room for not knowing what to do—or for mistakes.

The Sandinista government was over. As an opposition party, the Sandinistas still had a political presence in the National Assembly, although the

forum was now led by an ally of Virgilio Godoy, the bitter, Machiavellian vice president reported to be working closely with the contras. Sandinistas still filled the ranks of the police and army, but the police would be ordered to enforce the recessive economic policies of the new government, and the army would soon be cut by a third.

The contras, for their part, had broken one disarmament agreement after another, until the new government offered them huge tracts of land as "development poles." In these areas, outside the jurisdiction of the police or army, the contras were to have weapons given right back to them so they could become the territories' police.

Meanwhile, armed contras began to move in the capital itself. The new government launched hysterical campaigns about "atrocities" of the former Sandinista regime, and stories that seemed more like psychological warfare than reportage filled the media. There were disappearances and attacks, there was a crime wave, and there was a national case of bad nerves. In a middle-class home, an old friend lay down on her couch at night to read. "That's a concrete wall outside the window," she explained. "It's not that I'm paranoid, but why not be careful? Why sit up?"

Partisans of both the left and right were taking more elaborate precautions. After spinning out the party line about the need for "national reconciliation" with the contras, one Sandinista activist said she had something to show us. We walked into her bedroom and she nodded to the small arsenal atop her closet. "If they come for me, if I have to go out of this world, I will take at least four of those sons of bitches with me," she said softly.

The war of the last ten years, with contras invading from Honduras and Sandinista troops going off to the hills to fight them, may have ended. But a *guerra sucia*—a dirty war—may have been just beginning.

All over Nicaragua this spring, Sandinistas were thinking about their defeat in elections they had been sure they couldn't lose. To explain defeat away, nearly everyone pointed first to the power of the United States. Commander Victor Tirado of the National Directorate stated his conclusion in a blunt interview with the Sandinista daily, *Barricada*: "The cycle of anti-imperialist revolutions, in the sense of a total military and political confrontation with imperialism, is ending. Today, the best we can aspire to is coexistence with imperialism, even though it hurts to say it." In a war of attrition with the United States, a country like Nicaragua didn't have a chance.

■ ■ ■

Desgaste: literally translated as "attrition," a wearing away, a bleeding. But with fifty thousand dead, after ten years of what Pentagon planners referred

to as "low-intensity conflict," *desgaste* in Nicaragua has acquired a universe of meaning.

Desgaste: The endless fights inside stultifying bureaucracies unprepared to cope with a ten-year emergency. Government offices with peeling paint, leaking ceilings, no lightbulbs, no toilet paper, no paper clips. Never enough resources to go around, amid the desperate shuffling of energy from one crisis spot to another—the grim reality of what happens to people squeezed too hard for too long. The few who rise to the occasion, the many who don't, who drink too much, get careless or mean. The petty corruption, the more-than-petty corruption, the moral exhaustion, the suspicion and hopelessness and fear. "The last night I had a good sleep," said Sandinista guerrilla-author Omar Cabezas, rubbing his eyes, "was in 1978."

Desgaste: A centralized military hierarchy sprung up to deal with the war. During the hardest years of the war, the Frente's slogan was EVERYTHING FOR THE FRONT—EVERYTHING FOR THE COMBATANTS. And so many of the smartest and bravest and most creative Sandinistas went into the army, where a lot of them were killed, and the rest learned military discipline as a metaphor for running civilian jobs. "Always being on alert," said one, "it consumed us. Revolution is supposedly to work, to laugh, to sing, dance. But it wasn't like that. The other aspect always took priority—defense, defense, defense, defense."

Desgaste over time: Ten minutes is a long time if you're being tortured, if a group of contras breaks into your home, ties you up, and takes out your eye before cutting your throat. When you know about those ten minutes, an hour is a long time to be hiding in a trench behind your isolated farmhouse, waiting for the contras to come. Two days is a long time. Three days is a long time when your kid is sick, her thin chest shuddering with each breath, and there's no medicine in the country and the fever won't break. A week is a long time. Two months is a long time when a man you love is drafted to pick mines off a winding road in the northern mountains and you haven't heard a word from him. A year is a long time. Two years is a long time to be hungry. Three years is a long time to be hungry. Five years is a long time to be hungry. Ten years is a long time if you're waiting for a revolution.

For some Sandinistas, *desgaste* was explanation enough for their defeat. But the war was begun by Washington, financed and directed by Washington, and only Washington could call it off. If decisions made abroad inevitably determine Nicaragua's fate, then why even be a Sandinista? Activists with this view were at a political dead end. Since they could see no future, they could not accept what happened, and their views on the Frente were more

or less unchanged by the campaign and the election. They either insisted that "the people" were really with them, and voted for the right only out of desperation, or that the Frente was not beaten but betrayed. "They turned traitor on us," said an activist in Esteli, as she sat in the afternoon sun on her porch, watching a carload of the new government's supporters drive by. "This people would sell out anyone."

But there were others who looked for the cause of their predicament not by blaming others or conditions imposed from without, but in actions for which they themselves were responsible. These critics were the most hopeful, because they refused to accept paralysis.

"The people who have taken the defeat better are those with open minds," one critic noted. "All these schemes—whether orthodox or half-orthodox or seeing yourself as having the elevated truth—all this has to go. The time has come for a profound criticism of our history and process."

After ten years of calls for unity, after a decade of sacrifice and sublimation, Sandinistas were speaking out, and often "speaking bitterness." The process of self-criticism—sometimes wild and angry, sometimes thoughtful, but always deeply felt—was well under way when we came to Nicaragua in May. And at its center were the two great issues around which all revolutions revolve: social struggle and democracy.

■ ■ ■

Rural Nicaragua, run by the Somoza dynasty as a family farm for fifty years, was idealized by the guerrillas as "the mountain," a mystical center of resistance and growth. It was here that the Sandinistas intended to liberate the majority of the people, the campesinos, from backwardness and exploitation. Here was where the real Sandinista revolution would be made. Into the sealed-off world of the Nicaraguan peasantry—a deeply conservative world, ruled by centuries of habit and blood ties—came the revolutionary government, in helicopters and jeeps and on foot, young enthusiasts bounding up with clipboards and speeches about imperialism.

Linda, a sociologist from Managua, remembered opening up the first office of MIDINRA, the Ministry of Agrarian Reform, in a mountain village in the center of the country in 1979. At seven one morning, a month after the Sandinista triumph, there was a line outside the house where MIDINRA—its total resources no more than a borrowed table and chair, and Linda's notebook—was set up. The first campesino, an elderly man with a cowboy hat in his hands, stepped forward. "Thanks be to God that you've come," he said. "Thank God the revolution is here at last. I need a bull."

A decade of well-intentioned, erratic, mismanaged, underfunded, over-extended, contradictory land reform—a decade of punitive measures and manna-from-heaven prizes, of paternalism and collectivization, of micro-management and neglect—never gave the elderly man his bull. Sandinista government did succeed in giving agricultural workers, the poorest of the rural poor, working on haciendas expropriated by the state, enough to win many of them over to a fierce defense of their land and their union. But it did so at a cost, often giving the rich—the "patriotic bourgeoisie" in wishful Sandinista terminology—concessions that were outright bribes, even, in one highly publicized program, paying them dollars for their export crops.

For most peasants, Sandinista reforms were disappointing: the government's attempts to placate the rich provoked anger, and the emphasis on state farms, rather than individual plots, drew resistance. Relations between largely urban Sandinista officials and the campesinos reached a low point in 1985, when Sandinista army tanks blockaded rural roads to force campesinos to sell their crops to the government at a loss, in order that Managua workers could buy food at subsidized prices.

When a falling away of campesino support began to threaten the revolution, around 1985, the Frente Sandinista began to pass out plots of land to peasants—in effect, to give them their bulls. But it was a defensive measure, and by then the war had so damaged the economy that land titles alone couldn't reverse the economic crisis in the countryside.

MIDINRA, one of the few decentralized ministries at the beginning of Sandinista governance, was caught up in the war, which gutted attempts to build something new in the countryside. All of its policies were militarized, and, in the words of a local Sandinista organizer, "everything started to come from Managua."

By 1986 or so, acknowledged Luis Carrion of the Frente's National Directorate, the contra movement (reviled for years as a mercenary force created by the Yankees) was "a genuinely counterrevolutionary peasant army, with a real social base." The Sandinistas had to admit that their rural policies had created huge resentment, that much of the peasantry was reactionary, and that, in the words of Carrion, "We put a lot of effort into winning them over, with very modest success." In the elections, many of these angry peasants wound up voting for the rightist coalition dominated by the same bourgeoisie that the land reform was intended to displace. It would not take long before peasants and the peasant contra leaders began to realize they were not represented in the new government, and there were rumblings again in the countryside.

In Managua, *desgaste* is even more omnipresent. Nothing works in the

chaotic shambles of a capital whose population doubled during the war years: water is cut off two days a week, electricity is intermittent, and years of hyperinflation have reduced many citizens to getting by through barter or black-market dollars. As we arrived in the capital, the first major strike against the new government broke out, adding another layer of chaos to the exhausted city and setting in motion a dynamic of escalating confrontation and violence, which would be repeated in the general strike of July.

Nicaragua's only airport was shut down. The buses were stopped. The phones were out. The lights were out. It was a showdown: truckloads of anti-Sandinista toughs, some reportedly armed, were driving around to the state ministries, where Sandinista police faced Sandinista workers in a tense standoff. "Do your job!" screamed the toughs at the cops. "Obey orders!"

Roberto Vargas, once a clandestine FSLN organizer in San Francisco's Mission District, was standing behind the locked gate of the Foreign Ministry, which he and other ministry bureaucrats had occupied. It was here that, moments before, the Sandinista police had fired tear gas at their former comrades. Roberto, who has always liked drama, was in his element. Wearing a San Francisco 49ers shirt and guerrilla-style bandanna, he was exhilarated and sweating heavily. "Fuck, man, I haven't seen shit like that since Berkeley in the sixties," he exclaimed. "Know what this is? It's the class struggle. It was postponed for eleven years because we were in power. But this is what we expected—class struggle in the streets."

Few of his coworkers shared Roberto's Berkeley references, but the excitement among the strikers was palpable. It was a huge catharsis. After eleven years of discipline, austerity, and self-sacrifice, Sandinista workers were finally acting like Sandinista workers.

Social transformation was of course the principal aim of the revolution. But the Sandinistas increasingly subordinated this agenda to the goal of holding on to the state. Now the state was no longer the Frente's to hold on to. Since no one was prepared for this development, there were no rules and the result bordered on chaos.

Across town at the Ministry of Labor, "class struggle" in its full complexity filled the streets. Strikers locked themselves in the building. Outside, a large group of unemployed former state workers who were laid off by the Sandinista economic austerity package of 1988, had come to seek scab work from the new minister and to scream their hatred at the strikers. Between them, the Sandinista police, led by former *guerrilleros*, tried simultaneously to force open the ministry and keep the strikers inside away from the crowd outside.

Francisco "Big Boy" Rosales, the arrogant, abrasive ex-Sandinista who is the government's new labor minister, arrived on the scene, and his car was mobbed by the crowd. People were trying to shove pieces of paper containing their names through the window so Rosales would hire them to replace the strikers. The police encircled the portly minister's car to protect him from the crowd. All the while, vendors from the informal sector wandered around hawking snow cones and Chiclets, trying to make their daily pittance from the commotion.

Angry denunciations from the unemployed spelled out in stark relief the political price the Sandinistas were paying for having postponed the class struggle. "They never had one strike in eleven years," shouted a man almost beside himself with anger. "Before this, I thought they had the right to withdraw and in six years maybe return to power. But now they don't have the right to return, ever! They must disappear from the face of Nicaragua!"

■ ■ ■

Tomás Borge, the man who, more than anyone, embodies the history of the Frente Sandinista, was not about to disappear. But he didn't know what to do. A strategy, he told the assembled audience at the union hall, would have to be worked out through discussion. And that required the "democratization" of the party: "Nicaraguans, and in particular the Sandinistas, have won the right and have the duty to have voice and vote . . . in their communities, in their mass organizations, and now, more than ever, within the ranks of the Frente Sandinista."

Before the elections, such words coming from a commander in the directorate would have constituted a minor revolution. But Borge was playing catch-up, giving his personal sanction to what had become a clamor at the base and, in many cases, a fait accompli.

On paper, the nine men of the Sandinistas' National Directorate wield absolute power within the Frente. Their decisions require the approval of no one, and there is no mechanism for a member's removal other than by the directorate itself. The party's Sandinista Assembly is only a consultative body, its members appointed by the National Directorate. In practice, things are much more complex, and major decisions often involve ad hoc groupings whose participation extends well beyond the nine. But in the new political landscape, these methods were clearly inadequate.

"This party was born in a war, developed out of a war, and had the discipline for a war," explained a ranking Sandinista from the party newspaper,

Barricada. "When I joined the Frente [before the insurrection], traitors were shot. Shot on the fucking spot. That is the kind of discipline we were schooled in and that we schooled society in. Not because of theory or will, but because of survival. Yet all the time, we had this utopia in our hearts.

"Let me put it as a question," she continued. "Was our idea of building a democratic society in the middle of a war correct or incorrect? Can we have an organization strong enough to keep the enemy out, yet still have democracy within? It makes us look two-faced, like we are talking out of both sides of our mouth. Do we believe we can have our cake and eat it, too?"

The leadership had sought to defuse this contradiction by postponing the democratization of the party until after the war. And the war was to end with a landslide electoral victory, which the whole world, even Washington, would have to recognize. "There was this idea that we would win and then there would be a housecleaning," said Miguel Angel Gutierrez, a young Sandinista organizer. "So we waited."

First, guarantee control of the state through elections; then loosen the grip—both in the party and in society as a whole. This was the original content the Sandinista campaign slogan, EVERYTHING WILL BE BETTER, was intended to convey—before the campaign got smothered in staged rallies, kissing contests, machismo, baseball caps, and classic machine politics.

Then came the crashing defeat. And then, as with the social struggle, the democratization process took off and went running on its own.

■ ■ ■

The Casa de la Mujer is a women's health and counseling center, run from a small house shaded by almond trees in a poor Managua barrio. Luz Marina Torres, a short, stocky, gold-toothed organizer based at the Casa, explained how the Frente's national women's organization used to control the women's centers. For years, women at the base were told to moderate their feminism when the leadership thought it too politically threatening. During the years when the United States was provoking a church-state confrontation, the Sandinista leadership suppressed women's demand for legal abortion, to avoid alienating the powerful Catholic hierarchy.

But after the elections, Luz Marina, a working-class mother who had seen neighbors die from illegal abortions, was in no mood to listen. She continued to give women abortion referrals. "They used to send us plans from above and tell us what to do," she said. "Now we don't ask for permission. We do what we see needs doing. We don't wait for people who are out of touch to

tell us what we need. The Frente has to understand," she said, chain-smoking, "that we're not going to spend the rest of our lives bearing up and restraining ourselves and being bullied. We're going to fight for our own selves."

Miguel Angel was also thinking about democracy and social struggle. A quiet, reflective man who leaped into the insurrection in 1979 as a teenager, he worked with the Sandinista Youth, which after February held elections of its own and voted out most of its former leaders. The Frente's defeat gave him less confidence in his leaders' wisdom, and more in his own. Curly-haired, his dark eyes flashing, Miguel Angel measured his words carefully. "I will now take my own decisions," he said. "I will be the owner of my own actions without fear that they might question me, say I am abandoning the struggle, or call me a traitor."

Among Miguel Angel's *compañeros,* the lack of clear direction since the elections was referred to as the "big silence." For many it was an uncomfortable experience: "When the line doesn't come, people feel naked, and they don't know how to get dressed."

Miguel Angel spoke softly. "The danger exists that the National Directorate will return to the methods they have always used: send down the line. Yes, people still really, really want to hear from the leaders. I think what the leaders need to do is teach us how to use this space, teach us to use this silence they are giving us. The silence isn't nothing. Silence also talks."

■ ■ ■

Coming back to Nicaragua this time, after the elections, it was especially hard for us not to think about the silence of all the people who weren't there anymore: Leonel, Walter, Ruth, Felipe, Ana Maria, Patricia, Joaquin, Carlos, Benjamin, and fifty thousand others. It was hard not to think about what our country did to this country. We thought about the way fallen Sandinista heroes were *siempre presente,* always present, in the revolutionary pantheon of saints, and we thought about the anonymous daughters and fathers and younger brothers of someone's grieving family, and we thought about our friends.

Our friends who were still there had a lot to tell us. In the space of one generation, the Frente Sandinista had moved from being a tiny guerrilla band, to leading a successful insurrection, to founding a new state, to fighting off a foreign-led counterrevolution, to establishing the first democratic electoral system in Nicaragua's history, to electoral defeat. Many of its leaders are still in their thirties.

The Sandinistas now must synthesize the lessons from their accelerated political lives. As we talked with Sandinistas, we noticed that this reflection

seemed most creative among the "free thinkers" within the second tier of leadership. These are people with the broad vision of those at the top, but who for some reason—because they turned power down or because they were too cantankerous or because they were women—did not become isolated at the pinnacle.

"Maria," a beautiful, foul-mouthed woman with a sharp analytical mind, has been a revolutionary since 1960, giving her many years more political experience than most people in the movement. Over the years, she has turned down many opportunities to rise in the Sandinista movement. "I fight for power, but power isolates," she explained. "And I don't want to be isolated."

In 1985, Maria saw the party isolating itself from its constituency and wrote a criticism of the more-than-comfortable lifestyles of the National Director- ate. The party shut her out, but she continues to identify with the Sandinista movement. "I am a Sandinista, but not a Frentista," she insisted. And from this perspective—close to, but not in, the governing party—she was perhaps the only Sandinista in all of Nicaragua to predict the electoral defeat, and she went to the directorate in the days just prior to the voting and said so.

Sofia Montenegro has also run afoul of the party and has been expelled on two separate occasions. Both times, however, she mended her fences and came back. Today she writes editorials at *Barricada*. And this stance, as a two-time heretic now in charge of the party organ's political line, makes her at once defensive and assertive. When we stopped by her house to visit, for the first time since the election, she blurted out, unprompted, "Personally, I repent of nothing."

Sofia leaned forward. "Power means only one thing," she said. "To do." At the center of *Sandinismo*, "even at its worst moments," was "a sense of per- sonal empowerment in a collective context. The historical breakthrough the Frente achieved in Nicaragua was this: the profound conviction of a popula- tion that things that don't work can be changed. We created in this society the first experience of democracy—not all the power the people should have, but enough that people knew what power was."

And now the people have used that power to run the Frente out of office and to drop the state into the lap of the right. The new government is reflec- tive of the parties of the Nicaraguan bourgeoisie: divided, greedy, vindictive, with no political experience or history of democracy and no organized base of support. But if a civil war is to be avoided, the Sandinistas and the new government must come to an understanding, and they must do so while the streets are exploding with the postponed social struggle.

These dual tasks—of dealing with the urgent demands of the grass roots

and the new government—are pulling the Frente in different directions. To avert social chaos and even civil war, the Sandinistas could offer the government the social peace it needs to stabilize its rule. But if the Sandinistas are to win back their position at the head of a grass-roots movement, they cannot afford to cut deals with the right if those deals push grass-roots demands and leadership to the side. The Sandinistas are on a knife's edge, and everyone we spoke with, from members of the National Directorate to local activists, worried that the party could be torn apart.

Tensions are unavoidable. They erupted again in July, when cotton workers rose in insurrection against the new government's efforts to privatize the haciendas and a general strike, with barricades and street fighters, filled Managua's streets. They will erupt again. These tensions cannot be neatly resolved but only managed through creative day-to-day work. Yet, in the midst of it all, there is still room for activists to decide what kind of movement *Sandinismo* will now become and what kind of power Sandinistas will seek.

The kind of power that enabled the Sandinistas to topple Somoza was the highly unpredictable, spontaneous power of a mass insurrection. But once Somoza was gone, state power isolated the Sandinistas. Faced with Washington's relentless attempts to overthrow them, they decided they couldn't afford unpredictability or the mistakes that people at the grass roots in democratic organizations are bound to make. In the end, the Frente had more confidence in the power of its state than the power of its people.

"The reasons for the defeat begin with the fact that the population lost a sense of ownership of the revolution," said Sofia. "The mass organizations lost their identity, became submerged in the state. The state was like a father who brought up the social movements but didn't want to give them the key to the house. But the movements wanted not only the key to the house, they wanted the car, too, to go and come as they pleased, to fuck when they wanted to."

Over and over, Sandinistas told us that this top-down attitude, or *verticalismo,* is now recognized as a problem but its influence remains. When we asked him about the absence of any grass-roots education in the electoral campaign, Omar Cabezas gave *verticalismo* a sadly literal dimension: "What do you mean? We were constantly involved in political education with the masses. Listen, in Leon alone, we dropped more than three thousand leaflets from an airplane in one day."

This attitude infuriates those who think that the most urgent task for the Sandinistas is not only to catch up with the grass roots, but provide it with leadership. Maria bustled up our driveway after the first Sandinista strike,

complaining all the way: "It's everyone for themselves. The strikers didn't bring up the struggles or rights of anyone else."

Exasperated, Maria stubbed out a cigarette. "The Frente can't carry all these flags. It is not a vanguard around which anyone can unite. It has no strategy, and the people don't want it in power. All these crazy people shouting in the street—they are the vanguard. The Frente Sandinista is history."

Maria is not frightened by that idea. In fact, in the context of these dark days for the Nicaraguan left, Maria is something of an optimist. She refuses to be defeated and will continue organizing and agitating. "There is a new birth going on here," she declared. "Everything is changing. That is why no one can see the future."

Maria reminded us that Sandinismo survived the death of Augusto Sandino in the 1930s and the destruction of its incipient movement in the 1960s. "It is good that we lost, so that we had to face the fact that we couldn't govern," she said. "Power is transitory." And then Maria rushed off to another meeting.

Working within the party hierarchy, Sofia is perhaps more immediately focused on the Sandinistas' other flank: how to deal with new government

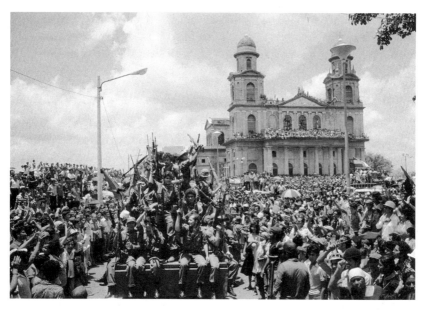

Nicaragua, July 20, 1979. Sandinistas overthrow dictator Anastasio Somoza. Courtesy of Susan Meiselas/Magnum Photos.

and the contras. "Perhaps we will be lucky and this will not explode into a civil war," she sighed as the night began to draw to a close. "Either we kill each other and disappear as a nation, or we resolve it. [The Frente] must propose a pact that will include all sectors, including the contras. Ten years of war didn't persuade the bourgeoisie that this is necessary; perhaps the exercise of power finally will. It's not so easy to govern this country. In fact, no one can do it alone. Perhaps finally everyone will say, 'Shit, this is an unruly place, we're going nowhere.'"

And then Sofia arrived at the same paradoxical conclusion as Maria: "As for us, if this government would fall tomorrow, we [Sandinistas] wouldn't want the damn thing." What Sofia wants is the room to reflect, to evaluate, and to criticize.

Sofia looked at the coffee table, seeing in the reflections there the faces of *compañeros* who have fought at her side in the Sandinista movement for the past two decades. "There are those who will go into nihilism and say, 'What the fuck have I wasted my life on?' and there are those who will try to digest the whole damn thing and go on."

Sofia paused. She was speaking hoarsely now, perched cross-legged in a rocking chair, smoking and planning the future of her revolution. "It was a new way of being in the world—a little better off," she said. "You're not asking much, but it's so hard, and you see the cruelty of the world. Here, in a little country, people tried to make some happiness. And if all we achieve is the faint memory of a failed experiment, I think it will have been worth it."

Creative Politics

In the first essay of this chapter, "El Salvador, 1988: Absolute Diabolical Terror," there is an account of the exhumation of the bodies of ten Salvadoran campesinos from a village in the central part of the country not far from the capital. Thousands upon thousands of Salvadorans were killed by government soldiers during the war—sometimes out of uniform and operating as "death squads," other times in uniform, as in this case. No one had ever been convicted for these crimes. No one had even been seriously investigated. It was essentially open season on the poor. But the incident in question had occurred in 1988, after a decade of U.S. efforts to "clean up" the Salvadoran military, "beef up" the completely dysfunctional judiciary, and make "human rights progress." By this time, the period of large-scale massacres was over and death squads were much more discriminating in choosing their targets and more careful to cover their tracks, yet these ten unfortunate souls had been

executed in the full light of day. The killing was so brazen, such a throwback to the atrocities of the recent past, that neither the Salvadoran government nor the U.S. embassy could find a way to avoid finally putting into play the shaky investigative and judicial mechanisms American aid had supposedly bought, and the bodies were exhumed.

The villagers claimed the soldiers had executed the victims at close range. The army claimed the victims had accidentally stepped on a mine. The unfortunate doctor the government had assigned to the exhumation was in an extremely precarious situation, since contradicting the Salvadoran military could lead to a nighttime knock on the door. But here were the bodies laid out on the dirt in front of him. Clearly nervous, sweating profusely, the doctor examined the bodies and announced that the victims had all died from gunshot wounds to the back of the head from a distance of a few centimeters. And then he left. Got out of there as fast as he could.

I filed an article about the exhumation for the *San Francisco Chronicle*, for whom I was stringing at the time. San Francisco is considered the most liberal city in the United States, and the *Chronicle* one of the nation's most liberal newspapers. Furthermore, there is a significant Salvadoran population in the city, many of whom at that time had fled the war. The Salvadoran war had been one of the biggest news stories of the decade, and the *Chronicle* had covered it extensively. In other words, the *Chronicle* was a liberal-leaning paper in a liberal city and had covered the war in El Salvador for years as a local, national, and international issue.

In my article, I wrote that the doctor had determined that the victims had been shot in the back of the head at close range, and that this supported the villagers' assertion that the victims had been executed and contradicted the government's assertion that they had stepped on a mine. Shortly after filing the story I had the following phone conversation with the *Chronicle's* foreign editor:

> *Chronicle foreign editor:* We have to talk about your writing. It is very unprofessional. I can't print this story. It is totally biased, full of your opinion.
>
> *Me:* Can you tell me specifically what you think is bias or opinion?
>
> *Editor:* You write that the doctor's assessment supported the villagers' version of events and not the army's. You can't say that. That is just your opinion. You need to get an expert to voice that opinion.
>
> *Me:* The villagers said the victims were executed, and the army said they stepped on a mine. The doctor said they were shot in the back

of the head from a distance of a few centimeters. I didn't write that this proved they were executed, even though it does. I just wrote that it supported the villagers' version of events. It does. That is not my opinion.

Editor: You can't say that. You should have got the doctor to say that.

Me: The doctor was not going to say anything other than what he said. All he wanted to do was to get out of there as fast as possible.

Editor: Well, you have to get some sort of expert opinion.

Me: What sort of expertise is required to know that someone who died from a bullet wound to the back of the head did not die from stepping on a mine?

Editor: Look, you and I both know that the army probably killed these people. Presumably at some point someone will be tried and convicted for these murders, and *then* you can say this stuff.

That ended the conversation. I did not write for the *Chronicle* anymore. The story of the massacre and exhumation went largely unreported in the U.S. media. Today, twenty years later, no one has been arrested or convicted for the crime, just as no one has been arrested or convicted for the killing of any of the tens of thousands of campesinos who were slaughtered.

■ ■ ■

In the larger context of the Salvadoran war, my dispute with the *Chronicle* over the murder of ten campesinos was small potatoes. Several years earlier, U.S.-trained troops had murdered the entire village of El Mozote and its nearby hamlets, killing everyone from the aged and infirm right down to babes in arms. Elderly women were raped before being executed with machine guns. Men and children were beheaded. The dead numbered over seven hundred. Within weeks of the massacre, Raymond Bonner of the *New York Times,* Alma Guillermoprieto of the *Washington Post,* and photographer Susan Meiselas managed to get to the massacre site despite great personal risk to themselves. They saw the unburied bodies. They interviewed the lone survivor. They interviewed relatives and neighbors. They took photos. Their stories and pictures were run on the front pages of the *Times* and the *Post,* America's two most powerful newspapers.

In response, the Reagan administration not only denied that a massacre had taken place, but mounted a concerted campaign against the journalists themselves. Bonner and Guillermoprieto were attacked by the U.S. embassy in San Salvador and by State Department officials testifying before Congress.

They were the focus of a campaign against them by the conservative media watchdog Accuracy in Media. The *Wall Street Journal* and *Time Magazine* both wrote editorials denouncing them as stooges for the rebels. Soon Bonner and Guillermoprieto lost their jobs, while the Reagan administration "certified" to Congress that "human rights progress" was being made by the regime in El Salvador.

The fact that reporters for papers as powerful as the *Times* and the *Post* could lose their jobs for reporting news that was not to the administration's liking, even if they were reporting facts they had gathered and photographed firsthand, was not lost on any of the American reporters who remained in El Salvador writing for newspapers with less clout.

The massacre at El Mozote happened in 1981. Eleven years later, a peace agreement between the rebels and the government finally brought the war to a close. The deal included the creation of a "Truth Commission" to investigate the atrocities of the previous decade. A forensic team from Argentina arrived, and a year later the United Nations published the Truth Commission's report. The report told of how 143 skulls had been unearthed from the northeast corner of the ruined sacristy of the church of Santa Catarina of El Mozote. All but 12 of the skulls belonged to children under twelve years of age. The sacristy was where the soldiers had herded the children of El Mozote before massacring them. The cartridges recovered at the site showed that "at least 24 people participated in the shooting" and that they fired "from within the house, from the doorway, and probably through a window to the right of the door." Of 245 cartridge cases that were recovered, "184 had discernible headstamps, identifying the ammunition as having been manufactured for the United States Government at Lake City, Missouri."

Finally, on October 22, 1992, the *New York Times* ran a front-page story under the heading "Salvador Skeletons Confirm Reports of Massacre in 1981": "Nearly 11 years after American-trained soldiers were said to have torn through El Mozote and surrounding hamlets on a rampage in which at least 794 people were killed, the bones have emerged as stark evidence that the claims of peasant survivors and the reports of a couple of American journalists were true."

Not on the front page but buried inside, thirteen paragraphs into the story, was the admission that one of the two journalists mentioned in the lead was from the *Times* itself. There was no editorial discussion of the significance of this admission, no reflection on how the paper had managed to break the news, then cover it up, then rediscover it more than a decade later. No mention of the cost in human lives that had been paid.

Eleven years after its own journalist reported all the relevant facts from the scene of the crime, with photographs, the *New York Times* was finally printing the truth. In the intervening years, American taxpayers had spent more than four billion dollars funding a civil war that left seventy-five thousand dead.

The story of the massacre at El Mozote, the situation that led up to it, and the years of fallout that followed, has been chronicled by Mark Danner in both a *New Yorker* article from 1993 and a follow-up book from 1994. I cannot recommend these works enough.[1]

■ ■ ■

It is an inescapable fact that war is not conducive to truth. Obfuscation, fear, denial, propaganda, violence, and outright falsehood impinge on it from all sides. People who are afraid are reluctant to speak the truth if there are reasonable grounds to think they might suffer a terrible consequence as a result. People who are terrorized may not remember the truth clearly. (The record of wrongful court convictions in the United States shows that even people who are not terrorized have difficulty with this.) People who have participated in something they believe to be morally wrong may be unable to acknowledge the truth of what they have done. Once people's lives are at stake, telling small lies to keep people alive is an easy decision to make. Telling small lies to advance your cause toward victory is no big deal. Once the lies start, discerning a small lie from a big one is a much more difficult problem.

I saw many things in El Salvador I will never know the truth of. Who fired the shot that killed this person? Which side initiated the engagement that resulted in these civilian fatalities? By whose hand did this woman whose body lies at the side of the road lose her life? Who planted the mine this child stepped on? Many Salvadorans who were not combatants died at the hands of the guerrillas. Some deaths were the result of honest mistakes. Others were the result of callousness. Others were the result of clear injustice. More than once, disputes within the leadership of the various rebel organizations were resolved through murder. By the end of the war, the rebel movement was a battle-hardened bunch that had been through more than a decade of brutal violence. In general, large groups of edgy, exhausted people with guns are good things to avoid.

I am certain, however, that the rebel movement never engaged in systematic atrocity of the sort that was routine on the part of the regime. After all was said and done, the truth remained that the war in El Salvador was a war of the rich against the poor, in which the rich systematically engaged in atrocities of the worst sort, and the poor did not.

■ ■ ■

For a period of time while I was working in El Salvador, my research was focused on the extreme right. I got to know Colonel Sigifredo Ochoa, who advocated a "nuclear solution" to the war (meaning annihilate the left to the extent that a nuclear bomb would, but using soldiers and death squads). I met Roberto Staben, an army colonel who ran the base near which the death squads dumped the bodies of their victims. The men he led became so addicted to violence and crime that as death-squad operations against unionists and students wound down because all the activists had been killed, his gang morphed into straight-up gangsters and began kidnapping rich oligarchs for ransom. I even met Roberto D'Aubuisson, the notorious leader of the whole "death squad" apparatus, a man whose hands were so bloody even the Reagan administration wouldn't touch him. He was most famously associated with the murder of Oscar Romero, the country's Catholic archbishop, who was gunned down while saying mass. But D'Aubuisson's victims, both direct and indirect, numbered in the tens of thousands.

These were very scary guys. If a person like this walks into a room, you know it right away. The vibe they put out is very powerful, very weird, and undeniable. D'Aubuisson, in particular, was charismatic in a profoundly unsettling way and always had followers and hangers-on around, feeding off his energy.

Since I believe that all humans are fundamentally created equal, these men are difficult to place, for I cannot see anything in myself that would impel me to act as they have. Yet there they are, the same animal as I, the same flesh and blood and bones, brains made from the same gray matter.

It is impossible to be around violence such as plagued El Salvador without noting that humans are capable of finding pleasure in cruelty. Social norms usually keep cruel behavior within certain limits. The sum total of those norms is what constitutes civilization in the most general sense of the term. But in places like El Salvador, where a grotesquely unjust social system is held precariously in place by state-sanctioned violence, there are significant cracks in these norms, and these cracks become populated with people who feed on violence like a drug. Civil war can burst these cracks wide open, and then the people who had found their niche in the cracks are given free rein and run amok.

When someone casts off all restraint and revels without reservation in that place where cruelty and power intersect, they tap into some animal thing deep in the human psyche and become charismatic in a very weird and specific way. They command attention, draw followers, and silence dissent.

Part of the buzz on D'Aubuisson was always about how he was such a ladies' man, how women found him so sexy. Yet he was not an attractive or imposing man physically, with a slight build, adult acne, and a lisp. What he actually was, was a killer, an unapologetic mass murderer. D'Aubuisson's presence was both attractive and repulsive at the same time, like a car crash, except more violent and much more sinister. Whenever I was around him, the phrase "in the presence of evil" would resonate in my head. I think that phrase was coined to describe being around people like him. The killer's charisma he exuded is, to my mind, the presence of evil.

This notion of evil is different from the Christian one, for it is not at the far end of a continuum that has white lies and petty selfishness on the near end. Evil in this sense exists only as an extreme.

In my own country we have men who have committed crimes as serious as D'Aubuisson's without ever touching a weapon or even seeing one of their victims. They kill by signing papers. Sometimes they kill simply through inaction. I have often wondered if their presence carries the same power as that of D'Aubuisson and his henchmen. I doubt it.

In El Salvador, I saw the presence of this sort of evil up close. It is real and powerful, and needs to be considered carefully by anyone who believes that social justice can emerge from armed struggle. It was a major reason why, in the final analysis, D'Aubuisson's gang won the war.

■ ■ ■

A handful of evil men can hardly kill 75,000 people by themselves. A lot of the killing was done by other poor people. The way soldiers were conscripted in El Salvador was something to see: an army truck would pull up at a bus stop and soldiers would jump out and start grabbing boys and young men. And once they had you, there was no way out.

There has been no shortage of horrific conflicts in recent history that have posed difficult questions about the limits of human behavior, from stoned teenagers in central Africa, to former neighbors in Rwanda and Yugoslavia, prison guards at Abu Ghraib, and religious fanatics of various traditions. How and when human behavior escapes from civilized norms into barbarity is an increasingly urgent question at the dawn of the third millennium.

In El Salvador, there was nothing spontaneous about the murderous behavior of government soldiers. They were carefully and deliberately conditioned to commit unspeakable crimes by their superiors. The Atlacatl Battalion, the unit that was responsible for the massacre at El Mozote, had received "training" that was enough to give anyone nightmares. They were ordered to shoot

animals and smear the blood on their faces. According to one reporter, they celebrated their graduation from their American-led training by "collecting all the dead animals they could find off the roads—dogs, vultures, anything—boiling them together into a bloody soup, and chugging it down."[2] The officers who ordered and encouraged such activities clearly did not believe that off-the-shelf campesinos would readily commit the atrocities the officers had in mind but would require a series of bizarre and explicit rituals to steel them for the job.

I spent a good deal of time with these soldiers. Once I spent a week on long-range reconnaissance deep in rebel-controlled territory with Yankee Company from the Atlacatl Battalion. I did not perceive them to be evil. They seemed more like victims themselves. I talked with them as we hiked through the sweltering forests of eastern El Salvador, and the conversation again and again turned to the movie *Rambo*, the Sylvester Stallone action movie about a deranged but invincible American Vietnam War vet. *Rambo* was shown to the Salvadoran troops in their barracks over and over. Everyone had seen it at least eleven times. They appeared to believe that Rambo was a real person. In every Salvadoran combat platoon, the guy with the M60 machine gun was referred to as "the second Rambo." When I talked with Yankee Company in the tents one night in yet another conversation about Rambo, it occurred to me that they did not know that the Americans had lost the Vietnam War. I gently broke the news. At first they thought I was joking. Little by little, I convinced them. In hushed whispers, the stunning news spread through the encampment in the Salvadoran night.

■ ■ ■

D'Aubuisson and his thugs led a campaign of political assassination against the left that was so broad, so systematic, and so continuous, one could argue it was the cornerstone of their entire war strategy. Among the generation of Salvadorans who organized the mass movement of poor people that rocked the country at the end of the 1970s, nearly every leader with any sort of public profile, and many who had no public profile at all, was killed.

The left believed that this strategy could only fail, that such open-faced brutality would always create more revolutionaries than it could kill. One fallen leader would be replaced by ten more. This thesis was resoundingly disproved. New cadre did emerge, but in every case without anything close to the leadership abilities of those who had gone before.

All effective political organizing strategies center on identifying people who can lead, and then empowering them with resources, education, confi-

dence, mentorship, and so on, beginning at the most basic unit of neighborhood, school, shop floor, or whatever, right on up to the movers and shakers directing large organizations and institutions. But it all starts with identifying potential leaders, and the reason it begins here is because anyone who has done this sort of thing for any length of time knows that not everyone can do this. "Leadership" is a peculiar thing, and involves a complex assortment of abilities that is much easier to intuitively grasp than to rationally dissect. These abilities have little to do with class, race, gender, or education. But in all social sectors, the pool of potential leaders is always limited, and the pool of leaders who can function at all levels from national to local, in a principled and effective way, is more limited still.

In a country as small as El Salvador, once an entire generation of such people has been killed, they are not easily replaced. The wealthy oligarch Enrique Alvarez Córdova, who turned his own hacienda into a campesino cooperative and was the first president of the coalition of leftist organizations; the fiery trade unionist Juan Chacón; and more than anyone, the beloved Archbishop Óscar Arnulfo Romero—the revolutionary movement never recovered from the loss of these extraordinary individuals, all gunned down by D'Aubuisson's death squads. The sad fact is that the right's campaign of mass murder worked.

■ ■ ■

The first generation of activists in revolutionary movements like those in Central America often work literally on their own. They have few resources to rely on other than their wits, and no superiors looking over their shoulder. A friend from the Philippines, who had been a leader of the guerrilla movement there, told me how he had been sent to Mindanao (the second largest island in the country) to open a new guerrilla front with nothing but a knife. Experiences like these are formative. The people who emerge from such a process have been shaped by an experience no one who comes up the ranks behind them will have. Once the movement has built an organizational infrastructure, everyone who joins will have to become, to at least some extent, an "organizational person": they must keep one eye on their actual organizing work, and another on their position within the organization. Almost inevitably, the former considerations come to be eclipsed by the latter.

At the risk of sounding completely ridiculous, what happens when an organizer confronts a complex situation on his or her own is, in a certain sense, not dissimilar to what happens when an improvising musician must confront a performance without a score: past a certain point, the only way forward is

to create in the moment. Of course, while music and politics at this level may involve the same sort of creative imperative, the consequences could not be more different. When organizing clandestine resistance to a brutal regime, the consequences of making mistakes are life-and-death matters. In music, the consequences of making mistakes are nonexistent, which to my mind is what constitutes music as an art.

■ ■ ■

The left argued that armed struggle was justified in El Salvador, since life there was already shot through with violence against the poor—the violence of the state in a country where wealth and power were concentrated in the hands of a few, and the violence of the daily grind of hunger and poverty. The poor, it was said, would be willing to risk their lives against astronomical odds because they had nothing to lose. There was without doubt some truth to this. The lives of the Salvadoran poor were wracked with violence, and the poverty was so extreme it was not far-fetched to view it as another kind of violence in itself. And poor Salvadorans did risk their lives against astronomical odds, particularly in the early years. But it was a mistake to think that this meant the poor had nothing to lose. People can live meaningful lives under the harshest conditions: they can fall in love, raise children, have beliefs and habits, accumulate meaningful memories, honor their gods and ancestors, and build some semblance of security, no matter how fragile. While the poor may have little to lose in terms of material wealth, they have the most to lose in the sense that there is so little cushioning them from utter destitution.

At the end of the 1970s, the radical movement had been rapidly building in size and strength, largely through labor and student organizing, land occupations, and radical Christian evangelism. The guerrilla fighters were not the central component and often functioned as an irregular defense force for actions by much larger groups of unarmed people. In 1980, with the Reagan administration taking power in Washington and promising a far more aggressive American foreign policy, the movement called for a mass insurrection like had recently happened in neighboring Nicaragua (and even more spectacularly in faraway Iran), hoping to present the incoming Reagan administration with a fait accompli. But upheavals such as happened in Nicaragua and Iran cannot be "called for" according to the timetables of events in other countries, and anyway, the "organized" left was in fact quite disorganized. The attempt at insurrection failed and was followed by the right's campaign of mass murder, which made activities like strikes and land

occupations suicidal. The left saw no option but to regroup into a guerrilla army that fell back into a rural war of attrition lasting a decade. As the war ground on, life in El Salvador got worse, much worse, and the lives of the poor deteriorated more than anyone's. Eventually things got so bad that the biggest problem for many poor people was no longer the country's endemic social injustice but the war itself. The idea that those living in extreme poverty had nothing to lose was a fallacy for which many people paid dearly. Of course, the highest price was paid by the poorest.

■ ■ ■

What a movement like that in El Salvador is trying to accomplish is wildly ambitious. Set aside the idealistic goals of socialism, a better society for all, an end to violence against the poor, a more equitable distribution of wealth, a redistribution of land, and even, for the evangelists of radical Catholicism, the kingdom of God on earth. For a moment, think just of the day-to-day life of someone trying to organize a clandestine army of illiterate peasants in a brutal police state. This is an insanely difficult job.

All the usual difficulties of political organizing are there. How to break down the work so that people feel like they are winning a string of incremental victories, no matter how small, to keep them motivated and optimistic. How to make everyone feel like they have a voice in decisions, yet keep everyone on the same page and focused around the same goals. How to keep personal squabbles and the petty discord of all human social interaction from messing up absolutely everything. To this mundane but daunting list, a whole host of others must be added, like how to teach someone who lives in a village of fifty people with no electricity or running water how to evade the surveillance of American high-altitude unmanned reconnaissance planes equipped with very long-range infrared night-vision devices.

How to teach a new understanding of time. Campesinos have a very loose understanding of time. Not because they are lazy as in the stereotype (the life of a campesino is a nearly relentless stream of backbreaking work), but because one could not survive in the Central American countryside with an urban sense of time. There is simply too much about time that is beyond their control. When you get places by walking long distances, it is hard to predict when you will arrive. If you are going to drive but the rains turn the dirt road to a mud bath, you simply have to wait. If the truck breaks down, there is no garage to take it to and no place to find spare parts. It will probably get fixed, but the required part may have to be assembled from odd materials

scrounged from many people's shacks, or the repair may require the advice of someone who lives two hills over but is not in and cannot be reached by cell phone to see when he will return. Or it may simply require a lot of head scratching and creativity to figure out how to make do without the resources urban people would take for granted. Any one of these problems could take a few minutes, a few hours, or a few days. People who live their lives like this do not get anxious when things go slow, when a 9:00 A.M. meeting starts at noon, when the contact who was supposed to arrive on Sunday morning arrives Wednesday afternoon. Anyone who lived for any length of time in these circumstances and insisted on clinging to an urban sense of time would go nuts. Unfortunately, war is waged with a military sense of time, which is even more precise than urban time. If an army post is to be attacked from two sides at 6:00 A.M. and one flank isn't ready until 6:15, there will be problems, and these might include imprisonment, torture, and death.

The constant awareness of the potentially catastrophic consequences of screw-ups is a difficulty in itself, an overarching element that multiplies all other difficulties by some very large number.

And we haven't even begun to discuss big-picture strategy and tactics, like where to get money to keep the movement going and weapons to keep it armed, and what the hell to do if the unthinkable happens and you actually win.

This is the hardest work I have ever been involved with, the hardest I can imagine. I have several friends in San Francisco who work in providing mental-health services to the indigent and homeless. Every time I speak with them about their work, I am impressed anew by the difficulties they face every day. But what the revolutionary movements in Central America were trying to do was far more difficult still.

Making music is, by comparison, a piece of cake. The consequences of making mistakes are trivial. Nothing actually depends on success or failure, which is in any case hard to even measure.

■ ■ ■

The people at the top of the revolutionary organizations in Central America were not the smartest, most creative, or most self-sacrificing. They were the most ambitious. They wanted power in an uncritical way and did not doubt their own judgment. The two men who rose to the fore of the movements in Nicaragua and El Salvador, Daniel Ortega and Joaquín Villalobos, are cut from the same cloth. They were handsome and macho, their speeches and writing were surprisingly dull and wooden, their political thinking lacked

all nuance, and they were very adept at juggling things to keep all the power within their reach tightly in their own hands.

Managing leadership is a problem for any political movement. When a movement becomes militarized the problem gets much worse, for the dynamic of organized violence imposes hierarchy everywhere and brings to the fore people who see the world in stark black-and-white terms. But the world is, in fact, not black and white, but has colors of every possible shade and hue. Politics requires an understanding of these nuances second to none. This became painfully clear when the Salvadoran civil war finally ended and the guerrilla commanders, forced to function in the civilian political arena, looked like cartoon caricatures bumbling about.

Looking around the world, it is rare that a truly great person rises to the top in a political-military struggle. Perhaps Ho Chi Minh is one of the few exceptions. Perhaps in a paradoxical way the South Africans were lucky to have a leader such as Nelson Mandela locked away in prison so long, where a more ambitious person could not sideline him or undercut his leadership. The fact that the South African struggle was always primarily a political one, with the military element a distant second, may have also helped a man like Mandela stay on top.

The leaders of the Central American revolutionary organizations were not evil, and despite leading their followers through years of brutal warfare, they never resorted to the mass killings that were the staple of their opponents on the right. But neither were they brilliant thinkers, nor even in many cases particularly well-liked by their followers. In the political reshuffling that followed the end of the wars, many of the most important commanders were revealed to be transparent opportunists.

■ ■ ■

Some of the most amazing people I have ever met were deeply involved in the struggles in Central America, but never at the top of their organizations. To find the truly inspiring people, you had to look one or two tiers down in the hierarchy. There you would find the brilliant ones, the original thinkers, the ones you imagined were at the top when you first encountered the whole enterprise. The ones who, because they were women, or gay, or too creative, or too suspicious of power itself, had hit the glass ceiling above which the best cadres rarely rise.

The complexity of political work on this scale makes it so engrossing and all-encompassing it can swallow you up. I have seen it drive people nearly crazy. Everyone is in over their heads, sink or swim. Everyone must be an

entrepreneur, an economist, a psychiatrist, an engineer, a social worker, a quality-control analyst, an athlete, an arms expert, and more. The road ahead is never clear, and there is no map. The people involved like to think that their ideology is their map, but this is a myth. In any given situation, the same ideology can always be used to support any course of action, even opposite courses of action. Ideology is brought in after the fact, to give an air of correctness and inevitability to decisions that are always essentially intuitive. Navigating all this requires a highly unlikely combination of unflagging energy and optimism about the future, together with a constant critical reassessment of the immediate past.

I met people who actually rose to these demands: wise beyond their years, smart beyond their education, equally able to deal with generals and laborers, bankers and street vendors, adept with a pen and a gun. Their past was never a good prediction of their future. One year might find them organizing unions, the next year working in international diplomacy, and the next leading a column of fighters in the mountains, but always working with people, putting people first.

They were always startlingly humble—their awareness of the difficulty of the task precluded any sense of arrogance. What distinguished them most

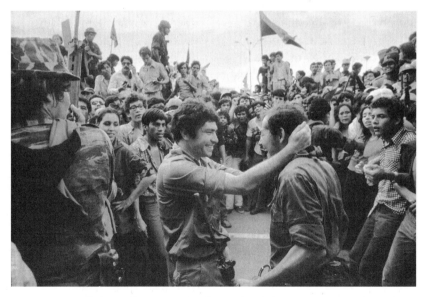

Managua, central plaza, July 20, 1979. Sandinistas bring democracy to Nicaragua. Courtesy of Susan Meiselas/Magnum Photos.

from those who rose to the top was their critical attitude toward the revolutionary project to which they were devoting their lives, and to power itself. As one friend put it to me, "I am still in the organization, because I think that in spite of everything, they represent the interests of the poor in this country. But if these guys ever actually come to power, I am quitting the next day to form an opposition." The next time I saw him he was already out. Though these people came from every possible position in life and could be found in every kind of work, the one section of road each and every one of them traveled was at some point to finally leave the revolutionary organization of which they had been a part and to look for other ways to advance the cause of the poor in their country. The courage this requires is exceptional in itself: with a war in which you had a crucial part still raging, and with years of your life spent building a revolutionary organization to which you had given absolutely everything, and to which many close friends had given their lives, to walk out when it becomes clear that your organization is beyond repair, and in spite of everything look around for a new niche from which to continue to struggle for justice.

I did not do that. When things got too crazy and hit a dead end for me in Central America, I moved to San Francisco and returned to the musical pursuits I had dropped when I became absorbed in Central America. It is a more comfortable life, and much easier work. But I have tried to take with me the kernel of what these extraordinary people taught me: to stick to one's path—not a particular direction, or mode of travel, or speed or style, but the path itself. To always question what you have just done and remain open to the possibility that the future might surprise you. To walk humbly and say what you mean. It is from these true comrades that I have taken the notion of "creative life" from which this book takes its title.

the balkans

In the 1990s I closely followed the news of the civil wars in fragmenting Yugo-slavia, as appalled as everyone else at the return of atrocities on a massive scale to Europe. The subsequent crisis in Kosovo and the NATO bombing of Serbia left me with profound unanswered questions. My close friends in Europe were split on whether Europe should intervene in Bosnia. Never had I felt so pas-sionately about an issue on which I could not decide between what seemed to be the available political options. All through the Bosnian war I had argued that the West had to do more to help Bosnia. But when NATO finally acted in the Kosovo crisis, the course of action chosen was as shocking as everything else: leaving Kosovo to Slobodan Milosevic's army and militia and instead bombing civilian infrastructure in Beograd, Novi Sad, and other urban centers far to the north in Serbia. I decided, as I often do, to work things out in my head by composing a new work on the subject. And I decided if I was going to perform the piece at all, I should do it first in the remains of Yugoslavia. And that is how this story began to take shape.

The Balkans 2000: Tour Journal

Though it is not the subject of this chapter, you ought to know something about the concert I prepared, Yugoslavia Suite.

Yugoslavia Suite *is in two movements, the first of which is called "War Games." I use a joystick modeled after the throttle of a jet fighter to "play" what looks like a computer game, which is projected on a big screen. The game is*

Still image from performance of *Yugoslavia Suite.*

actually a collage made in part from commercially produced fighter/bomber computer games, and in part from "real" images from the U.S. military and NATO. These latter show what pilots flying over Yugoslavia were actually look-ing at when they were dropping bombs, as well as what tank gunners in the Iraq war were looking at when firing their guns. There are also images from U.S. Air Force and Army training software, which look very much like games. In fact, at times the computer game images look more real, and the "real" war images look more like what most people think of as games.

The second movement, "These Hands," uses video footage from the civil wars of former Yugoslavia, each scene chosen because it shows someone doing something interesting with their hands (loading bullets into guns, bandaging wounds, reading maps, playing chess, wiping away tears). My colleague Rich-ard Board is also onstage, with the light set so that the audience sees only his seemingly disembodied hands suspended in black space. Using a video camera and special software, I can place live images of Richard's hands directly into the projected video scenes. He can reach his hand right into Milosevic's, or warm his hands by a refugee campfire.

This second movement begins with the sound of Richard clapping his hands in the dark. His hands appear gradually. Then, while the image of his hands is transformed into the hands of striking miners in Kosovo, then Milosevic's hands while gesturing during a speech, then a soldier shooting a bazooka, and so on,

the sound of the hand clapping slowly multiplies into a group, then a larger and larger crowd, then a soccer stadium roar, a torrential rain, explosions, and finally ferocious wind—all made from the sound of clapping hands.

Excerpts from "Balkan Journal" were originally published in the February 2001 issue of The Wire.

■ ■ ■

Once I began to organize the tour, it became clear that just getting into Serbia was not going to be easy. There were no diplomatic relations between the United States and rump Yugoslavia, so Richard and I sent our passports to the Yugoslav embassy in Canada, which sat on them for two months. We did a little research and found that no Americans, other than the most mainstream corporate press, had been granted visas since the NATO bombing. Yugoslav embassies had been instructed that visa applications from Americans could be handled only directly in the Foreign Ministry building in Beograd, and Beograd always said no. Yet two concerts in Serbia were booked, one in the northern city of Novi Sad, and one in Beograd, sponsored by Free B92 radio, the lone anti-Milosevic voice left in the Serbian media.

With only four days left before our departure for the first gigs of the tour in Slovenia, I called the Yugoslav Embassy in Canada and asked them to return our passports by express mail. This they promised to do, saying, "We're sorry, but no visas." I set about canceling the concerts in Serbia.

The next day the passports arrived, and mine had a visa in it! But not Richard's. The embassy had no explanation. "Yes, I know, you are a *team*," the bureaucrat on the other end of the line practically shouted at me in that particular Serbian way. "A *team*. I cannot explain. Even my ambassador personally signed an urgent fax to Beograd saying, 'Why just one?' But you cannot have two!"

My concert organizer in Beograd later surmised that, at the moment of putting the passports and application fees back in the envelope, some enterprising office hack decided that since I could not do the concert alone, he could pocket the application fee for one visa and still keep us out of Serbia.

We pored over our options. Richard could apply again at the embassy in Budapest, where we were to perform just before going to Serbia. I could try to do the concert alone. I could go alone but just play some improvised music (I often do improvised shows). Or we could try to find someone of a different nationality to perform Richard's part. We put all these plans in parallel motion and got on the plane with the matter completely unresolved.

Monday, October 11

We arrive in Ljubljana, capital of Slovenia, the northernmost province of what used to be Yugoslavia and the first to secede and declare itself a new state. We are met by Miha Zadnikar, the tall, bearded director of the Cinematech of Slovenia. He teaches sociology, and with him are two of his students, videotaping our arrival. Somehow all five of us and all the gear cram into a little Yugo and zip off to the capital as the radio blares, "Bye-bye, Miss American Pie."

Miha, his students, and basically everyone we meet in Slovenia are in a good mood. Slovenia has done okay. They made it out of Yugoslavia with comparatively little fuss, only a "weekend war." Slovenians see themselves as becoming increasingly westernized while the rest of the Balkans fall deeper and deeper into hell. On the whole, they like their president, Milan Kucan, a communist-turned-democrat who finessed the departure from Yugoslavia. Many will admit that, given the chain reaction of terror that followed, perhaps Slovenia's exit from Yugoslavia was a bit precipitous, but, as opposed to almost everyone else in the Balkans, the Slovenes are looking forward.

For the next day and a half we are wined and dined by our hosts. Mostly wined. We quickly discover the staggering difference in alcohol consumption between San Francisco and the Balkans, a discrepancy that will keep us mildly drunk, completely sloshed, or in hangover recovery for most of the coming weeks.

This first night the combination of drink and jet lag sends us off to our only full night of sleep in the Balkans.

Tuesday, October 12

The next day we discover another continuing pattern that will follow us around the tour: the organizers have not really read our detailed list of technical needs we sent in advance, so the day is spent frantically trying to put together the sound system, video projector, and theatrical lights needed for the show. Richard deals with these problems while I attempt to communicate with the Serbian organizers via e-mail, trying to come up with an alternative to canceling the Serbian leg of the trip.

Any one of these problems would have made for a stressful day. But the combination of putting a complex show together without the right equipment, with risky political content in an unfamiliar part of the world, and with the future of the tour in doubt, pushes the stress load right off the meter. I am glad for the bounteous offerings of alcohol.

Meanwhile, the national television has sent a crew to shoot the show and

interview me. We are just discovering that we are actually big news: Americans in an area Americans usually bypass, doing a concert on a political situation most Americans know little about, shortly after the war.

And then, as we are finishing our setup, a bug turns up in the software I had written for the piece. This sort of thing is absolutely unavoidable for artists who use computers and write their own software. Microsoft employs a small army to beta test its software, yet bugs always appear after commercial release. NASA puts its technology through every possible test yet still occasionally has a rocket explode moments after takeoff. There is simply no way a solo artist can show up at the first concert of a composition that involves custom software and expect everything to work.

Debugging computer code demands total concentration, and the worst thing you can do is hurry. Yet here I am, onstage, in a faraway, war-torn country, with a TV crew looking over my shoulder and a sellout crowd waiting in the foyer, wondering what the hell this American is going to do. Finally, with a few minutes before showtime, it seems we are ready to go.

Amazingly, the concert runs without a hitch. A little ragged, to be sure, but not bad for the first show. The audience response is effusive. Everyone wants to thank us, shake our hands, get autographs, and offer us drinks and more drinks. I relax for the first time in days. The TV crew stays overtime to get their interview, but their first question is, "Why did you put our President Kucan's image in your piece next to Milosevic and Tudjman?"[1] This is a difficult question to answer, given Kucan's complex role in the dissolution of Yugoslavia. In fact, I had put him in and taken him out several times during the creation of the piece. First interview, and they had gone right to the issue about which I myself was the most ambivalent.

Mixed with the congratulations and thanks, several times I am asked incredulously, "You are going to do *that* piece in *Serbia?*"

After the show we go out to eat and drink. And smoke pot. I myself do not smoke marijuana, but it seems like everyone in Ljubljana does. I can't even keep up with the drinking, let alone the grass. But I love the relaxed, outgoing nature of the Slovenes. At dinner I sit next to a pleasant college girl who studies sociology. I ask her what her major is. "Blow jobs with iced tea," she responds matter-of-factly.

Dinner is accompanied by wine and Slovenian *eau de vie*. Following dinner come more joints, then we go out for drinks. In the Balkans, when they say, "Let's go have a drink," they don't mean a drink. They mean drink until the sun comes up. We drink at the restaurant until it closes, at which point

we move to a bar. When that bar closes, we move to another bar. When that bar closes it is after 3:00 A.M. and the group prepares to move to yet another bar. Richard and I beg off, explaining that we are jet-lagged, have had an exhausting day, and must be up early to head to the next town. Our hosts are slightly offended.

Before falling asleep, I mentally review the chaos that surrounded putting the show together and decide that trying to do this show in Serbia without Richard is out of the question. Some other solution to the visa problem must be found.

Wednesday, October 13

Wednesday begins completely up in the air. We are supposed to do a gig in Koper, a town near the sea, but it is looking like a long shot. The gig is at a club run by Marko Brecelj, quite a storied man in the Balkans. "The Yugoslav Frank Zappa" is how most people refer to him. Brecelj was a Yugoslav rock star in the early 1970s and in fact organized a Zappa gig in Yugoslavia long before other Western rock bands appeared in Eastern Europe. Brecelj cut quite an eccentric figure back then, and the intervening three decades have not brought him closer to the mainstream.

What he does not do very well, it seems, is organize concerts. Though the show is tonight, he has not secured any of the equipment nor, more urgently, our transportation to Koper. We sit in the Cinematech office while messages fly back and forth to Koper. "Marko has arranged for the light man to drive you." "No, the light man has no car." "Marko says you can take the bus." "There is no bus." "Marko knows a woman somewhere who can maybe drive you later in the day, but you won't get there in time."

I sit in the middle of the chaos exchanging e-mails with Beograd, trying to figure out what to do about "the visa problem."

The one thing that everyone coming in and out of the office in Ljubljana agrees on is that Marko is an exceptional man and we must go to Koper, if only to meet him.

Finally, Marko Brecelj succeeds in getting a personal friend, Marko Kosnik, to drive us to Koper. Richard, the instruments, the backpacks, Marko, and I pile into his tiny Yugo and we are off.

The ride turns into its own little epic, for Marko Kosnik turns out to be a very interesting man. He has wild stories to tell about the Yugoslav army, into which he was drafted in 1981. Somehow Marko's encounter with Balkan militarism ended with him handcuffed to a bed for three days under military arrest. He was subsequently placed in military psychiatric care and doped with psychiatric drugs at doses far beyond what any real doctor would use.

Marko, the only veteran of the Yugoslav army I meet on the trip, is also the only person I meet who does not condemn the NATO bombing out of hand. "You will have to wait a few years before you can look back and see if the bombing was a mistake or not," he argues.

Marko cofounded LAIBACH with others drafted along with him, a group that has attained a near-mythic stature among those in the know in Eastern Europe. Most easily described as a rock band, Marko prefers to call LAIBACH a "media provocation":

> It was about being taken to the police station very often. It was about having nothing to eat. It was about our decision not to study the "false" philosophy. It was very near the social suicide when being called a fascist in that period of Yugoslav politics. And my best friend, who became the front man and did the most of poetry, could not avoid it at a certain moment, December 21, 1982, he hung himself.

LAIBACH was part hardcore rock band, part performance art. They created their own state with its own passports, all of it stridently, violently fascist. In 1982 LAIBACH was considered enigmatic and opaque. When the cataclysm of the 1990s arrived, they were reinterpreted as geniuses working ten years ahead of the curve. But by then Marko was long out of the group and venturing into video art. In the process, he had become one of the few people in the world skilled with the core video software I am using for these concerts. As we talk, I feel an immediate artistic affinity with him, a rather uncommon experience for me. I begin to hatch a plan.

We arrive at the club in Koper—a rock dive with graffiti-covered walls, a kitchen in which Marko Brecelj's wife, Arijana, is cooking us eggs, numerous other people coming and going, and none of the technical things we need to do the concert. Richard goes to work trying to assemble the necessary goods. I go to the phone and computer to resume communications with Beograd about what to do about the visas, while Marko Brecelj, a portly man now in his fifties, seems to half pout and half storm around the place. And of course, everyone drinks wine.

I finally reach the Beograd organizers by phone and they are adamant I must come. I hang up and approach Marko Kosnik with my plan. Why doesn't he come with me to Beograd? He knows the technology, he knows Beograd, and he saw the show last night in Ljubljana. Richard can train him tonight. As a Slovenian citizen, he can get a visa no problem.

Marko thinks carefully. His schedule is busy. He has a show coming up in Switzerland he needs to prepare for. He is also not really *looking* for any more run-ins with Yugoslav authorities. We talk about the project.

Finally, he looks me in the eye and says, "So what you really have in mind is being something like video guerrillas taking it right into the heart of the beast, right?"

"More or less, that's it," I reply.

"Then I have to do it," Marko answers.

Now the chaos doubles, with Richard and me trying to get ready for the show, me trying to get through to Beograd to tell them of the new development, and Marko trying to begin making all the necessary arrangements to leave for Serbia in three days.

Finally the show comes together, everything works, all is well. The crowd is the sort that has become typical for me in recent years: small, but quite passionate about my work. One group is there from Ljubljana. They had seen the concert last night and traveled to Koper to see it again. Another group has come from Italy for the show.

But beyond the hardcores, the audience reaction is decidedly mixed, much more so than the previous night. One man, a crane operator by day, dislikes the work to the point of agitation. He points out that we show an image of the Mostar bridge exploding right after showing an image of Bosnian Serb commander Ratko Mladic. "But the Croats blew up that bridge," he exclaims. "It's another lie."

I knew the Croats blew up the fourteenth-century Mostar bridge. In fact, on my bulletin board at home is a newspaper clipping in which the Croat commander on the scene lectured an incredulous reporter as his men were destroying the bridge. "Don't worry," he proclaimed, "we Croats will build another bridge in its place, more beautiful and more ancient."

What I had not known was that the audience would infer from the order of the images that I was blaming the Serbs for the destruction. I am learning how much identity counts in the Balkans. It is one thing to know it from a book or newspaper. And another to know identity politics in a place like the United States, where racial identity is usually something one can infer at a glance. Croats, Serbs, Bosnians, Slovenes—to me they look alike. In fact, they *do* look alike. They are ethnically indistinct. We're talking shades of white. The *only* way to make sense of these wars is as *religious* wars. Then everything becomes clear: Orthodox vs. Catholic vs. Muslim. El Salvador, my only other war experience, was a class war. I am realizing how little that experience can offer to help me navigate where I am now.

One person at the show whose feedback I seek out in particular is Sasha Mikrobz. Sasha is a giant bear of a man who performs around the Balkans as a storyteller and, happening to be in Koper, came to the show. He also lives

in Beograd and works with Free B92 radio, my hosts in Beograd. Sasha was the first Serb to see our show, and I was quite curious as to his reaction.

Though he is a professional talker, Sasha is extremely reluctant to discuss the concert. He is obviously disturbed. Finally, he says, "Well, okay. We Serbs are the bad guys. So?" I asked if he thought it was appropriate to do the show in Serbia. Several times his mouth said "yes" while his tone and demeanor said a loud "no." It was extremely unsettling.

It took me a while to sort out my reaction to Sasha. After all, yes, Serbs had been bad guys. Along with many others, of course. What I was unprepared for was how deeply ethnic identity works in the Balkans.

I am an American. In my view, there are very few nations who have as many "bad guys" as my own country, but I don't carry that around on my shoulder. I don't see myself as having much to do with them. In fact, I joined the "other side." I spent years working with the Central American left. That's me, fifth column all the way. In Central America I was around friends painting "Yanqui Go Home" banners, and marches denouncing "North American imperialism," but I never found it insulting, never felt anyone was pointing a finger at me.

They weren't. My Central American comrades had more or less the same take on all this as I did. After all, their countries were even more divided than mine. As nationalistic as they were when confronting the US, no Salvadoran I ever met felt any moral burden for coming from the country that produced Roberto D'Aubuisson and his death squads.

I had assumed that the Balkans would work in a similar way. That people who had actively stuck their necks out in opposition to the war policies of their governments would not feel personally indicted when others did the same. I clearly had a lot to learn.

After the show I meet with Marko Brecelj to settle the money for the night. It turns out he is running the club on such a shoestring that the extra expense of lighting for the concert is worrying him deeply, thus his barely veiled hostility in the afternoon. For my part, this tour has never been about making money, so I promptly cut my already token fee in half. Marko immediately lightens up. Now we are best friends. Now we have to drink together. Homemade wine from the area. If you think about the last time you bought a bottle of Yugoslav wine (maybe never?) then you can get a good picture of what we are drinking. But drink we do.

Only then does it come into clear focus what an amazing character Marko Brecelj is. He describes his last project. He got a flatbed truck, put a big sound system on it, positioned it at the foot of the hill the town sits on, aimed the

speakers at the town, and had the rock bands he godfathers go to work. At 3:00 A.M. Marko leans over as if to share an important secret. "Very disturbing music," he whispers.

Soon we are quoting Brecht to each other. Richard and I are invited to spend the night in his apartment. After more drinks, we are at his modest abode, and it is 4:00 A.M. Richard and I have to be on a train at 6:00 A.M. We catch a catnap, then return to the club in a stupor to pick up the gear. Marko grabs a laptop, the one we bring as a backup in case one of the other two computers fails, to carry to the car. He sets it on top of a wall and turns around to unlock the car door. *Bam*. The laptop crashes to the street. Marko is profusely apologetic, but there is no time for that. We assure him all is fine and rush off to the train.

Thursday, October 14

The train is set to leave as we pull up to the station and by some mad dash make it on board. One hour later we are changing trains at a gray, nondescript junction in a haze of exhaustion. With an hour to kill in the cold morning, we find the steamy cantina and order breakfast.

Coffee. We are from San Francisco, yuppie coffee capital of the world, and we need our coffee. We get our trays, sit down, take a big sip of the hot drink, and spit it out coughing. The stuff is absolutely undrinkable. It is not just bad coffee, it is some entirely other substance that I cannot precisely identify, but something about the flavor suggests a dog had pissed in the pot. I cannot believe *anyone* could actually drink it.

I look around the cantina, full of sullen workers fueling up before settling in to another day of minding the tracks, mopping the floors, cleaning the johns, and all the other dull jobs that keep a train station running. And sure enough, not a one is drinking coffee. Every single customer, from the train crews to the old washerwomen, is having a very tall bottle of beer with their eggs. For breakfast. Seven A.M. Slovenia. End of the millennium.

We arrive in Maribor, the second city of Slovenia. Here we play at Kibla, a surprisingly well-equipped multimedia center. Kibla feels very Western. Off from the bar is an Internet café, equipped with numerous computers with high-speed connections and full of teenagers surfing the Web. The teenagers, I am told, are always there. So much so that Kibla has had to start closing for lunch just to get the kids out the door. Parents were complaining.

As opposed to the first two gigs, the Kibla folks have read the tech rider and have everything we need. Yet bizarre problems plague the setup. Cable after cable goes bad. We get electrical shocks when we touch the gear. Fi-

nally, Richard gets out his volt meter and checks the power in the hall. The outlets at the back, where the video projector is plugged in, and those at the stage, where everything else is plugged in, are wired differently, and the two grounds are off by 110 volts! We have just cooked the solder off most of our cables! Frantic rearrangements ensue, continuing right up until showtime.

Somehow, everything comes together, and we play by far our best show. The audience, however, offers only cursory applause before quickly filing out. That unsettled feeling I am becoming familiar with returns.

Dinner and drinks follow. Once again, our hosts could not be more gracious. David Braun, a human-rights lawyer and sometimes music critic, is among them. David has studied my music as seriously as anyone in the world and was central in helping me organize the tour. He is preparing to go to work for the International War Crimes Tribunal. Peter Tomaz Dobrila, the director of Kibla, is an extremely warm man, as is his partner, Aleksandra Kostic.

After what is for me a considerable amount of alcohol, the talk turns to the concert. David is very enthusiastic. In fact, he had written a preshow article for the Maribor newspaper saying that I was the only artist he would trust with such politically delicate material. Coming from David, this was extremely flattering. I ask him about the subdued audience response. "Think about the nature of the show," he tells me. "Of course, the better you do it, the less the applause."

I press them about whether I should go ahead and do the show in Serbia, should that prove possible. They are decidedly mixed on this score. Aleksandra tells me it all depends on how much I value my teeth. Peter's opinion is just a straightforward "no," it would be too dangerous.

After more drinks, however, Aleksandra loosens up and really speaks her mind. Not only does she think I should not do the piece in Serbia, she thinks it is inappropriate for me to do it anywhere in the Balkans. "The images you use," she explains, "we have a completely different relation with them than you or anyone else who is not from the Balkans can have. We have seen them every day for ten years. At first we cried over them. Now we watch them over dinner without a second thought. You cannot know this experience. Your piece is very good, don't get me wrong. It has been a very long time since I have seen such an effective use of image. You should definitely do the piece. In Austria. Do it in Germany. Certainly do it in the U.S. But do not come here and do this piece. It is wrong."

This silences the group. Our hosts seem worried that Aleksandra has crossed the line of polite behavior. I am half elated to be finally having a

serious discussion of my work with someone who is obviously extremely intelligent and articulate, and half panicked over the content of her remarks. The fallout from her outburst occupies the rest of the evening. As we part company, she says once more, "Don't do this in Serbia, unless you don't mind coming back without your teeth."

I turn this over and over in my mind before falling asleep. I think she is right. This is the first time I have used video with my music, and I am learning how different image and sound are. It is very rare that a sound, by itself, will carry such specific personal, social, and political baggage as an image. Though we do not all hear sound the same way, the difference in how we see images is much greater. This difference is greatly magnified by the media. In San Francisco I really had to dig to find the images I used. In Maribor, I could have taken them from the TV almost any night in the last ten years.

Friday, October 15

Today we head to Budapest for one more show before Serbia. That is, if I do, in fact, go to Serbia. It is our first day with no concert, and we are thankful for it. Before departing for Hungary I collect my e-mail at the Kibla Internet café and step into the morass once again.

There is a message from Marko Kosnik, saying he will not be able to accompany me to Serbia, after all. Serbia is so locked down that even Slovenes cannot get visas. Marko is quite surprised. He has always received a visa with no problem and has performed in Beograd several times.

The second message is from the organizers in Beograd, encouraging me once more to go ahead and come, insisting that all will be fine. I write back a detailed account of Aleksandra's comments last night and add that after having thought about it, I am inclined to agree with her.

Richard and I discuss all this on the train. There are several options in front of us.

Plan A: Richard can try to get a visa in Budapest. This seems such a long shot as to be virtually out of the question.

Plan B: I can go but just play concerts of improvised music.

Plan C: I can go but just do "War Games," the first half of the concert. I can handle this piece on my own. And it is the second half of the concert, "These Hands," which is being perceived as anti-Serb. On the other hand, I cringe at the idea of doing one version of the show in Serbia that is "sanitized" for Serbs, and another version everywhere else. It seems fundamentally dishonest. Better to not do the show at all. But this is a bitter pill after so much

preparation, finally getting my visa, and arriving a stone's throw from the border.

There is one more possibility. In Budapest we are to hook up with Jozef Cseres. Jozef is a professor of aesthetics from the University of Bratislava who has been instrumental in helping set up this tour. Jozef is planning on going to Serbia at the same time I am, for an art show he has a hand in in Novi Sad.

Plan Z: in Budapest we teach Jozef to do Richard's part, and then Jozef does the concerts with me in Serbia.

The number of factors to weigh, the complexity of each, the diminishing time before a decision must be made, and the accumulating sleep deprivation and alcohol in the bloodstream leave me extremely stressed out. I begin to feel sick.

Saturday, October 16

In Budapest things go wrong from the moment we arrive at the venue. Our concert is at the very grand Palace of Fine Art in central Budapest, but inside we find a dismal situation that is all too typical of my experiences of such places. Though the building is gigantic, our concert has been banished off to a decidedly not-so-grand lecture hall in the basement. Serious work will have to be done to mount the concert in this room. Unfortunately, that is not what the technical crew has in mind. The crew views concerts like ours as an irritation imposed on them by bureaucrats who for some reason cannot be happy simply putting on the more mainstream fare upstairs. And they view us as rank amateurs who have no idea what we are doing. They have not even looked at the technical rider. And when we show it to them, they simply do not believe that we actually need the gear we request. It is going to be a very long day. For Richard in particular, it will be a fight to the wire to get the show up and ready by curtain time.

Any thoughts of spending the day training Jozef to do our show are scrapped. Things are not helped by the fact that I now have a full-fledged fever, cough, and sore throat. All I want to do is lie down. For the fourth time in four concerts, the setup continues for the entire day, right up to, and in fact a few minutes past, showtime.

After the show, which was not surprisingly subpar, we discuss the concert with audience members. There is one man from Serbia, and of course I seek out his opinion. He is ethnically Hungarian, part of the Hungarian minority in the northern Serbian province of Vojvodina. He is very moved by the

piece, and he thanks me effusively for the evening. But he is quite taken aback when he hears that I might be leaving for Serbia the next day. "You can do this concert in Vojvodina," he says. "This will be fine. But do not do this piece in Beograd. They will kill you."

Off we go for the night's drinking, fever and all. I almost collapse in my chair before they finally consent to call me a taxi. I go to sleep more torn than ever over what to do the next day, though really I am too sick to think about much at all.

Sunday, October 17

In the morning Richard and I meet Jozef and several others for breakfast. Breakfast with wine and schnapps, of course. I get a last e-mail from Beograd. It is a lengthy, detailed, and articulate response to my last message, describing why I must, without any doubt, leave for Serbia that day.

Finally, I am too sick and too tired to think about it anymore, and I just give it all up and say I am going. I will go, and I will play one set of improvised music, and the first movement of *Yugoslavia Suite,* "War Games." I will leave the desktop computer and all the accessories necessary for the second movement, "These Hands," with Richard in Budapest. With nothing but the two laptops I can do the stripped-down show I have decided on. But we have to move quickly.

Jozef agrees to come along for moral support and because he will write an article about the tour afterward.

I empty everything possible from my bags: books (most importantly the history of Kosovo I am reading), papers, notes, and most of my CDs (don't want customs problems on top of everything else). It is a routine I am familiar with from crossing borders in Central America a decade ago. I pare down to the laptop computers, spare socks and underwear, and a toothbrush.

As I am saying good-bye and making arrangements to meet Richard back in Budapest in several days, Richard insists he will go to the Yugoslav embassy in Budapest in the morning to try to get a visa one last time. I try to explain that he would be better off just enjoying himself in Budapest instead of wasting his time pointlessly arguing with Yugoslav bureaucrats, but Richard has decided. I am concerned for him. Aside from brief tours with me, Richard has hardly been out of his home state of California, much less out of the United States. The idea of him, through some weird fluke, getting a visa and coming into Serbia by himself is disconcerting. On my way out the door, I turn and tell him that, even if he gets the visa, he should not bring the trunk with all our instruments, which would make him an easy mark crossing the

border. This means that even if he comes we cannot do our full concert, but it seems the only prudent course.

Everything is tense. Jozef and I plan to take the train to Novi Sad, then connect with a car to take us to Beograd. (Trains no longer run through to Beograd, as NATO has bombed the bridges.) We share nervous beers in a wonderful "old Europe" restaurant in the grandiose but grand Budapest train station. There is a white grand piano on a stage in the middle of the restaurant. Very fancy. Each of its three legs is carefully seated in a glass ashtray. Very odd. Jozef thinks this is hilarious and wants me to take his picture seated on the stage and pointing at one of the ashtrays as if he is giving a lecture. Waiters come running, terrified that the bohemian character with raggedy clothes, a thick beard, and few teeth is actually about to play something at the piano.

At the border things are even more tense. Team after team of customs officials, immigration officials, police, and soldiers pass through the car, asking to see our tickets for the third time, our passports for the fourth time, our visas for the nth time, and so forth.

After nearly an hour wait and no serious problem, the train lurches forward and we are heading into the final remains of Yugoslavia, thinking we are in the clear. Wrong.

Two very large and aggressive Serbian cops come into the car, pass by everyone, and stop squarely in front of us. They want my passport. They want to know what I am doing in Yugoslavia. They want to go through my bags, item by item. There is not much to look at. For some reason they are not interested in the laptops. Even more surprisingly they are not interested in the CDs, which are usually the touchy issue at borders. But these are police, not customs officials.

They are done with me. I breathe a sigh of relief, but then they turn to Jozef. Since Jozef is traveling with me, he is also under suspicion. Typically, a Slovakian traveling into Yugoslavia would not attract much attention, so Jozef did not pack his bags with the expectation they would be searched by Milosevic's police. But now he is traveling with an American. And in his bag, it turns out, is a cornucopia of modern-art *stuff*.

There are many languages in Eastern Europe. Almost no one can speak them all, but almost everyone speaks a little English. So Jozef and the cops discuss the contents of his bag in extremely broken English.

The cops find a packet of snapshots. "Vat is dis?" "Dis is pictures of exhibition at Andy Warhol museum." The flustered policeman carefully scrutinizes each of the photos for subversive content. Out come more and more photos,

programs from obscure Dada-esque exhibits, mementos of the extreme absurdism popular among Eastern European intellectuals. The cop examines each one as if it were a counterfeit hundred-dollar bill, scratching his head, squinting, but trying to maintain his aggressive and intimidating presence, which he accomplishes quite successfully.

Out come the lecture notes from Jozef's performance the previous night, an absurd and completely hilarious bit that featured Jozef lecturing about artists floating in space making art that emanates from their suits as electromagnetic waves.

The cop is now completely stumped. "Vat is dis?" "Dis is art lecture about artists in fvuture."

Next out comes the program from my show in Budapest. Oops. There is a picture from "War Games," which shows a stealth bomber looking like a giant bird flapping its wings. "Vat is dis?" "Dis is parody of American var games." Not good. Not the right photo. Not the right answer.

But worse is to come. "Vat is dis?" "Dis is article I vrote for Slovakian minority in Vojvodina." This requires some explanation.

Vojvodina is Serbia's northernmost province. Other than Kosovo, it is the only area in Serbia with significant minorities, and, unlike Kosovo, there are many: Slovakian, Hungarian, Croatian, Gypsy, and more. Like Kosovo, Vojvodina enjoyed considerable autonomy until Milosevic came along. It is conceivable that at some point in the future Milosevic will have a problem with Vojvodina on the same scale he has now in Kosovo. But the police are Serb, and for now they have everything in hand. Some of these police, in fact, are standing right in front of me. They don't like minorities, and they particularly don't like the idea of foreign intellectuals stirring up the local minorities.

Not that Jozef is going to stir anyone up. Jozef's work is all about absurdity and impossibility, about Andy Warhol and pianos in ashtrays. But these subtleties are beyond our policemen, who are looking increasingly unhappy.

Back to Jozef's magazine for the Slovakian minority. The cop doesn't believe such a magazine exists. (Slovakians read magazines?) Jozef produces a copy.

Finally, the police are gone, and Jozef and I relax. Okay. I am in. The only American artist in Yugoslavia. Maybe, with Jozef, the only foreign artists in Yugoslavia.

I look around. Not surprisingly, the train is almost empty. Very few people want to go to Serbia now, and the few that want to cannot get visas. The countryside is typical of this part of the world: farms and fields in every di-

rection. Huge bunches of wheat in rows. Farmers with tractors and even an occasional elevated irrigation system are interspersed with farmers on foot using handmade tools. You often see these solitary figures walking through a field or on a road with no buildings or vehicles in sight. These are people who walk a very long way.

Novi Sad is the capital of Vojvodina and our first destination. I am to be picked up by car in Novi Sad and taken to Beograd. After the Beograd concert I will be driven back to perform in Novi Sad before finally leaving Yugoslavia.

But just as the train pulls into Novi Sad, the police are back. "You," they point to me, "and you," they point to Jozef, "must come vit us to police station in Novi Sad." Without further discussion we are marched to the very back of the train. This is seriously not good. In a rational sense I am not afraid. My visa is in order. My invitations are in order. It is not credible that the Yugoslav government would find it in its interest to create an international incident over a visiting American musician. On the other hand, many things have happened in this land that seemed scarcely credible, and I do *not* want to go to the police station in Novi Sad. I am feeling very alone. After all, the United States was not the only country to break diplomatic relations with Yugoslavia. There is hardly a Western embassy left in the country. If I am in trouble, there is no one to go to for help.

The one thing between us and the police station is the concert organizers who are supposed to meet us at the train station. I hope they got the message that we would be on this train. I hope they are on time. I hope I will recognize them. But when the train stops we are led out the back door and into a dark area away from the small crowd on the platform. Just before disappearing into the blackness I blurt out that I just need to tell the people who are waiting for us where we are going, and I head off in the opposite direction toward the light and the voices, with the startled police following close behind.

"Bob Ostertag?" A face materializes out of the crowd. "Velcome. How are you?" "Fine, fine, just a small problem with the police," I answer, motioning to the cops following on my heels.

A short time later Jozef and I are seated in an Italian restaurant on the main square of Novi Sad. Seated in a semicircle facing us are Elza Vuletic; her technical director, Arpad; and two other men. Boris and Olya, who came from Beograd to pick us up, have been banished to their car. "Shouldn't we invite them in, too?" I ask. "They have nothing to do with this," Elza re-

sponds. "They are just drivers." So for the next hour, while Jozef and I warm up over cappuccino, Boris and Olya freeze outside in the front seat of their unheated Yugo. Apparently the bad blood between Beograd and Novi Sad extends even to cultural organizers.

Typically, upon arriving in a town for a concert, a touring musician exchanges a few pleasantries with the organizers, visits the venue, goes over some tech, and goes to the hotel to freshen up. But any sense of pleasantry evaporates when, first thing, Elza looks me straight in the eye and says in an icy voice, "So, do you really think you have anything to teach us about the bombing?"

It dawns on me this is less a friendly cup of coffee than an interrogation, by five very angry people who want to know why the hell I am there and what I have to say for myself. They watch my every move, my every twitch. I try to explain. I am not there to teach anyone anything. I was opposed to the bombing. I have written a piece about the crazy conflict of our cultures I want to perform for them.

It is heavy going. In part they are testing me, probing this stranger in a place where no one visits. And in part they are, in some very small way, starting to spill their guts about the horrors they have recently gone through, and which they have had no chance to share with anyone who did not go through the nightmare with them. And in part, as I learn much later, they are testing each other, but that is getting ahead of the story.

People in Vojvodina certainly have reason to be angry. Vojvodina is Serbia's *other* multi-ethnic, formerly autonomous stronghold of opposition to Milosevic, but NATO rained more bombs down on them than any other part of Serbia. Their once-beautiful bridges now lie in the Danube blocking boat traffic. (A new locally produced postcard proclaims, "Novi Sad, where the Danube runs *over* the bridges.") No bridges were bombed in Beograd, where NATO hit the Ministry of Defense, the state television, and other military and political targets. In Novi Sad they hit the bridges, the power plant, the oil refinery, and the cigarette factory.

There were no militarily strategic targets in Novi Sad. Kosovo is at the southern tip of Serbia, Vojvodina at the north, as far from the fighting and refugees as one can get. Not once in ten years has the region voted for Milosevic. But NATO decided not to fight a war in Kosovo, but rather to bomb Milosevic into submission by destroying Serbia's industrial infrastructure, much of which happened to be in Novi Sad.

I remember back to my days as a journalist in El Salvador. Economic sabotage played a key role in the rebel strategy to overthrow the U.S.-backed

regime. The sabotage consisted mostly of blowing up electrical poles and small bridges with homemade bombs. And every time the guerrillas did so, the American embassy would trot out some talking head to condemn the act. Bridges and civilian infrastructure, they would tell us, were *not legitimate military targets.* Though I was quite sympathetic to the rebels, I agreed with the embassy on this point. Counterproductive, too: the rebels lost enormous popular support over it.

In Novi Sad, we're not talking about a local militia member strapping a homemade bomb to the electrical pole on the corner. We're talking about high-tech bombs that explode above ground, spreading magnetic junk specifically designed to take out major power installations. The war is over, but when the wind comes up the junk blows around and more damage ensues. All this is in the isolated and bankrupt Serbia of Slobodan Milosevic. There is no money to rebuild much of anything that was destroyed.

We arrive with the first chill winds of winter, which bring the Serbs face-to-face with a very harsh reality. The coming winter is going to be hard. There is no heat in Novi Sad, and the electricity is intermittent. The weather is not improving anyone's mood.

Finally, the people from Beograd have had enough of sitting in the cold. They come and rescue Jozef and me from our interrogation. We pile into the tiny Yugo with no heat or defrost and speed into the night toward Beograd.

Olya, a thin, beautiful young woman who does not say a word, is driving. A very tall string bean of a man named Boris who looks to be in his late twenties does the back-seat driving and talks nonstop. Together with the cop, that makes two really tall Serbs I have met already. I remember how the NBA is stocking up on Yugoslav basketball players.

Boris is a student. He is full of opinions, and he hates Milosevic. He doesn't want the War Crimes Tribunal in The Hague to get their hands on Milosevic, because they have no death penalty. Yet as the conversation develops, it becomes clear that his hatred of Milosevic is of a particular sort.

Boris lives with his parents. His father is a colonel in the Yugoslav (Serb) army. A "war hero" in the last war, according to Boris. (I briefly wonder how one becomes a hero in a war where one side just picks on civilians and the other side launches missiles from hundreds of miles away.) The family lived on a military base until the beginning of the bombing, at which point they moved into a friend's house, since the base was expected to be hit. Now the war is over, but the family is still squatting with friends. Apparently Milosevic lacks even the resources to find housing for decorated army colonels. Boris's

anger at his housing situation is multiplied by his feelings for his dad, whom he clearly worships, and the result is a deeply felt rage.

What he hates most is his country's isolation, and he dreams of getting out. The first chance he gets, Boris is out of here and not looking back. He doesn't want to go to demonstrations, doesn't want to fix anything, he just wants to leave. And when he gets to the West, he is going to buy a nice car. This is what he really wants to talk about, what kind of car he will get in the West.

Unlike the people we left in Novi Sad, Boris is very up-to-date on the international music scene of which I am a part. He is the first fan I have ever met who wanted to talk to me about hot cars. Somehow, in the midst of all the extremes and contradictions I am surrounded by, at the moment this is the most jarring. But this is nothing compared with what comes next.

After cars, Boris wants to talk about John Zorn. Would I please tell him everything I can about John Zorn. John has been a close friend and colleague for twenty years. From the obscurity of the avant-garde, John has shot up to a celebrity status previously unimaginable for "one of us." As a result, everywhere I go people want to talk about John.

Finally, I say, "You know, I have collaborated with dozens of extraordinary musicians, but everywhere I go people only want to talk about John. I wonder why that is."

Without a moment's hesitation, Boris answers back, "Because he's Jewish." I am dumbfounded.

"But, he's industrious, not lazy. So it's fine," Boris continues. "Many of them can be like this. I have no problem with them."

To get to Beograd, Olya has to negotiate one of the scariest roads on which it has ever been my misfortune to travel. The highway to Beograd was a grand idea that was never completed, as the Tito regime ran out of money in the 1980s. It was intended as a four-lane divided highway, but only one side was built. Traffic in both directions now squeezes onto the same half. The oncoming traffic is taking one good lane. Traffic going our way drives on what was intended to be the shoulder. The other actual traffic lane, between us, is used as a passing lane for cars going both directions. The result is a constant game of chicken that involves everyone on the road.

Major unrepaired potholes are everywhere, but do the holes and the soft shoulder make anyone slow down? Not in the slightest. We drive as if we were out on the German autobahn. Each near miss or thud from a pothole elicits fresh curses or expressions of surprise, but the velocity of our little chunk of metal hurtling through the cold Balkan night remains constant.

Before falling asleep at the hotel, Jozef and I exchange notes just long

enough to agree on one thing: in no case should Richard come to Serbia. We both have the exact same reaction when imagining Richard—technically skilled, socially provincial, politically naive—on his own with the people we had just met in Novi Sad: they would eat him alive. I decide to call first thing in the morning to tell him to stay put.

Monday, October 18
The new day brings a whirlwind of activity as different in feeling from what I had been through in Novi Sad as one could imagine. Despite everything, Beograd is still a busy city, and no part of it was busier than the offices of Free B92, where I spend most of the day.

Free B92 is the only major independent media functioning in Serbia. It encompasses a radio station, a Web site, and TV shows that are passed by videocassette among several local stations around the country. In the beginning it was known only as B92, a lone voice of authentic opposition. Milosevic got his money's worth by making sure everyone knew that *he* was allowing something as critical and sharp-edged as B92 to operate, while in neighboring Croatia, with whom Serbia had been at war, the *other* butcher of the Balkans, Franjo Tudjman (whom the United States supports), allowed nothing of the kind.

But that war was over. When the war with NATO started, Milosevic's goons marched into B92 and took it over. The workers were free to stay, in fact, strongly encouraged to stay, because the goons knew nothing about running a radio station. But from then on, party hacks would be in charge. The story went that the new director decorated his desk with a framed photograph of himself with Milosevic, a photo that was an obvious montage.

The staff would have none of it, and within weeks *Free* B92 was on the air, operating from different premises a few blocks away, with a frequency sublet from another radio station. The hacks were left in an empty office broadcasting taped music all day, admiring the faked photograph of their boss with *the* boss.

To an urban Western radical like me, Free B92 is a sort of Shangri-la. In a country run by a bona fide war criminal, they fearlessly tell the truth. Their use of the Internet is pioneering. The sophistication of their ideas about media, politics, and culture is second to none. Their shows are very popular. People actually listen to them. They're young, hip, and good-looking. They've got style for days. They manage to mix real politics with real music. And we're not talking Pete Seeger or Tracy Chapman. We're talking *my* music, which gets no airplay *at all* in my home country.

Amazingly, they seem pretty excited about me, too. Suddenly, I am transformed from obscure avant-garde artist into minor celebrity. By the end of the day, I have done three television interviews, four radio interviews, and one newspaper interview.

Everywhere people seem somewhat incredulous. First, that I have made it there at all. Second, that I wanted to come in the first place. Third, that I have actually done my homework and can discuss the breakup of Yugoslavia in a nuanced way.

People in Beograd have a unique take on the most recent war over Kosovo. They were not bombed as heavily as the people up north. There has been no fighting there like down south in Kosovo. Their direct experience of the war was limited to the long-range missiles and bombs that fell. And the highly accurate and selective targeting of these weapons made that experience into something of a show.

As it was first explained to me, "If you were in a pub drinking a beer, and a missile hit your car outside, you would just go on drinking." The point being that the NATO bombs were so accurate and selective that ordinary people could go about their lives, after a fashion. Several people told me stories of smoking pot on their balconies while watching bombs fall and anti-aircraft guns shoot tracers.

The remains of the war one sees around Beograd lend credence to these stories. Buildings tied to the Milosevic regime or to the army stand in various stages of rubble, while the buildings next door on either side seem untouched. (In Novi Sad, a floating restaurant at the foot of a formerly majestic bridge that is now crumpled in the Danube did not even sustain a broken window.)

This almost artificial character of the war in Beograd leads to the wildest conspiracy theories. Everyone has one. No intrigue is too far-fetched. My first night in Beograd the concert organizers take me to dinner. Over pizza and the Spice Girls blaring from the Muzak system, they explain to me how the war was fake: a theatrical, phony war contrived by Milosevic and Bill Clinton working in cahoots behind the scenes for their mutual advantage.

One hears more and more of these stories. They differ wildly, but if you add all the conspiracies together, and subtract those details that do not match from one story to another, what you are left with is this lowest common denominator: the war had two players, Bill Clinton and Slobodan Milosevic, and one set of victims—the Serbs. Kosovars just don't figure in the math.

A few weeks before my arrival, the opposition had announced it would

hold nightly protest marches against the regime until Milosevic resigned. But that was before it became clear how weak the opposition is. Not weak in numbers—very few Serbs actually support the regime anymore. But the opposition is divided. There is a huge gulf between those who hate Milosevic because he is a war criminal, and those who hate him because he lost the war. There is no alternative politician who arouses anyone's passion. And in the meantime, Milosevic has made it clear he will not leave without bloodshed. The state media continually warns of the possibility of civil war.

As a result, every last person I meet in Serbia is pessimistic and depressed. This, truly, is a country—or rather, one part of a former country—that has just lost four wars.

There seems to be a generational response. Boris and the twenty-some-things think only of leaving. Bojan Djordevic is Boris's thirty-something boss and the chief organizer of my concert. Bojan is a wonderful, soft-spoken man with a gentle manner, a lawyer by vocation and a concert organizer by avocation. Bojan is not going anywhere. Bojan is old enough to remember communist Yugoslavia, and somehow the result is a lasting political commitment to his country. "These younger people, they just want to leave," he explains with a heavy air of resignation. "I understand why, but it is sad. My generation wants to stay and somehow set this situation right."

The memory of communist Yugoslavia is a fascinating piece of the current patchwork of political life. I ran a highly unscientific opinion poll, asking everyone I met in current and former Yugoslavia what they thought of Tito. Stacked against one negative reply were dozens of positive responses. In fact, "positive responses" doesn't really get it: there were many forthright expressions of love. From Serbs, Slovenes, and Croats. I try to imagine an American president staying in power for forty years and people still loving him. Nope, can't do it.

Everyone reminds me that Yugoslavia was the only communist country with an open border to the West. While East Germans were risking death climbing over the Berlin Wall, Yugoslavs could come and go as they pleased. In fact, given Tito's role as founder of the Movement of Nonaligned Nations, a Yugoslav passport was possibly the easiest passport to travel with in the world. Many Yugoslavs took regular advantage of this fact, as did many criminals—Yugoslav passports may have been the most frequently stolen in the world.

There never was an anticommunist revolution in Yugoslavia. No one was itching to throw off the yoke of Bolshevism. What there was instead was an

extremely rapid decline of the Communist Party's credibility after Tito's death. When "democratic" elections finally appeared on the agenda, the only card the party had left to play was blatant, aggressive, violent nationalism.

Now every night, people march through downtown Beograd to demand Milosevic's resignation. I accompanied my friends from Free B92. Despite the reduced numbers from just a couple of weeks ago, there is still energy crackling in the cold night air. People whistle, boo, and shout slogans. "Slobo-Saddam, Slobo-Saddam," seems to be the one that touches the deepest nerve.

The march ends up at the square where the club at which I will perform sits, which bodes well for the turnout at the concert. I break off and go in to set up my instruments. I get a message that Richard is in Novi Sad. My heart sinks. Somehow, he got a visa in Budapest and crossed the border (without the instruments, as I had hastily instructed). But there is no time to even *think* about this now. He is on his own.

I boot the two laptops, one for audio and one for video, and disaster strikes. In all the chaos and stress, I had completely lost track of the fact that the second laptop, which until now had only been along as a backup, had not been turned on since its fall from the wall back in Koper. And in fact it is damaged. It doesn't boot properly and exhibits various kinds of erratic behavior. With time winding down, I go through yet another round of extremely stressful last-minute high-tech fiddling. Finally, the computer is at least partially working. Every time I reboot, the system manifests a new kind of weird behavior, so if for any reason I have to reboot, there is no assurance I will be able to get it working again. But as long as no one touches it, the concert *might* be okay.

Despite the fact there has been very little publicity, since no one knew exactly when or if I would arrive, an overflow crowd appears. There is also Free B92 TV, radio, and newspaper. To say that I am nervous would be an understatement, but at least the nervous tension is picking me up out of the lethargy of my cold.

I start the show and play an improvisation that the audience seems to be quite excited about. Then I do "War Games," which is a disappointment. It may have been the tension, or the fatigue, or being sick, or the malfunctioning of the computer, but it is the worst version of the piece I have done. Combined with the fact that it really was intended as the opening statement for a finale that is missing, this leaves me with a bitter taste about the show. But the audience is appreciative, and there are more TV and radio interviews to do.

The moment I finish the show another tall Serb strides across the stage and is in my face. "I tried so hard to forget about these things," he tells me, "and now you bring them all back."

"I hope I have not offended you," I reply.

"No. No, not at all," he responds. "Thank you. Thank you very much." He warmly shakes my hand and turns and walks away.

Tuesday, October 19

Up early in the morning and off for Novi Sad, with Olya again at the wheel of her beat-up car with no heating. Only this time it is pouring rain, and the broken defroster keeps her new companion busy trying to maintain at least a modicum of visibility by wiping the window with his hat. Through the foggy windows, I perceive a disconcerting feature of the road I had missed in the darkness of night on my way in: the sides of the highway are strewn with the metallic carcasses of numerous car wrecks.

In Novi Sad, we find the theater, and find Richard inside having a very tough time of it with our hosts. Richard, it turns out, had his own travel difficulties on the way in to Serbia. Police pulled him from the train at the border for interrogation in a room somewhere in the train station. Where was he going? Why? Who was he meeting? And the cop kept asking if he wanted a Yugoslavian dinner. Richard thought this was not a good sign, since at first they had told him it would take only a few minutes. But, being the exceedingly polite and open person that he is, he responded each time by saying, "Thank you, you are too kind, but I have sandwiches in my backpack." What Richard did not know was that the Yugoslav currency is the *dinar*. The cops wanted money, and Richard was offering them sandwiches. Evidently, at some point it was determined that Richard was not a threat to the security of Yugoslavia and he was sent on his way.

Upon arrival in Novi Sad, Richard landed on the same hot seat I had encountered, but there was no car waiting to rescue him away to Beograd. Richard is an excellent lighting designer and theatrical technician, and a generally wonderful person, but politics has never been his thing. His knowledge of Yugoslavia is limited, as is his experience in travel of any kind or dealing with people from other cultures. But Richard spent the evening at Elza's surrounded by the same crew that "greeted" me the night before. There was no heat, and then the electricity went out. Huddled around a candle, he tried to answer the questions. "Why did you bomb our oil refinery? Why did you bomb our cigarette plant?" It was a very long night.

When I arrive at the theater, however, there is little time for catching up.

The show is scheduled to start in just hours. I pull the laptops out, boot them up, and discover that the one that took the fall in Koper is functioning more erratically than ever. Time for more frantic computer fiddling. Eventually I decide that maybe the memory chips were knocked loose in the fall. Using only Richard's Swiss Army knife for a tool, we start dismantling the computer right there on the stage.

An exceedingly drunk Serb walks up on the stage, announces he is an artist, and watches our work. "Vat are you doing?"

"Trying to fix this computer." The situation is tense, and time is running out. The last thing we want to do is humor this drunk, but we are not sure how to make him go away.

"It's broken?"

"Yes." We are trying our best to ignore him.

"How?"

"Someone dropped it in Koper."

He gets a wild light in his eye. He grabs our laptop by the screen and raises it over his head as if ready to smash it on the floor.

"Vell, if a Slovene broke it, hey, I am Serb. I should *destroy* it!"

"No No! NO! Please put the computer down!"

"No, you don't understand. If a Slovene broke it, then a Serb should really SMASH IT TO BITS."

It is difficult to tell if he is really going to smash the computer on to the floor, but he is holding the thing by the lid, and it is certain that his thumb is about to go right through the screen. The guy goes teetering about the stage with the computer over his head and Richard and me trailing, pleading, "*Please* put the computer down."

We finally get the computer back and the man staggers off, but things do not improve. We coax and curse and blow on it and reboot over and over, but this computer is toast. I explain to Elza that we will not be able to do any part of *Yugoslavia Suite*. There are two options, I continue. I could do a concert of improvised music on the one working computer, or we can cancel the show.

Now the real trouble starts, as it becomes clear whom we are dealing with. It turns out that the man who first agreed to present the concert, an artist friend of Jozef's, had left Novi Sad for Stockholm. He passed the job of hosting our show on to Elza, and Elza passed it on to the Cultural Center. And the Cultural Center staff is straight out of central casting for the role of Balkan bureaucrats. They never smile. They are stern and seem constantly annoyed. More importantly, they do not seem to understand why we are here, they don't like us, and they definitely don't trust us.

Arpad is the man from the center to deal with, and Arpad decides we will postpone the concert until tomorrow night. This makes no sense at all. The computer is not going to fix itself overnight, and in any case we are scheduled to leave the next morning. But the decision has been made, the audience is asked to come back the next night, and soon Richard and I are upstairs in the office, in another meeting that feels more like an interrogation.

Arpad does not actually believe that the computer is broken. He keeps asking us why we do not want to do the concert. What he imagines we are "really" doing is not at all clear, but he finds our whole project fishy. By this point Richard and I are thinking that even if the computer worked we might not *want* to perform *Yugoslavia Suite* in Novi Sad, but we certainly don't say so, and it is a moot point, anyway.

Arpad announces that overnight they will find us another computer. I try explaining that this is far-fetched. The computer we have is quite fast, stuffed with an extraordinary amount of memory, and includes special video hardware I am sure he cannot find in Yugoslavia.

Arpad produces Sinisa Sremac, a chunky fellow of about twenty-five who has got "hustler" coming out of every pore. Sinisa produces a cell phone and announces that with a quick call he can produce any computer I wish for. I give him the list of our requirements. After a few phone calls, he admits it may take a bit longer but promises he will have it in the morning. I reiterate my view that we are on a wild goose chase, but refusing their offer of a replacement computer and heading for the train station does not seem to be a realistic option.

Off we go to an uneasy dinner. I spend most of my time conversing with Elza, whom I am starting to warm up to. She is tough as nails, with a pronounced masculinity about her that in the United States would be misread as "dyke" but in Novi Sad just means that she is up to the struggle of daily life. We discuss Milosevic and his wife, whom they hate even more than him. They say she is more hard-line than he is and that he is completely dependent on her, calling her more than ten times every day. I mention that I am often skeptical when the wives are blamed for the shortfalls of political couples. "No," Elza firmly replies. "I completely understand this thing of a woman dominating a man."

As much as they hate Milosevic, it is difficult to engage them in a real way. Nothing bad happened in Kosovo, they are quite sure. They know it from a neighbor boy who was drafted. As for Bosnia, Elza flatly declares that "ethnic cleansing never happened." It is disconcerting to hear such a statement from an obviously intelligent and well-informed person.

Richard and I go to bed in a hotel that, like everywhere else in Novi Sad,

has no heat and no hot water. We are counting the minutes until we can leave Novi Sad. Unfortunately, we don't know when this will be.

Wednesday, October 20

Back at the Cultural Center in the morning, Sinisa reports that he cannot get the video hardware we need. (Oh, really?) He is shocked there is a computer item he cannot get and has ordered one just to prove to himself and anyone who will listen he can get it. But it will take three days at the earliest to arrive.

Just when Richard and I think we are off the hook, Arpad and Sinisa announce Plan B: they will *repair* our computer. I try to explain that this is the latest model Apple laptop, that we have already checked to see if the memory is loose, and that what really needs to happen is that it should be sent back to Apple.

Our hosts take this as an insult. We Americans do not understand the industriousness of Novi Sad, how people here learn to make the most of the little they have and to find substitutes when the thing they need is unavailable. "We have really good hackers here in Novi Sad," Sinisa counters. "Just give me your computer. In three hours I will bring it back working."

There is no way I am going to let this shark walk off with my computer, so soon Sinisa, Richard, Arpad, and I are packed into a car racing across Novi Sad to hacker central. I am there because I want to be with my computer. Richard is there because he doesn't want to be left alone at the center. And Arpad is there because he wants to keep an eye on us. All the time we are in Novi Sad, Arpad is there, watching our every move. If he isn't there himself, he has someone else there for him.

We pull into an apartment complex of towering gray cinderblocks like communists built all over Eastern Europe after the world war. Up the rear elevator to the top floor. An apartment door opens and here we are. Hacker central. The room is full of computers, very late-model ones at that. A laptop like ours (minus the video hardware) is sitting on a table. "Nice computer," I comment.

"Yah, it vas stolen in Germany," Sinisa replies.

They have an Internet phone hookup and insist that I should make a "cheap" call anywhere I want. But, oops, their account is empty. Do I have a credit card? Yes? Just type in your numbers there. Good. I never did manage to make the call, but they got $25 off my credit card for their phone line.

They bring us coffee, and we sit and sip at a coffee table piled high with computer mail-order catalogs and gun magazines, surrounded by whirring

disks. They point out a field outside the window where several Tomahawk missiles fell during the war.

And then we meet the hackers. The hackers are worth the wait. These are serious kids, doing amazing things. So amazing, in fact, that we had to promise not to discuss their work with anyone.

Despite their skills, of course they cannot fix my computer. But Arpad is still unconvinced. Back in the car and off to another hacker joint we go.

Finally, it is late in the day. We are back in the office at the Cultural Center, and I am facing the same interrogation team I was facing last night. Arpad has finally gotten it: the computer is broken. It is not a trick. I am not faking it. There is no subterfuge. It just got dropped by a drunk Slovenian rock star.

"So, vat do ve do now," he spits out.

Once again, I repeat, word for word, what I had told him last night: that I can do an improvised music concert, or we can cancel the whole thing. I remind him that we are doing this for no money, not even travel expenses. I add that I am an internationally known composer, with fourteen CDs of my music released, and that video is a recent addition to a career of concerts of mostly improvised music.

Arpad crosses his arms, leans back, squints his eyes, and, in the iciest tone he can muster, says, "Vat *kind* of music?"

People have been asking me this question since I was in junior high school, and I have never found a satisfactory answer. Avant-garde? Too academic. Experimental? Not really. Computer music? I *hate* computer music. Lately I have settled on Unpopular, but I don't think Arpad would get it. So I hand him a CD. "Listen for yourself." Arpad recoils from the object in horror.

Finally Arpad decides I should play. An audience about half the size of the previous night comes. We explain the situation. I play. Before the concert Arpad insists on coming onstage to tell me the way I am setting up my software and sound is completely wrong. At this point I sort of snap. I mean, I *wrote* this software. What is he talking about?

After the concert I grab Elza and tell her we need to talk. She is the one person in Novi Sad I feel any real connection with, and I have actually come to like her a lot. She takes me into her office:

> Elza, you gotta cut us some slack. There are millions of Americans, and Richard and I are the only ones that came here. We've studied the politics, made this concert, got the visas, and asked for no money, just to show some art and have some kind of a dialogue. But you all haven't trusted us since the moment we got here. You don't believe us when we say the computer is bro-

ken, you watch us. I *told* you from the beginning that trying to fix this was a waste of time. And now Arpad tries to tell me how to use my own software.

I go for broke.

And as long as I am telling you what I think, I gotta say I think ethnic cleansing *happened*. You are a smart, well-informed, and honest person. I respect your opinion. But I have done my research, too, and it *happened*. It was very real and very, very bad.

Elza doesn't flinch. She speaks very quietly. She explains that the center people have been bothering her, too, but since she technically does not work for them there is little she can do.

"But if you really knew the computer was broken, why did you go along with all this effort to fix it?" she asks.

"Elza, think about it. No one believed me. I honestly didn't know what would happen if I had announced we were leaving."

"Bob, you don't understand the Serb mentality. If that is what you really thought, you should have said so, and told them, '*If you don't believe me, I am going to drop seventeen more Tomahawk missiles on your heads!*'"

"Elza, you know I couldn't do that."

She knows. "And as for ethnic cleansing," she adds, "maybe I am not as well-informed as you think I am."

We talk more. She tells me she is actually Croatian but married to a Serb. I note that Croatian forces were guilty of crimes as heinous as those committed by Serbs. She asks me to send her any good documentation I have on ethnic cleansing. I feel very close to Elza, a very good person in a very tough situation.

Thursday, October 21

We finally leave Serbia. Richard is so happy I think he might break into song. I am mostly feeling tired and sick, but I am looking forward to hot water. When I think back to how Elza had one position on ethnic cleansing when in the presence of the men from the Cultural Center, and another one in private, I decide it was fortuitous that we were unable to perform the complete *Yugoslavia Suite* in Novi Sad, and probably even in Beograd. A project like ours assumes the existence of at least the minimal amount of political space necessary to have the dialogue the art is about. In Serbia, that space did not appear to exist.

The tour continues through Eastern Europe and into the West, ending in

Bern, Switzerland, the tourist capital of the Alps, where everything is neat and tidy and the Balkans are far, far away.

We have the working computer back. We discover that, given appropriate conditions, our show is actually quite easy to set up and perform. Free to concentrate on the work, the concert improves to the point we are very happy with it. As the shows improve, so does my health.

I haven't sent Elza the materials I promised on ethnic cleansing. She is quite Internet-savvy, and there is documentation all over the Web when she is ready to find it. I would love to see her again, but not tomorrow. Some time needs to pass.

On the other hand, I am in regular touch with Bojan from Free B92, and also Marko Kosnik, with whom I am discussing a possible collaboration. And I sent a copy of my favorite Brecht poem to Marko Brecelj:

> I stood on a hill and I saw the Old approaching, but it came as the New.
> It hobbled up on new crutches no one had ever seen before, and stank
> of new smells of decay no one had ever smelt before.
> The stone that rolled past was the newest invention and the screams
> of the gorillas drumming on their chests set up to be the newest
> musical composition. . . .

Back home in San Francisco, I turn to my next project: a multimedia collaboration with a Salvadoran playwright about a Salvadoran war veteran who is homeless on the streets of Washington, D.C. At this time next year, we hope to be touring it in Mexico and Central America.

—December 1999

POSTSCRIPT

Excerpts from this journal were published in the British music magazine *The Wire*, followed by numerous letters to the editor both supportive and critical. The responses I really cared about, however, were from Elza Vuletic, the Croatian woman living in Serbia who hosted the concert in Novi Sad, and Aleksandra Kostic, the Slovenian art curator who had told me I should not tour my performance in the Balkans. Two strong, smart, opinionated women.

> Dear Bob,
> I have read your article very carefully. I cannot comment on it yet. In some parts I felt bitter, in others I completely agree with you. In some situations I

think you misunderstood me, in some others you understood me better than I understand myself. Anyway, you are right in one thing: There should be some time until we really realize what was happening. I just hope it will happen soon. I wish you all the best in your private and professional life. And truly I am sorry you did not perform *Yugoslavia Suite* in Novi Sad.
Elza

Dear Bob
Final conclusion: yes, you certainly are an American and no, we are not Yugoslavian any more—unfortunately. Maybe you haven't noticed that my and older generation are deeply nostalgic for Tito's Yuga. It was a special time. Ruining it with terrible human sacrifices is a tragedy difficult to understand. Such a hate is born from a deep love, I believe this.
Best,
Aleksandra

I should also note that Aleksandra and I have become close friends, she has stayed with me at my house in San Francisco, and I have returned to play

Bob Ostertag in Novi Sad, Serbia. Bridge destroyed by NATO bombing in background. Courtesy of Richard Board.

in Slovenia at Kibla, the venue she is associated with, once a year. In 2000, Marko Kosnik organized an ambitious if somewhat chaotic symposium for Balkan artists at which I spent several weeks teaching. And Elza and I maintain a warm correspondence. At the personal level, at least, the dialogue I had hoped for has in fact taken place.

POST-POSTSCRIPT

The reaction of several friends of mine who have read this journal can be summed up thus: why? Why were you so insistent on going to Serbia, as the obstacles mounted and it became an increasingly questionable call as to whether it was even a good idea in the first place? What did you really hope to accomplish? I have asked myself these same questions.

Past a certain point, these kinds of pursuits lose any sense of rational calculation, and you do them simply because you know you have to. It is the same reason why Ali Janka, despite all common sense, surreptitiously removed the window glass and stuck a balcony off the Ninety-first floor of the World Trade Center (see "Art and Politics after September 11," page 2 in the Introduction), why Jim Magee sank a small fortune into a monument to nothing in the west Texas desert (see "Desert Boy on a Stick," page 105 in Chapter 3). But it is also why my friend in Central America stayed involved in the revolutionary movement even after he knew that "if these guys ever actually come to power, I am quitting that very day to form an opposition" (see "Creative Politics," page 54 in Chapter 1). Here again, the difference between art and politics fades away until it vanishes. When one pursues these endeavors beyond the point of rational expectation of return—this is where one leaves the continuum that has "hobby" at one end and "career" at the other and enters instead into what I am awkwardly calling, for lack of a better term, creative life.

Program Notes for *Yugoslavia Suite*

The following are the original program notes from the Balkan tour of Yugoslavia Suite *following the NATO bombing of Serbia.*

■ ■ ■

Perhaps it is a crazy idea that an American artist should go to the Balkans in the wake of ten years of war culminating in the NATO bombing. What could an American, coming from so far away and knowing so little, have to say to

those who lived through these experiences every day? Isn't this part of the problem, that Americans feel they can sit in judgment on faraway peoples? [. . .]

I do believe that we live in a global community, in which we are called upon to reflect on, and take positions on, events in faraway lands.

I come to this from the position of an American citizen, whose government is unique in the world at having amassed the technological means to project military power anywhere in the world, at almost no risk to itself or its soldiers. The recent bombing of Yugoslavia was the first time that American spokespeople explicitly articulated a moral position vis-à-vis this capability: that there are causes for which Americans should be willing to kill, but not willing to die. A truly shocking development.

I also come to this as an artist who has used technology extensively in his art. It is striking that the technology NATO used to bomb Yugoslavia is the same technology I use to make music, which is also the same technology used to make the computer games that simulate real-life wars.

This is a historically new development. The technology used to make, for example, violins, soccer balls, and automatic rifles couldn't be more different. But today, the tools we use to play, kill, and compose music are the same.

I have even worked personally with an instrument designer who, when his musical work doesn't keep him busy, supplements his income by selling the same technology he develops for music to NASA (the U.S. government agency that builds satellites and rockets).

"War Games" is a reflection on this new reality. The video mixes footage of computer games you can find in an arcade or play on a home computer, computer games the U.S. military uses for training airplane pilots and tank personnel, actual footage of bombing missions in the Balkans, and various images from American television.

As a member of the audience it will be difficult to tell which is which. Not to worry: neither can anyone else. As I learned doing the research for this piece, the experience of playing a fighter-bomber computer game is now so similar to the experience of actually bombing a real city that the U.S. military views recruits with extensive experience playing computer games as particularly promising.

Or take a gunner in a modern tank. Even in actual battle, when he pulls the trigger he is not looking at the target he is firing at, but at a screen showing an animated computer version of the target, the same image most of us associate with computer games. In fact, in many cases a child playing a game is looking at a more realistic image than a soldier firing a weapon of enormous destructive power.

Still images from performance of *Yugoslavia Suite*. Video projection of live disembodied hand choreography.

"These Hands," by contrast, is a reflection on the "old-fashioned" kind of war, which recently occurred in, for example, Bosnia. The kind in which killing happens at a distance of three meters instead of 30,000, and perhaps there is even eye contact between the executioner and the executed.

I have experienced this only through the mediation of American television. Thus this work is perhaps more accurately described as a reflection on the experience of watching these images flashed around the world by satellite to my TV. And this again is of course the same digital technology we just discussed.

I have no idea how these works will be perceived by people whose experience has been at the opposite end of this technology: who saw the real bombs really explode, and lost real friends and real homes, and now worry whether their water is really safe to drink, and their air really safe to breathe.

We sit on opposite sides of a technology chasm unfathomably wide. My hope is that these performances will be part of a dialogue across that divide.

Many, many thanks to the many friends in the Balkans who have done so much to make this tour happen.

Yugoslavia Suite was commissioned by Real Art Ways, an alternative art space in Hartford, Connecticut, USA.

queers

Desert Boy on a Stick

This chapter began as a radio portrait of Jim Magee and Annabel Livermore commissioned by the Kunstradio program of ORF Radio, Vienna, which was broadcast on June 8, 2002.

■ ■ ■

Desert boy on a stick,
bent, broken, beaten, battered, baked
no fake that boy . . .

El Paso, Texas, is a border town if there ever was one. Together with Juarez, Mexico, it is one big, poor, dusty city of two and a half million cut down the middle by the Rio Grande. The drive out of El Paso to the hill takes you through an arid high-desert landscape. Vistas stretch for hundreds of thousands of acres as far as the eye can see. Overhead the sky extends even farther. Look ahead and you can see one hundred miles into New Mexico. Look behind and you can see one hundred miles into old Mexico.

An hour or so of driving gets you to the town of Cornudas, population three (or four) (sometimes five). A truck stop really, with an old covered wagon, a gift shop with wooden Indians and portraits of Elvis on velvet, Lyndon LaRouche political handouts, Texas-sized hamburgers, and a Texas flag. When they first put up the flag, they flew a Puerto Rican one by mistake. Some trucker must have noticed the discrepancy, and now Cornudas salutes an American state instead of an American colony.

The storms that often blow through here are biblical in scale. "I love the taste of this sand in my mouth," Jim Magee muses. "It's very Old Testament. From this very spot, if we were to continue driving due east, we would end up in Jerusalem. How much gas do you have?"

First you go to El Paso, which is nowhere, by art-world geographical reckoning. From there you head a hundred miles or so to Cornudas, which is nowhere by most anybody's reckoning. Turn off the road somewhere near Cornudas and head out into the desert on some faint tire tracks in the dirt, and you arrive at the hill.

Just what the hill is is difficult to pin down, even for Jim—and he made it.

"The hill is my whole life. I don't know what to say beyond that. I guess everything I do leads me back to this hill. It's everything for me. I dream about it. I dream about it a lot. I don't know how to go into that. That dream is where the hill is, not where we are going. It's a fingerprint. We all leave fingerprints on the earth, I suppose. Someone once called it a collect call to the future."

The road that took Jim to the hill stretches through the entirety of his fifty-six years. It began with his conservative Protestant midwestern upbringing, continued through law school, travels in Africa, a Christian monastery in France, work for the United Nations in New York City, a junkyard on Staten Island where he made his home and first began to work with large-scale junk art, and his next home and studio in a chicken coop and ladies' underwear factory in upstate New York.

But more than anything, the hill took shape in the small hours of the mornings in the abandoned shipping piers on the West Side of Lower Manhattan, which in the brief period between Stonewall and the AIDS epidemic became the anonymous stage for one of the most incredible sexual theaters the human race has ever known. Dark and derelict buildings with huge rooms, high ceilings, and rotting floors, filled with every kind of junk, and with men, in every state of undress and every kind of sexual act. For many of the men who participated, it was a soul-searing experience that shaped them for the rest of their lives. None were more affected than Jim, who participated in characteristically startling ways: once, in a dark and shadowy room filled with silent shadows and the muffled sounds of sexual pleasure and agony, Jim stood and recited Yeats with a declamatory, Shakespearean voice.

The whirl of days at the United Nations, nights at the piers, and every moment in between spent working on art at the junkyard—at some point it all became too much for Mr. James Magee. He resolved to devote his life to art, but the resolution came with a rider: in order to do so he would have to

get as far from the art world as he could. Thus began the trek that eventually landed Jim in Nowhere, Texas, where he found the hill he had seen in his dreams, bought it, and spent the next decades adorning it with four large stone buildings connected by giant stone walkways, and then creating the art to fill the buildings.

> I enjoy working on things for long periods of time, whether people see them or not. My process is very slow, and the hill, or whatever I have done out there, is amenable to that.
>
> I went out with a string and compass, and staked out where it would be. With that everything else was set. We had no architect, no blueprints, the entire construction was laid out with me pacing and using a string and a transom, that's it. The construction of the buildings was all in scribbles in my notebooks.

The site seems more like an archeological dig than a gallery, covering 55,000 square feet. Two thousand four hundred tons of stone went into the buildings and walkways. After more than twenty years, Jim has completed the buildings and filled three with art. He is planning on spending the next ten to fifteen years completing the art for the fourth building.

The art itself defies description. Giant works of many tons each. Steel and iron triptychs on huge ball bearings. Studies in rust and decay and detritus. Acid and honey. Beeswax and burnt rubber. Paprika and cold-rolled steel. Barbed wire and pig bone.

This is the only art I have ever seen that always leaves the viewer speechless, groping for but never finding an adequate reaction. This is partly because it is so surprising in scale and composition, partly because it is so stunning in detail and execution, but mostly because it is so intensely and profoundly personal. Going to the hill is not like going to view art, but going into the dreams and imagination and bones, blood, and muscle of James Magee.

Everything seems to be constructed of industrial debris, but in truth there are very few found objects in the works. Jim makes his own junk from scratch, welding and machining and casting and pouring it, rusting and cracking and breaking and burning it.

"You can't find all the found objects that you need. People start from different points. It's their makeup that decides how they begin. I begin in my head, from my gut. I can't find my sketches readily along a roadside."

Jim gives these works titles that often run on to several pages of text. Poems, really. His idea is that you stand in front of one of his works, and as you

view it he stands behind you and whispers the title in your ear. If the titles alone were the sum total of his artistic output, Jim would be an American poet of the first order.

Then tell me Jerusalem,
Where to begin when Hartley walks across the floor as Hartley
to press the bread against my head
the sun lies cracked
a broken dish upon the field
a pinch of salt
2 eggs
some batter
a shake of flour a little yeast a little later in October
when trees turn color against our barn
And he's returned from beyond to plant the corn between the cracks of
 dried Christian blood
For Hartley had the darkness flowing in his veins from birth
Like the red black river he dug up one day under the gray rock by the
 back fence and drank it into his head
so now instead of my soup he's got that on his brain, never mind my
 bread
nor ever happy nor even mean
just queer about nothing ever being right or wrong
like the way he wears his hat is too much to one side and it's his head to
 begin with
or I tell you forget that the rock out back is dead, he calls it Dad, even if
 it tilts like his face out of control
and the morning air on a clear day fresh as a bouquet of roses is either
 too hot or too cold for poor Hartley
lord. guess we're both growing old along with Jerusalem on this Texas
 farm
Sometimes when the light goes out I see it there, a great city half
 hidden among our trees, ancient as sequins glittering black
 between me and the trap I set for it every night with the head of
 Christ pitched atop a clothesline pole high above the yard, floating
 as a dream forum, a body torn from itself, above a still older tower
 of voices trying to sing through the stone
You're not alone Hartley
Your friend Lester too laments that ruined city

he sees it out there at dusk, charred and rubbled, the millennia washing
 over its walls, the crowd cheers and clears away from a field
Lester gets up off his knees, too soon I think to wrap a wound.
But let him wail until my bread rises in the pan
for I know of no more tender beauty than that of a gentle man like
 Lester quaking in his heart
and cradling as if it were a child in late afternoon that ancient tower of
 voices fading slowly from his hands

Very few people have seen the hill over the years Jim has worked on it. It is not open to the public, not advertised, has no art-biz huckster boasting of its import. Yet he has poured his life into it, thousands of hours of labor, and tens of thousands of dollars of materials. It is a life's work, more so than any other work by any other artist I have known. And it has been seen by only a handful of people. Jim has very deliberately created a work that can never be sold, will never acquire any market value, can never be moved, and is even difficult to find.

■ ■ ■

One of the earliest visitors to the hill was May Carson, who runs the truck stop and gift shop that is the town of Cornudas. A former truck driver who prides herself on being the self-appointed mayor of the town of three (or four) (or five), she describes the works on the hill as

> *pyramids.* Is that good enough? It's all of that. I think he's got the same concept.
>
> He said he was going to build this building, and wanted to know if he could borrow some water to put the cement together. I told him sure. In another couple of years, he said, "Do you think you could loan me some more water to build some more?" I said, "Sure, why not?" Then he said he wanted to build three this time. I said, "Three? What happened, did your ship come in?" So we started on the third. I've been in all of them.
>
> Of course all the people in this area think he's a nut. I've even had some people think he's a devil worshipper because of the pedestals up there. They've been up there peeking, they peek through them doors. In place of them thinking it's something to put art on they think it's some kind of pulpit or something. They said, "Well, have you seen his work?" And I said, "No not really, but if I just call him he'll show me." And they said, "Oh, May, *don't go.*"
>
> I don't know how to describe [his art]. One of a kind, I guess? Life, maybe?

. . .

There is another El Paso–based artist with whom Jim is close, an elderly re-cluse named Annabel Livermore. Annabel is a retired school librarian who is spending her sunset years painting watercolors of flowers and oil paintings of fantastic landscapes that seem to come more from the Mexican side of the border than the gringo side. In stark contrast to Jim, she has done quite well in the art market over the last decade or so.

Annabel has risen from total obscurity to stardom in the Texas art world. Her dealer, Adair Margo, says that Annabel is the only artist her gallery has ever shown who sells out entire shows. Her work has been featured in two books, one on paintings of flowers by the noted English art critic Edward Lucie-Smith, the other a survey of American landscape painters in which An-nabel is presented as a sort of spokeswoman for the American Southwest.[1]

Annabel decided to celebrate her success by donating a vase of flowers to each patient in the Thomason Hospital in El Paso every Christmas. An accompanying card reads, "With this card I wish you health and happiness, Annabel Livermore." Eventually, the hospital invited Annabel to design and paint a nondenominational chapel for the facility, which she did.

One of the most remarkable things about Annabel's work is the passion it evokes among her fans. Adair Margo:

> She has really touched people's heartstrings here. She has processed the border region in a very unself-conscious way. People look at it and say, "This is who we are, we love this work."
>
> We started from scratch. Annabel didn't have any real notoriety or name. She didn't even have a real résumé, like the art schools that she went to or the museums that she was in. Her résumé was a school librarian's. But people bought the work anyway, even though it wasn't really tied to the art world. I mean, it was shown in art galleries, but it wasn't with assurances of Annabel rising to stardom. People loved it, and they bought it because they loved it. And they are not all wealthy people. One woman bought an Annabel for $5,000 and pays us $100 a month. She's a schoolteacher.

. . .

What is perhaps most remarkable about Annabel's success is that it has not been undermined as it has gradually become known that she does not exist in any conventional sense but is the creation of Jim Magee. But "creation" is not the right word. "Persona" is the word her dealer eventually settled upon. Personality? Alter ego? Perhaps the precise word does not exist.

Years ago, a much younger Jim Magee was living in upstate New York and doing his first experiments with the gnarled, rusted, almost terrifying art that would fill his life for the coming decades. He made an experimental film in the same vein and sent it to the brothers in a Christian monastery in France where he had spent some time. The monks wrote back their response: "We're sorry you feel so bad. We suggest you take some time to look around and appreciate God's good works."

Jim went straight out with canvas and paints and painted some flowers. He found the exercise profound but so totally removed from the other work he was doing that he did not see how one person could work in both directions at the same time, and Annabel Livermore was born.

Among the many things that Annabel is, there are a few things she is not. She is not a marketing scam. And she is not a drag queen. Annabel has her own studio, in a detached room behind the garden at Jim's El Paso home. And her association with Jim Magee has been accepted by her fans in El Paso, one of the most conservative cities in one of the most conservative states in the United States. In fact, one of her supporters has been Laura Bush, former first lady of Texas and currently the first lady of the United States. "She loved Annabel," Adair remembers, "and saw the work, and then later invited Annabel to exhibit her work in her offices at the state capitol in Austin."

Janice Keller is an El Paso socialite whose husband, Bobby, does real estate deals across the border in Mexico. She speaks with a long Texas drawl and belongs to the El Paso Country Club. She and her husband have a beautiful split-level home from which Bobby leaves to make his deals in a shiny SUV. Once a year Janice and Bobby take their kids on a gambling vacation in Las Vegas. Janice is so passionate about Annabel's painting that it would be fair to say she has in part built her life around Annabel. Not only is Janice the proud owner of several of Annabel's works, but she changes the flowers every day at the hospital chapel and puts together a group of ladies to deliver Annabel's flowers to the hospital's patients each Christmas. She knows the connection between Jim and Annabel, accepts it, and lets it go.

The first time I met Janice was at the hospital chapel. The walls of the chapel are lined with Annabel's watercolors, the frames of which are on hinges. Small bits of paper and pencils sit on ledges below, and visitors are invited to leave prayers and thoughts for their loved ones in cubbyholes behind the paintings. Janice clears out the prayers when she changes the flowers each day. She now has several thousand prayers, and an idea of what to do with them, as well: "I think Annabel should make a calendar with twelve of her nicest works, one for each month, and we will pick 365 of the nicest prayers

and put one on each day." Janice turns to Jim. "So Jim, if you would, please tell Annabel I have this calendar idea." Jim says nothing.

Now that the link between Jim and Annabel has become more broadly known in Texas, some of Annabel's fans have been more exposed to the work of Jim Magee. Laura Bush herself has been to the hill, with an entourage of secret security and a police helicopter overhead. And though Jim's work is difficult for Annabel fans, they give it their full attention and seem to remain unshakable in their allegiance to Annabel, regardless of their reaction to Jim. Janice explains that Jim's

> sculptures are so harsh to me, they scare me. I can see myself, if I could, watching Annabel paint, and Annabel would be painting, and it would be Jim. But I find it hard in my mind to picture Jim doing Jim Magee's work. What would he be like? I wonder, I don't know. Would he be attacking something viciously, or putting each thing very carefully down, like everything obviously is, but with all of the force of the metals he uses and all of that kind of thing, that's really harsh to me. If I ever got to see either one of them do the real work, I'd rather see Annabel than Jim.

■ ■ ■

I find Annabel's work beautiful, Jim's titles extraordinary, and the hill profound. But what I love most of all is the package as a whole. Jim's path has cut a dizzying trail through locales and social settings as disparate as the United Nations bureaucracy, the Manhattan art world, the gay Manhattan underworld, the genteel world of El Paso socialites, and the isolation of Cornudas, Texas. He has worked in film, sculpture, architecture, steel and ironwork, painting, and large-scale construction, without ever thinking about "mixed media." He has become two people without trying to be weird or schizophrenic. He has struggled every inch of the way: with difficult materials like rust and steel, with sandstorms and blistering heat, with his own personal demons. Through it all he has uncompromisingly followed connections and imperatives he felt deeply, even if he was not sure why. What he has done, in short, is lead a creative life.

■ ■ ■

After knowing Jim for years, I proposed to him I set his titles to music, and he enthusiastically agreed. It was a given that Jim would read the titles himself, both because of their intensely personal nature and because of the uniquely musical voice in which he reads them. I wanted to write for a solo string

instrument, as an instrumental complement of Jim's voice, and asked cellist Joan Jeanrenaud if she would premiere the work. Joan had been the cellist in the Kronos Quartet for twenty years. She had been recently diagnosed with multiple sclerosis. One result of the diagnosis was that she left the Kronos Quartet in order to be able to focus her creative energies on projects of her own choosing. I was delighted when she agreed to accept my project with Jim as her first post-Kronos endeavor.

I try to build all my projects on direct personal relationships, so the first step was to get Joan to Texas to meet Jim and see his hill. Joan, her cello, and I flew from San Francisco to El Paso, where we loaded into Jim's decrepit old pickup and headed into the desert. Out there in the Texas sun, surrounded by dirt and rock and bright light and snakes and spiders and bones and carcasses (nothing decays on a human time scale in the desert) and huge vistas and endless celestial canopies and desperate plants clawing their way through the earth's crust and Jim's stone buildings and gnarled sculptures, one comes unavoidably face-to-face with the fine line between life and death, the omnipresence of mortality, and the smallness of the whole human endeavor.

Each of us was feeling a special connection to confrontation. My connection was the weakest: I have HIV, though I have been fortunate enough that it has thus far caused me no serious problems. Joan's connection was much deeper, with her recent MS diagnosis and the looming possibility of losing her muscle coordination. Jim's connection was the most acute. But then, this was Jim's desert, Jim's spiritual and artistic abode.

Jim was diagnosed with AIDS very early in the epidemic and somehow had survived the dark years when the only treatment available was AZT, a drug that turned out to provide little benefit but was itself extremely toxic, particularly in the huge doses prescribed at the outset of the epidemic before anyone knew better. Some years ago, weird things started happening in Jim's feet. He got tuberculosis in his feet. He got repeated bone infections. None of these were typical AIDS complications. His doctors were stumped. Was he being exposed to some sort of toxicity at his metalworking shop? The problems accumulated until the doctors amputated first one of Jim's legs and then the other. They finally concluded that the bizarre feet problems must have been the consequence of all the AZT he had taken. It is possible that losing one's legs is the expected outcome of taking that much AZT, but no one knows this because almost everyone who took that much AZT died. At this point Jim has had over thirty surgeries. He has mastered the hospital routine. He takes the doctors' orders as "suggestions." He refuses to wear hospital clothing. He gets wheeled into surgery wearing a dinner jacket.

Out in the desert, Jim told Joan the story of how he had come to terms with his loss of limbs. He had just come out of his first hospitalization due to weird goings-on in his feet and was wearing the first of many braces doctors would give him between that moment and his later double amputation. The doctors had told him to find a new line of work, as he would no longer be able to make sculpture in the desert. For Jim those were fighting words. He headed straight to the Big Bend wilderness with his paints and eighteen pieces of plywood to begin work on what would become known as the Annabel Livermore Big Bend series. He was struggling to learn to walk with a brace. He had his easel set up at the roadside observation point in Santa Elena Canyon, when a black van pulled up next to him and out jumped a dog and a beautiful, strapping young man whose short pants and short-sleeved shirt fully revealed two prosthetic legs and one prosthetic arm. Dog and the man bounded off across the rugged terrain as Jim watched, transfixed. When the man returned to his vehicle, Jim left his easel and approached, awkwardly saying something about how he couldn't help but notice how athletic the man was given his multiple amputations. The man looked down at the brace on Jim's leg, then looked Jim in the eye and said, "When they have to take that leg off, *let it go,*" and then jumped back in the black van and sped off. Jim

Annabel Livermore, *Desert Dream City #6,* oil on panel, 2000–2001. 48″ × 32″. Courtesy of Annabel Livermore.

was stunned. At that point the idea that he might eventually lose even one limb had not even entered his head. The encounter stayed with him for years, through the ordeal of losing first one leg and then the other. "He has been a spiritual presence for me ever since," Jim explained to Joan. "My angel who revealed himself to me."

Joan listened to this story dumbstruck. She knew this man. She was sure of it. How many athletic triple amputees with a dog and a black van could there be? She knew him well. In fact, this man had once been her lover.

I do not believe that coincidence reveals any divine plan or cosmic truth, but I do believe that meaningful relationships are often forged when we are willing to go through doors that have unexpectedly opened before us. Serendipity is often an opportunity to let one's guard down in the company of others doing the same. In this case the result was *Desert Boy on a Stick*, a concert-length work for cello and spoken word, premiered by Jim Magee and Joan Jeanrenaud at Colorado College in the spring of 2001.

All the Rage, Spiral, and PantyChrist

I have always thought the notion that there is such a thing as "gay art" was ludicrous, and I have never been interested in being a "gay artist." I don't even make a very good "gay man." I don't like show tunes, Judy Garland, opera, disco, all electronic dance music, fashion, interior design, church music, or brunch, and my most sustained intimate relationship has been with a lesbian—Sara Miles, who cowrote the articles on El Salvador and Nicaragua reprinted in this book. My "lifestyle choice" has been focused not on identity but, as I wrote in the Introduction, the notion of "approaching art, politics (relations between large groups of people), friendship, and intimacy (relations with small groups and individuals) in the same manner: always be open to new ways of understanding what it is you are doing, always be open to reassessing whatever you just completed, and try not to repeat yourself." These ideas resonate better with the "queer" subculture than the "gay" one, and I have made a number of works that are commonly seen as "queer." Yet I have the same ambivalence about my work being labeled "queer" as I have about it being labeled "political." I make what I make not because I am trying to claim an identity but because social relationships, and in particular their power imbalances and subversive potentials, are the material I instinctively gravitate to, like some composers gravitate to harmony or certain painters to color.

. . .

In the early 1990s, the Kronos Quartet approached me about a commission after hearing my composition *Sooner or Later,* which I created almost entirely from a recording of a young Salvadoran boy speaking at his father's funeral. (See the essay "*Sooner or Later,*" page 38 in Chapter 1.) They were interested in something similar, something that also made use of documentary audio in an emotionally charged way.

Not long after my initial discussions with Kronos, California Governor Pete Wilson vetoed a gay-rights law that had been ten years in the making and that he had promised to sign while campaigning for gay votes only a short time before. A riot broke out within hours, and in San Francisco the California State Office Building was set on fire. I grabbed a portable tape recorder and recorded everything I could. By the time I arrived home I had decided what the project would be: I would have a string quartet play a queer riot.

I sifted through the recorded material and ferreted out those sections that to my ear suggested music: chanting or screaming that had a sort of musical phrasing, windows smashing, and so forth. Much of the sound was colored by the omnipresence of whistles that many queers carry as a basic self-defense tool against gay bashing and that emerged from people's pockets by the hundreds during the riot. (A survey by the *San Francisco Examiner* at about that time indicated that over one million hate-motivated assaults against queer people were taking place in the United States each year.)

I then set up these isolated audio fragments in a digital sampling keyboard and began to shape them into a composition. I used very little conventional electronic signal processing. Instead, I broke the original sound down into very small blocks and strung them together in sequences that were close to the way they had originally occurred yet had a more musical structure. As a visual analogy, imagine I had filmed the riot, snipped the film into individual frames, and strung them back together in such a way that movements that suggested dance were developed into a full dance form. By carefully preparing the setup of the sounds in the sampler, I was able to improvise with these creations, then record the improvisations and edit them into final versions.

I chose this way of working for a reason. The point was not to transform the riot into something else, but to use music to bring the listener into the riot. Not in the gimmicky sense of creating an audio illusion of actually being in the riot, but to get inside the energy, the passion, and most of all the anger. I found that the moment I started using more conventional sorts of electronic processing (phase shifting, filtering, delay, etc.), the riot quickly

became something else, became the audio equivalent of a special effect in cinema. So I limited myself to reproducing the original audio as faithfully as I could and composing with it using the methods I have described.

While I was satisfied with the results of this work in terms of the music, I worried it would be too easy for listeners to be overwhelmed by the crowd— that the very intensity of the crowd would become an emotional barrier for the listener. A spoken text seemed like a good addition that might help let the listener in by somehow presenting, in a very personal way, the emotions and passions of one individual in the crowd.

I had attempted to interview people during the riot, but it proved impossible. There were undercover cops taking pictures of everything, and it was just too crazy trying to explain to complete strangers in the middle of a riot that I was not a cop but a composer who wanted to record their most intimate feelings because I was writing a string quartet.

I asked writer/artist David Wojnarowicz if he would collaborate on a text, and he agreed. But David was sick with AIDS. For weeks David and I talked and waited for him to get well enough to work on the project, but his health steadily deteriorated. With the deadline for delivering the composition to the Kronos Quartet bearing down, Sara Miles (poet, journalist, and my partner in romance and just about everything else at the time) graciously stepped in and wrote a text on very short notice. Her words draw on both her life experiences and my own and are divided into four parts, dealing with growing up queer, gay bashing, AIDS, and love.

Eric Gupton of the theater troupe Pomo Afro Homos (Postmodern African American Homosexuals) read the text for the recording. Eric also died of AIDS soon after. The composite queerness of the final result was just what I wanted: a real-life mixture of the voices of three queers: a white woman, a black man, and a white man. It was intimate and personal, yet bigger than one person/gender/race. With this done I could finally turn to writing the parts for the quartet.

My idea was to have the quartet actually *play* the riot. So, in one way or another, I developed all the string parts directly from the sounds of the riot. To put it simply, I used the computer to pick out pitches that were present in the sound of the riot, and those would become notes for the quartet to play.

The process for accomplishing this was rather complex. The riot audio is extremely dense, so using pitch analysis technology to extract anything musically useful from the barrage required considerable technological savvy and many hours of simple trial and error. I used a different technique for each section of the piece, depending on what aspect of the riot I wanted the

quartet to play. This was directly related to how I had "played" the audio on the digital sampler, which in turn was directly tied to the content of the original riot recording. Thus, though there are many layers of work in the music, in the end it presents a pretty integrated package.

More difficult than getting the pitch sequences, however, was putting them into musical rhythm. At this point, I had a series of pitches synchronized to the playback of the riot audio, but they were not in any musical time. So I would listen and ask myself, "If I were playing this part, what tempo would I be feeling?" Since the source audio was a riot and not a written piece of music, the implied tempo would frequently wander. When it wandered too far, I had the choice of writing a tempo change into the score, or editing tiny fractions of seconds of the audio to make the tempo steadier. I used both these methods in different sections of the piece. Once I had a "map" of implied tempos, I added time signatures (which in some places had to change quite rapidly) and rounded off the durations of the pitches generated by the computer into musically meaningful values.

Asking an ensemble to perform in this manner with an audiotape created unique kinds of problems. Most compositions that combine audiotape with live ensemble performance use a tape that has audio content with an obvious pulse, or a click track the musicians hear via headphones during performance, or they are written in such a way that the live performance does not have to be strictly synchronized with the audio from the tape.

Since my objective was to have the quartet play the riot, there was no alternative to the musicians taking the tempo from listening to the tape, despite the fact that the implied tempos changed frequently, wandered, and at times were far from obvious. A good deal of rehearsal time was spent listening to the tape repeatedly while I explained, "Here the tempo changes from such-and-such to so-and-so. Count the time from when the window breaks to when the woman screams. At the new tempo, that's a dotted quarter note."

The final section is, I think, the most beautiful and also the most difficult to play. I had an image of someone smashing windows with tears pouring down his cheeks. I began with a section of the riot where someone yelled "Burn it" three times. When looped appropriately, the shouting became a very musical phrase lasting for four bars of 4/4 time at a clearly implied tempo. I set up the sampler so that, with each repetition of the phrase, I could improvise with looping tiny sections of the sound back on itself. This gave the sensation that with each repetition of the phrase, different parts of the sound stumble, or snag on something before flowing on down the stream. After recording my improvisations, however, I edited the results so that the phrases were spread

over 4/4 bars counted at a tempo that held steady. The result was that while each individual phrase would stumble and snag, the following phrase would arrive on a downbeat that had not snagged at all but came on an absolutely steady pulse.

This gave exactly the effect I wanted: the music seems to stumble and sway under its emotional weight but at the same time marches resolutely forward.

The string parts here are extremely detailed transcriptions of the voice shouting "Burn it," and the parts follow every little crack and choke. This was also the effect I wanted: to put the moment under a microscope and magnify every detail, so that listeners' sense of scale would shift as they go into the music. I wanted the music to envelop the listener to the point that instead of being full-size people listening to a small sound through their ears, the music grew until the listeners were the size of the dot on the quarter note and the music was all around them.

Here again the notation posed a problem: I could notate simple rhythms against a tempo that staggered in complex ways, or I could notate rhythms that would appear much more complex against a steady tempo. While the former approach would have produced a part that would appear much simpler on the page, I chose the latter method since it reflected what I really wanted to happen in the music. Also, this way the part could be rehearsed correctly without the tape.

For the quartet, I think this is the most difficult part of the piece. In order to be effective, the string playing must be exactly synchronized with the tape, otherwise the effect of the detail of the transcription is completely lost. However, hearing the tape strongly skews the musicians' sense of tempo. If the musicians' sense of time wanders with the tape, the parts no longer synchronize with the audio, and they always find the downbeat of the next phrase arrives sooner than expected, since that actual tempo does not "snag."

The piece closes with the viola playing the "Burn it" melody unaccompanied by either the quartet or the tape. In part this decision flows from the entire logic of the piece, of bringing out the essence of the moment through music. And the lyric, almost vocal qualities of the viola make it ideal for the solo passage.

But I had more personal reasons, as well. Hank Dutt is the violist in the Kronos Quartet, and his lover Kevin was living with AIDS. I wanted *All the Rage* to be a piece that speaks to a general, human anger anyone can feel. But first and foremost I want it to be a piece for queers. I wrote it for our anger, for who we were at that moment in history, and how we felt with violence

coming at us from every side, with the intimate parts of our lives discussed every day in the media by arrogant bigots who had not the slightest clue what they were talking about, with so many of us sick and dying. I wanted *All the Rage* to end with Hank alone playing his viola, playing the most passionate music I could write. It is a sort of present for Hank, and for Kevin.

■ ■ ■

Around that time I became obsessed by the work of David Wojnarowicz. David's life was not an easy one. From a violent home in New Jersey, he dropped out of high school and hustled on the streets of Manhattan, which he used as a most unusual art school. He wanted to be a photographer, but though he managed to steal a camera, and regularly steal film, he could not steal film developing. After shooting a roll, David would store his undeveloped film in a bus station locker. But as is always true for people living on the streets, the precariousness of his life situation made it difficult to follow a schedule, and the day would always come when he would not make it back to the bus station in time and his possessions would be cleared from the locker. Thus neither David nor anyone else ever saw most of his pictures.

If I had known David better, a chapter of this book would probably be devoted to him. But I found David too late. I asked him if he would write and read a text for my composition *All the Rage*. He agreed, though he was too sick to create new work. Over many weeks we talked on the phone, waiting for a window in which his health would improve to where he could take on a new project. It never did. He died on July 22, 1992.

Before getting so sick he had managed to make several movies, write three books, and make numerous pieces of visual and performance art. He covered entire walls of the West Side piers with paintings of extinct animals (the same piers frequented by Jim Magee). His collage work is arresting, and I have used it on three CD covers. His writing about his sexual experiences is deeply erotic. His writing about AIDS captures the anger of the early epidemic in a way no other writer did. I am not the only one who feels this way. News of his death triggered a spontaneous march through the streets of Manhattan's East Village.

In 1996 I was commissioned to create a piece for the *What about AIDS?* art exhibit, a large show that traveled around the country featuring art by people who had somehow been affected by the AIDS epidemic. Not long before his death, David had written a text describing his experience of the dying process that was stunning in its power and immediacy, and I decided to build my piece upon this text.

David Wojnarowicz, *Untitled (burning man)*, 1983. 48″ × 48″. Courtesy of PPOW Gallery.

David wrote of feeling that he was turning into glass. I imagined music played entirely on glass instruments and brought in instrument-builder Oliver DiCicco as a collaborator. Some of the instruments Oliver created were quite simple, such as an untuned glass marimba and glass bullroarers. Others, such as a series of suspended and amplified tuned glass rods, were beautiful sculptures that could be played. And one, a glass harp, was a full-fledged musical instrument. The harp consisted of two wooden frames that opened like a book. Glass rods were suspended in the frames from two piano wires each. Both the rods and the wires were tuned. Thus one could play the glass and use the wires as resonators, or play the wires and use the glass as resonators. Still other instruments were fashioned by myself out of "off-the-shelf" glass: crystal wineglasses one could bow with a finger, a crystal bowl filled with glass marbles that one could rotate or shake, amplified sheets of glass, and plates of glass suspended over cardboard tubes that doubled as drums and as resonant surfaces on which to amplify other objects. I also used a glass

mortar and pestle that Bo Houston, a close friend and novelist, had used to mix the substance he ingested to take his own life when he arrived at the end of his long battle with AIDS.

Experimenting with using amplified sheets of suspended plate glass gave me the idea of using them not only as amplified percussion instruments but as projection surfaces as well. I brought in another friend, Pierre Hébert, who at the time was making animations by scratching on black film stock with a knife. Pierre's images are literally empty pieces of light carved into dark space, giving them an eerie affinity with David's text. We projected Pierre's images on suspended sheets of amplified glass, as singing percussionists played the glass with mallets.

Glass harp constructed for *Spiral* by Oliver DiCicco. Courtesy of Oliver DiCicco.

Glass rod instruments constructed for *Spiral* by Oliver DiCicco.
Courtesy of Oliver DiCicco.

Every time *Spiral* was performed, I experimented with a different lineup.
Percussionist Gerry Hemingway and technical director Richard Board are
the only people who participated in each performance.

But ultimately there were very few performances. On the way back to
San Francisco from a concert in Brussels, United Airlines lost the instru-
ments. When the cases finally showed up days later, they had been dropped
so forcefully that the glass rods inside had not merely broken but shattered
into glass dust.

That was effectively the end of *Spiral*, though I am not sure this is such a
bad thing. The destruction of the glass was poetic, the perfect end, actually.
The music was never recorded. All that is left is some dust, some photos,

and some memories. I think of *Spiral* less as a musical composition than as a ritual in which I engaged to mark David's passing, and the darkest time of the epidemic in this country.

SPIRAL

David Wojnarowicz

Sometimes I come to hate people because they can't see where I am. I've gone empty. Completely empty and all they see is the visual form: my arms and legs, my face, my height and posture, the sounds that come from my throat. But I'm fucking empty.

The person I was just one year ago no longer exists; drifts spinning slowly into the ether somewhere way back there. I'm a Xerox of my former self. I can't abstract my own dying any longer. I am a stranger to others and to myself and I refuse to pretend that I am familiar or that I have history attached to my heels. I am glass, clear empty glass.

I see the world spinning behind and through me. I see casualness and mundane effects of gesture made by constant populations. I look familiar but I am a complete stranger being mistaken for my former selves.

I am a stranger and I am moving. I am moving on two legs soon to be on all fours. I am no longer animal vegetable or mineral. I am no longer made of circuits or disks. I am no longer coded and deciphered. I am all emptiness and futility. I am an empty stranger, a carbon copy of my form.

I can no longer find what I'm looking for outside of myself. It doesn't exist out there. Maybe it's only in here, inside my head. But my head is glass and my eyes have stopped being cameras, the tape has run out and nobody's words can touch me. No gesture can touch me. I've been dropped into all this from another world and I can't speak your language any longer.

See the signs I try to make with my hands and fingers. See the vague movements of my lips among the sheets. I'm a blank spot in a hectic civilization. I'm a dark smudge in the air that dissipates without notice. I feel like a window, maybe a broken window. I am a glass human. I am a glass human disappearing in the rain.

I am standing among all of you waving my invisible arms and hands. I am shouting my invisible words. I am getting so weary. I am growing so tired. I am waving to you from here. I am crawling around looking for the aperture of complete and final emptiness. I am vibrating in isolation among you. I am screaming but it comes out like pieces of clear ice. I am signaling that the volume of all this is too high. I am waving. I am waving my hands. I am disappearing. I am disappearing but not fast enough.

■ ■ ■

Spiral performance. Oliver DiCicco in foreground. Courtesy of Phyllis Christopher, www
.phyllischristopher.com.

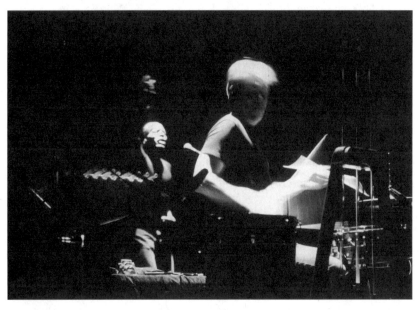

Spiral performance. Gerry Hemingway, percussion; Raz Kennedy, vocal. Courtesy of
Phyllis Christopher, www.phyllischristopher.com.

Spiral performance. Courtesy of Phyllis Christopher,
www.phyllischristopher.com.

I have often felt fractured by the fact that while my colleagues in music and
politics are overwhelmingly straight, my social world is predominantly queer.
At times I have tried to address this by deliberately creating projects that
would bring the two worlds together. Of all the people doing creative things
in the queer community it has been my good fortune to meet, Justin Bond
had a particular dazzle, and from time to time I would muse over what sort

Animated image scratched directly on film by Pierre Hébert, projected on glass for *Spiral*. Courtesy of Pierre Hébert.

of project we might do together. There was no easy answer to this, as Justin does drag cabaret, and I do, well, all the things this book is about. Finally I decided maybe we should just go onstage together and see what happened. My friend Otomo Yoshihide, a sort of noise DJ from Tokyo with whom I occasionally did improvised gigs, was coming through San Francisco and asked me if I could set up a concert or two. I secured a venue in San Francisco (the Great American Music Hall, a five-thousand-square-foot nightclub built in 1907 with ornate balconies, soaring faux-marble columns, and elaborate ceiling frescoes), and arranged the show in two sets. The first set would be a trio of Otomo, myself, and Mike Patton, an extremely talented vocalist who at the time was alternating between fronting the platinum-selling heavy metal group Faith No More, his much more adventurous rock band Mr. Bungle, and fringe gigs of improvised music. The second set would feature Otomo, myself, and Justin. I called the two groups House of Discipline and House of Splendor.

At the time, I don't think Justin had even heard any of my music, or *any* improvised music, for that matter. He had never met Otomo. But Justin was an improviser, no doubt about it. His cabaret shows were notorious for the sudden left turns and curveballs he would throw into the show when he

forgot the words, or forgot where he was (there was generally a considerable amount of chemical enhancement in his performances), or just because he felt like it. I had absolute confidence in Justin's intuition. We did the concert without any rehearsal. I simply told Justin, "So, there will be the Japanese guy with turntables, and me with a sampler, and we are going to make a bunch of noise, and you just do drag: sing songs, dance, tell stories, do your makeup, anything you like."

I should note that in addition to Justin being completely unfamiliar with this sort of performance, Otomo had had very little contact with queer culture or queer people. Gay culture in Japan is a pretty dreary place, largely hidden and full of sadness. There is no "queer" fringe to the subculture.

I should also note that Justin doesn't really have to "do drag" in order to project gender ambiguity. He is an extremely effeminate man. Justin is one of those guys who, if he was ever in a place where his life depended on passing for straight, he would just have to die because there is simply no way Justin could *ever* pass for a straight man. It is out of his hands. Those are just the cards he was dealt. What makes Justin so special is that he was born not only with a generous helping of gender confusion, but with even larger servings of brains and talent.

The concert was one of the oddest nights I can remember. The hall was packed with Faith No More fans who had come to see their hero and had no idea what they were in for. They were already taken aback when the first set turned out to be a barrage of abstract sound, featuring Mike snarling wordless noises into busted microphones built into a podium originally designed for street-corner evangelists to power with car batteries. The audience had no forewarning that in the second set Mike would be replaced by a drag queen from another plane. Justin came onstage in a one-piece ladies' swimsuit with a jar of indoor tanning lotion and announced he wanted to have a perfect tan before the end of the set.

I think the audience was simply stunned. When we got back to the dressing room, Otomo, Justin, and I looked at each other and asked, "What *was* that? Was that pretty good or the worst thing we have ever done?" At that moment, for the only time in my life, a man from a record company burst in, beside himself with how great our show had been and gushing about how we had to make a record for his label right away. Thus was born PantyChrist. Or PC, for short.

The man was Naut Humon of the Asphodel label. With an advance from Asphodel, we booked another show and arranged to bring Otomo back from Tokyo and Justin back from New York, where he had recently moved. The

idea was that we would do a live show one night and spend the following day in a recording studio. Everything would be improvised. After Otomo and Justin had left, I would take the tapes and see what sense I could make from the carnage.

The concert was fine, but the following morning I became extremely sick and spent the entire day in the hospital. I got home from the emergency room at about the same time Otomo, who was staying at my place, returned from the studio. I was quite curious about what had happened, particularly since Otomo spoke very limited English and Justin's improvisations consisted largely of hilarious drag queen rants full of black humor and double entendres.

> *Bob:* So, how did it go today?
> *Otomo:* It was fine.
> *Bob:* Could you understand what Justin was saying and singing?
> *Otomo:* No, I understand nothing.
> *Bob:* So, um, how did you decide what to play?
> *Otomo:* I watch recording engineer through glass. When I see he laugh,
> I play something funny.

After Otomo and Justin had left, I took the hours of tape from the concert and studio session, cut them into little bits, and reassembled them into something that made vague sense. I then overdubbed a bunch of tracks of my own, adding a layer of connective tissue that imposed a sort of "song" structure on the whole thing. I then invited a few friends over, one at a time, to add more tracks. (Jon Rose on violin, Richard Rogers on keyboard, Trevor Dunn on bass.) I didn't really tell them much of anything about what the project was or what was on the tape. Instead, I simply told them to start playing right from the moment I hit "play," to not stop until the end, and not to worry about wrong notes—there could be no "wrong" notes in this project. I then subjected these tracks also to the same slice-'n'-dice procedures I had used for the others.

When Asphodel received the tape, the owners of the label were ecstatic. One called to tell me that the reason she had gone into the record business was to make recordings like this. Naut called to say they wanted to double the promotional budget. They wanted Justin's address to send him a bouquet of flowers. And then, silence. Weeks went by. Finally, Naut called to say that Asphodel would not be releasing the recording at all. He explained that as the label had grown, the original two owners had brought in someone with more experience in the "biz," and that this someone found our recording so offensive that he would quit the label if Asphodel released it. Naut felt so bad

about it that he returned the master tape *and* told us to keep the advance, essentially telling us to take his money and go away. Record companies *never* give artists something for nothing, but apparently PantyChrist had blown the fuses at Asphodel.

Eventually we released the CD on Seeland, a micro label run by the media guerilla group Negativland. Almost no one bought it. We did a handful of shows in Europe: the Taktlos Festival in Switzerland and shows in Germany, Belgium, and Portugal. And then, as with most of my projects, I simply ran out of the energy it took to keep it alive. It was like pushing water uphill. Otomo didn't want to do it anymore. I think he had never been fully comfortable onstage with someone as queer as Justin. And Justin himself was ambivalent. To my mind, PantyChrist was a way for Justin to escape from the "drag queen" box his cabaret act kept him in and move into a much more open-ended terrain. But PantyChrist was so far from his usual turf that I think Justin never felt fully at home there. And in the meantime his drag cabaret act, Kiki and Herb, had taken off. Kiki and Herb have now achieved celebrity status. They have sold out Carnegie Hall and had extended runs both on and off Broadway. Then Justin was cast as himself in John Cameron Mitchell's feature film *Shortbus*. Justin is a star.

More than once, straight colleagues have told me that "if you are interested in being taken seriously as a composer, you don't help your case any by working with drag queens." But frankly, I don't care. I still consider PantyChrist one of my most successful projects, bringing together disparate elements both social and musical into one organic whole that somehow makes sense yet is utterly odd. A critic who saw our only German concert wrote that it was "like seeing the entirety of American culture stuffed into 30 minutes." A review in a gay zine wrote, "To say that this has made me radically rethink my use of the word 'queer' is an understatement." From my perspective, this is the highest praise to which I might aspire, especially if one takes the word *queer* not in the limited sense of a gay subculture but in the broader sense of something so out of the ordinary that it startles the attention and piques the curiosity. In this sense, I would be happy if people had such a response to every project I have ever done.

Why I Work with Drag Queens

In 1999 my group PantyChrist (with Otomo Yoshihide and Justin Bond) performed at the Taktlos Festival in Switzerland as part of a European tour. The Taktlos Festival presents mostly improvised music and had never presented

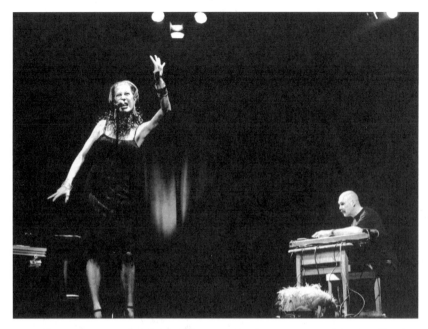

PantyChrist: Justin Bond and Bob Ostertag at the Great American Music Hall in San Francisco. Courtesy of Phyllis Christopher, www.phyllischristopher.com.

anything close to PantyChrist. The following interview was published in the Swiss magazine WoZ *prior to the concerts.*

■　■　■

WoZ: Why is Bob Ostertag, the avant-garde musician, the politically conscious and openly gay person, interested in drag queen culture?

BO: Though some may find it improbable, I thought joining my music with the work of drag queens was very natural. Now that the act of appropriation has become the quintessential act of the late 20th century avant-garde, it seems only reasonable to recognize that for drag queens this is nothing new. "Deconstruction," "reconstruction"—drag queens wrote the book on these ideas long before they attained currency in the art scene. The idea of dipping into mainstream culture, picking out elements you might like or find useful, and then recontextualizing them according to your own intentions or vision—drag queens have been doing this for over one hundred years.

WoZ: Isn't this recontextualization with drag queens much more existential than with avant-garde music?

BO: Drag queens go further than most artists, since they embody this appropriation and deconstruction, they play with their own gender identity, which most people consider to be unchangeable and fixed. This is art that gets under your skin, and thus makes some people very uncomfortable. Drag can be a great antidote to the smug emptiness which pervades so much "postmodern" art. It is difficult *not* to be personal if you are using your own gender as your raw material. This is what interests me most, and it has always been one of my primary concerns: how to create contemporary art that is so directly personal it may occasionally even feel uncomfortable. For example, think of my first performance at Taktlos in 1991, when I performed *Sooner or Later.*

WoZ: Did the avant-garde also influence the drag scene?

BO: Of course, influence from one sphere to another is never a one-way street. Drag changes just like any other art, and in the last ten years drag (at least in San Francisco) has become much more fluent in using resources that are now common currency in the avant-garde. But this influence is only about making explicit what was implicitly already there.

WoZ: What are your own methods of "influencing"?

BO: The method that Justin Bond, Otomo Yoshihide and I have used to create the group PantyChrist was actually quite similar to what I did in Say No More. The first gigs were completely improvised. I constructed the CD out of fragments of improvisations, as I did with *Say No More.* [The *Say No More* project is discussed in detail in a following chapter.]

Justin Bond is a very special talent. I am always interested in virtuosity, and Justin is a virtuoso, though instead of an instrument, he plays his sex, his gender. Justin does just what Otomo and I do—he improvises. PantyChrist live is an improvising group.

I had wanted to work with Justin for years. I considered him one of the truly special talents in the San Francisco area. But at first I could not imagine what form such a collaboration could take. Formally, I make electronic music and Justin does drag cabaret. As is often the case, the solution was not to *decide* what to do, but to *do something.* The first gig was completely improvised. Justin had never even met Otomo, and I think he had heard very little improvised music (maybe none at all). By the end of the gig, everything had become clear. Well, relatively clear anyway.

WoZ: Now you will be playing at Taktlos, a festival for avant-garde music. Are you trying to provoke?

BO: No comment.

WoZ: Are you also involved in the gay and drag-queen scene?

BO: Yes and no. About 99 percent of the gay scene is completely unin-teresting to me. But then there is this little percent of it which I find really interesting. In the last 20 years, after the fight for gay rights was at last taken seriously, we have witnessed a strange dynamic: the more the movement became political, the more conservative it became as culture. Today it has become one of the most conformist cultures, where everyone is trying to be like everyone else, to the point that identity becomes a fashion you can wear, like "the leatherman," which is nothing more than a very expensive set of clothes! But then again there is a subcultural area, where "coming out" still means to reinvent oneself. Some people do that in a highly creative manner. Often, but not always, this also involves drag—though not necessarily "drag queens." When I say drag, I understand it more in the sense of finding the right mixture of feminine and masculine that fits each person individually.

music and machines

Between Science and Garbage

In 1939, Edgard Varèse, the composer who first articulated a grand vision of how machines would change the way humans made music, announced that "sound-producing machines" promised nothing less than the "liberation of music":

> If you are curious to know what such a machine could do that the orchestra with its man-powered instruments cannot do, I shall try briefly to tell you: whatever I write, whatever my message, it will reach the listener unadulterated by "interpretation."[1]

From late modernists like Karlheinz Stockhausen down through rock experimentalists like Frank Zappa and now to the thousands of DJs who pump electronic sound through dance clubs, the idea that electronic music would give composers more *control* while freeing them from relying on human relationships to realize their musical ideas has been the dominant thrust in electronic music. The notion of the machine as a perfect interpreter of musical ideas, in contrast to the necessarily flawed interpreter that is human, has gone unchallenged.

My work has gone in a substantially different direction. My experience of using electronic technology to make music was never one of machines as ideal musicians over whom I exercised perfect and exquisite control. I didn't really see that as a problem, however, as the unpredictable and unruly behavior of the machines I worked with quickly became my muse. However,

as the years have gone by, the meaning I attach to this unstable and tense relationship between human and machine has evolved substantially.

■ ■ ■

I began making music as a kid with a guitar, first an acoustic guitar and then an electric. Like most electric-guitar players, I started adding stomp boxes to modify the sound of my guitar. When the first affordable synthesizers became available in the 1970s, I sold my guitar and a bunch of other stuff and bought an ARP 2600. It quickly became clear that my aptitude for making music with synthesizers exceeded my aptitude for making music with guitars, and off I went—first to the new electronic music program at the Oberlin Conservatory and then to New York City, where I became the only member of the first generation of "free improvisers" in New York City to use a synthesizer as my main ax, with the tape recorder as a close second.

My first record, *Getting A Head,* involved a highly unstable "instrument" made by running the same spool of recording tape through three tape decks lined up one after another. Performances were duets of myself and an instrumentalist whose playing was recorded on the tape running through the three decks during the performance. I had rebuilt the middle tape deck so that I could continuously change its speed ± 100 percent. By using the record and playback heads from the three decks in different combinations while changing the speed of the middle deck, I could manipulate the instrumentalist's sound in various ways. The catch was that the tension on the tape had to be held constant in order to keep the motors of the decks engaged even while the speed of the middle deck changed. I accomplished this by running the tape through grommets attached to helium balloons. The balloons would rise and fall as the sound did, making the whole "instrument" a sort of wacky sculpture. The contraption was constantly on the verge of calamity: the slightest breeze would send the balloons pulling the tape off of its track, and the speed of the middle deck had to be continually monitored to prevent the tape from snapping or getting chewed up in the transport mechanism. "Playing" the instrument was an exercise in disaster control, while the instrumentalist performing with me was placed in the awkward situation of never quite knowing how the contraption would mangle the sound next.

Getting A Head was released in 1980, featuring the guitar playing of Fred Frith on side one, and percussionist Charles K. Noyes on side two. (Like all of my recordings discussed in this book, it can be downloaded free of charge at www.bobostertag.com.)

Getting A Head: three tape decks and four helium balloons. Courtesy of Tina Curran.

I then set about making a more mobile and flexible setup for recording and manipulating sound (traveling with three reel-to-reel tape decks was a calamity in and of itself). I used a collection of cheap cassette recorders, each modified to malfunction in a different way, and a stack of looped cassette tapes of different lengths (the looped cassettes were manufactured for use in early telephone answering machines). I would shuffle the tapes in and out of the machines, recording one here, playing it back there, all the time changing the playback parameters of the modified decks. The fidelity was very low—this was all cheap, broken stuff—but that was part of the aesthetic.

I first used this rig in a concert with Fred in January 1980. It was a crazy moment in American history: Ronald Reagan was being sworn in as president, something that no longer shocks us now but at the time was nearly unthinkable. The American hostages who had been held in the U.S. embassy in Tehran following the Iranian revolution were coming home to a tumultuous welcome that unleashed a malignant wave of patriotism that would propel the country through the wars of the coming decade: El Salvador, Nicaragua, Grenada, Panama, the Persian Gulf, and more. At the time, the juxtaposition of these two events seemed like a coincidence. It was only later, with the unraveling of the Iran-Contra scandal, that it was discovered that Reagan's men had been secretly negotiating with the Iranians to keep the hostages until after the U.S. presidential election. I had recently returned from my first trip to Nicaragua and was experiencing severe cultural-reentry shock. I turned on the TV that awful weekend and started recording to my looped cassette tapes. Without telling Fred, I brought these tapes to the gig along with other cassettes I had recorded in Central America and played them during the performance, using my synthesizer to modify the recorded sound.

In effect I was " sampling," though the term did not yet exist, as this was before samplers had been invented. Using broken cassette recorders similar to those used by journalists at the time, I was bringing the political world of the mass media into an improvisational setting that resulted in a musical mayhem that reflected the political events of the day. Years later, when digital samplers became commercially available, making music from sampled fragments of politically charged media clips would become commonplace among hip-hop artists, rock bands, and others.

A few months later Fred and I did a similar concert in London, which became my last concert for nearly a decade. Just before we went onstage, my synthesizer was destroyed in a technical mishap. I was left with my broken cassette machines and a contact mic I used as a noise source by clenching it between my teeth. Fred had brought only a piece of wood with a few screws

at either end and guitar strings strung between them. Faced with doing the concert with such a bare set of instruments, we hastily recruited vocalist Phil Minton out of his seat in the audience and, without any time for discussion, began the set. It was one of the most powerful concerts it has been my good fortune to participate in.

We released the two concerts as the LP *Voice of America*, with the New York show on side one and the London show on side two. But when I returned from London I was left with the reality that my main ax, my synthesizer, was toast. Oddly, this felt like a relief to me. I had been feeling increasingly torn between music on the one hand and my increasing involvement in activist work with Central American refugees on the other. With no money to replace my synthesizer, the question of where to direct my attention was settled. I left music entirely and became a full-time organizer and writer around Central American issues.

■ ■ ■

When I returned to music in the 1990s, I launched my first ensemble project, with a group of stellar musicians I was extremely fortunate to work with. The initial members of the group included Phil Minton (voice), Mark Dresser (contrabass), and Joey Baron (percussion). Joey was subsequently replaced by Gerry Hemingway.

I began the project by asking the players to go into recording studios, separately, with no communication with each other nor instruction from me, and record solo improvisations. I next took the resulting tapes and, using a digital editing system, exploded these solos into fragments and then assembled an "ensemble" piece by piece from the splinters. The result became the 1992 *Say No More* CD. At that point, the group had a CD but by conventional reckoning had yet to play a note.

I then created an unorthodox score of the compositions I had created on the computer using the solo improvisations as sources. I gave the musicians both their parts from the score and the computer-assembled recordings on the CD and asked them to learn their parts. After extremely limited rehearsal, we then recorded a live CD at ORF Radio in Vienna, *Say No More in Person*, released by the ORF in 1994. So this second CD was a live ensemble performing compositions made on a computer out of fragments of the members' solo improvisations.

(I should note that the limited rehearsal we had is a story in itself. After our access to rehearsal space at the radio was literally sabotaged by the more conservative forces at ORF, we were sent to another town to rehearse in a

garage used by local rock bands, which promptly caught fire. Far from un-usual, such circumstances are the norm for anyone working on novel musical projects such as this.)

I then put these live ensemble recordings back into the computer, exploded them into fragments, and created a new computer-based work, *Verbatim,* released on CD in 1996.

Finally, I created a score of *Verbatim* and gave it back to the ensemble along with the recording itself and asked the members to learn these new parts. The group toured the new material and then recorded a fourth CD, *Verbatim, Flesh and Blood,* in concert at the Kunstencentrum Vooruit in Gent, Belgium, in 1998. The CD was released in 2000.

Thus the project involves a human/virtual cycle:

- live solos disappear into the computer and are transformed into mu-sique concrète compositions;
- these emerge from the computer to become ensemble compositions and performances;
- the live ensemble performances disappear back into the computer and are transformed into new musique concrète compositions;
- which finally emerge back into human performance.

Here again, my focus was not on computers and technology as tools that offer me greater precision or control, nor as tools that could liberate me from the necessity of human interaction. To the contrary, I wanted to highlight the tense and problematic relation of human and machine. In effect, the play-ers were put in front of a machine-made mirror of themselves. It was not a perfect mirror, but more like the digital equivalent of a funhouse mirror that was curved, with wacky lenses that distorted the image into something superhuman. In the performances the musicians tried to keep up with their digital reflection, a task at which they could only fail.

It was for this reason that the original percussionist, Joey Baron, withdrew from the project. After I finished the first piece, I mailed tapes of it to the musicians. Joey called me a few days later. He had listened to the tape several times, and though he was quite excited about it, he could see no point in at-tempting to perform it live. "You have already created the perfect realization of this work," he told me. "There would be no point in trying to perform it live. All we could do is screw it up."

I explained to him that I had no interest in making a "perfect" anything, that the whole point of the project was to set up an opposition of humans and machines—an opposition that was necessarily imperfect and difficult.

I was not interested in re-creating the music I had made on the computer, but in developing a repertoire of ensemble music out of this encounter of humans and machines.

Joey is a perfectionist, which is why he is the remarkable musician he is, and he was resolute in his view that all we could possibly accomplish by performing these works would be to mess them up. He withdrew from the project and was replaced by Gerry Hemingway, another extraordinary percussionist, who understood immediately what I was trying to do.

■ ■ ■

In recent years my main performance project has been Living Cinema, a collaboration with Quebecois filmmaker Pierre Hébert.

For years Pierre was known primarily as the master of the obscure art of live scratch animation. In performances, he would sit in the house among the audience with a drafting table and a 16 mm film projector in which a loop of black film was threaded. He would start up the projector, grab a piece of the film, and begin to engrave on one frame with a knife. When he felt the projector tug on the film, he would let go and grab the film again at a different spot and begin engraving on a different frame. He would continue in this way, until by the end of the performance he would have filled the film loop with an animation. These were not abstract patterns but highly emotional

Say No More: Phil Minton, Gerry Hemingway, Mark Dresser, and Bob Ostertag. Courtesy of Massimo Golfieri.

representational drawings. Since he was engraving with a knife there was no erasing, so any "mistake" had to be incorporated into the animation. In order to have the option of occasionally blacking out the projected image, he had wired a kick-drum pedal to a little piece of cardboard that would cover the projector lens when the pedal was depressed. We did many duo concerts in which he sat in the audience plying this craft while I played music onstage behind a scrim (a fabric, used in theater, that is opaque when lit from the front and transparent when lit from behind). We arranged the lighting so as to make it appear as if I was in the image.

I found Pierre's work enormously appealing. In an era in which people spend $100 million and several years making a film, here was Pierre making movies in one evening with nothing but a knife digging into the celluloid. Filmmaking as archeology.

For our Living Cinema project, I created computer software for Pierre that allows him to make "live animation" drawings on any surface and with whatever tool he likes. In performance, he sits at a table. There is a small video camera suspended over the table. To the side, Pierre has a collection of paper, glass, chalkboard, pencils, pens, paints, chalks, erasers, found objects, maps, newspaper clippings, and so on. He assembles an image on the table and quickly photographs it with the overhead camera, then tosses it aside and makes another image. The software allows him to sequence the images using the sorts of techniques previously used only in animation studios, and as the images are sequenced they are projected on a screen above us. I sit at the table next to Pierre, and another video camera captures how I am making the music. All these images are collaged together on the fly—living cinema. The performance is innovative enough to be difficult to describe to those who have not seen it, yet one of its strengths is that the audience can immediately grasp exactly what we are doing and how the process works.

Our first work, *Between Science and Garbage,* was intended to be about homelessness. But our first major performance was shortly after September 11, 2001 (we flew to the concert in Minneapolis on the first day that planes were allowed back into U.S. airspace), and this changed everything. We had assembled a bunch of garbage we used for live stop-motion animation, intending to create a rain of the garbage among which the homeless have to live. But in the aftermath of September 11, the audience interpreted these images as representing debris falling from the collapsing World Trade Center. In another section, Pierre sifted baking flour over the image to represent snow falling on the homeless sleeping outdoors, but the audience saw it as anthrax (the U.S. Capitol had just been shut down due to envelopes contain-

ing anthrax mailed to Capitol offices). It was as if the crush of world events had become so heavy that we could not prevent them from intruding into the performance. We decided that if we could not keep the world out, we would throw open the doors and welcome it in. As we toured the show, new events in the world news would be immediately added to our performances. An oil tanker broke up off the coast of Portugal while we were playing in Porto, and a broken toy ship appeared in the piece. While we were doing concerts in Slovenia, a major protest erupted over whether a train carrying U.S. military supplies for Iraq would be allowed to cross Slovenian national territory, and a toy train appeared. We began using the day-of-performance front page of the local newspaper in whatever city we were in as the opening image in the performance.

As the tour progressed it began to dawn on Pierre and me what live cinema is good for. Obviously, if you make a movie onstage during a performance, it will not have any of the nuance or polish commonly associated with cinema. On the other hand, many movies take years to complete, yet we could make a new one every night, which made the narrative of day-to-day world events available to us as a cinematic narrative in a way completely unavailable to conventional filmmaking.

Still image from a projection created during a performance of *Between Science and Garbage.*

The chaos of world events is complemented by the chaos of our performances themselves. Though *Between Science and Garbage* uses computers intensively, the project is not a celebration of technology in any way. Rather, what the audience sees is two people on stage struggling to keep up with a technology-driven process that seems to be engulfing them. Performances generally have the same frenetic feeling as the performances of my *Say No More* ensemble, and in each case the tension comes from the nexus of human and machine. But while in *Say No More* that confrontation is located in the compositional process and thus not immediately apparent to the audience (the audience cannot infer directly from the performance that the musicians are chasing digital specters of themselves), in *Between Science and Garbage* that confrontation is made transparent and moved to center stage. There are two people onstage surrounded by a good deal of technology with which they struggle, and meanwhile the debris resulting from how the images and sounds are created begins to accumulate—two human performers racing to keep pace with a steadily accumulating pile of science and garbage. All kinds of garbage: from the discarded elements of the last image that Pierre has captured and discarded, to junk food, broken consumer electronics, and other flotsam of consumer society that make their way into the piece, to the media images that we incorporate, to the very laptops (tomorrow's garbage) we use to synthesize the image and sound.

■ ■ ■

The countercultural milieu of the 1960s and early 1970s fundamentally shaped my early interest in synthesizers and electronic music. Jimi Hendrix had transformed the electric guitar into a radically new instrument that was much more than just an amplified version of an acoustic instrument. Miles Davis was incorporating electric sound into music that traced its lineage to the jazz tradition. John Cage, David Tudor, and many others were putting electronic sound at the center of the avant-garde.

The prevailing view of technology and society was captured in the *Whole Earth Catalog*, a sort of operating manual for the counterculture which sold millions of copies and always seemed to be lying around wherever people with a countercultural bent congregated. Via the jumbled pages of the *Catalog*, one could buy books by Buckminster Fuller, learn how to tell the age of a cow, identify edible plants, and order composting toilets or Moog synthesizers. The common thread through this eclectic collage was that every item was seen by the editors as a tool for personal empowerment. The motivating idea was that "Access to tools" (the *Catalog*'s subtitle) would lead to a more

Garbage fills the stage after a performance of *Between Science and Garbage*. Author photo.

peaceful and enlightened culture through the diffusion of knowledge and know-how. The *Catalog* described its mission like this:

> So far remotely done power and glory—as via government, big business, formal education, church—has succeeded to the point where gross defects obscure actual gains. In response to this dilemma and to these gains a realm of intimate, personal power is developing—power of the individual to conduct his own education, find his own inspiration, shape his own environment, and share his adventure with whoever is interested. Tools that aid this process are sought and promoted by the WHOLE EARTH CATALOG.[2]

It was no coincidence that the *Catalog* was published out of the area south of San Francisco that would later become known as Silicon Valley, for the social circle from which the *Catalog* emerged also produced the personal computer. Parts for the very earliest personal computers were available through the *Catalog,* and the publishers hoped that the widespread adoption of personal computers would lead to a radical democratization of society.

Today these ideas seem anachronistic and hopelessly naive. Our current "access to tools" is without precedent. Our lives are inundated with digital tools that promise to improve communication but seem to only make us more alienated. Electronic music has exploded out of the avant-garde to become the deafening monochrome background roar of wired yet disconnected culture. Discarded consumer electronics are piling up in landfills in Africa, leaching their heavy metals into the already impoverished soil. Every technological advance seems to bring a further erosion of privacy, a new kind of violence, and another environmental disaster. It is harder and harder to see anything empowering in all of this.

■ ■ ■

In the 1970s when I was a student at Oberlin, my teacher Dary John Mizelle suggested that instead of using technology to make new sounds, I should try to use technology to create new relationships between musicians. Our ears, he argued, are fast learners. The first time we hear a sound we have never heard before, we perceive the sound as "new" (and in the 1970s the sound of electronically synthesized music was indeed new in this sense for many people). But this "newness" is very short-lived, and sounds we have only recently been introduced to quickly become as familiar as those we have heard our entire lives. Dary John felt that by using technology to create new human relationships instead of new sounds, a more fruitful artistic practice could be forged.

Dary John was an inspiring teacher, and I attempted to follow his advice. But as I proceeded in this direction, when I stood back and looked at the body of work I was building, what stood out was not the technologically mediated relationships between musicians but the confrontational relation of musicians and machines. In fact, one could easily place my work in a narrative of increasingly explicit awareness of this shift, using the projects I have discussed as signposts along the way. When I made my first recording, *Getting A Head,* I was thinking in terms of the relationship between myself and the instrumentalist created by the tape-and-balloon instrument, though my struggles to make it through a performance without the rickety contraption breaking down was what made the biggest impression on audiences. Fifteen years later with the *Say No More* ensemble, I began the project with my focus on the relationships I would create between myself as composer and the ensemble members as improvisers. But as soon as the group got together and began to play the compositions I had made, it became obvious

that the tension between the musicians as flesh-and-blood humans and their digitized mirror image on the computer was where the real action was. This realization caused me to reconsider all my previous work in that light. Since that project, the focal point of much of my work has been on the confrontation of human and machine.

(This might be a good time to refer to my three rules of thumb stated in the Introduction to this book: "always be open to new ways of understanding what it is you are doing, always be open to reassessing whatever you just completed, and try not to repeat yourself.")

This reassessment of the meaning of technology in my own work paralleled a similar long-term shift in my understanding of the role of technology in the broader culture. The idea that new musical relationships between musicians can be created through technology is analogous to the idea that new social and political relationships between people can be forged with technology, which is the central claim of the "information technology" industry. But the more familiar I become with "information technology," the more deeply I doubt that it creates any new relationships at all. Once all the hoopla dies down, it seems that what we are left with is the same old relationships in new packaging. What changes is not so much our relationships with each other but our relationship with technology and, by extension, our relationship with the natural world.

Joel Chadabe wrote a book called *Electronic Sound: The Past and Promise of Electronic Music,* that is a standard introductory text to the subject of electronic music used in undergraduate classes around the United States. Chadabe starts off his book by setting up the conservative American composer John Philip Sousa as his straw man. Chadabe has Sousa complaining about the intrusion of machines into the world of music and quotes Sousa asking: "When a mother can turn on a phonograph with the same ease that she applies to the electric light, will she croon her baby to sleep with sweet lullabies, or will the infant be put to sleep by machinery?" To Chadabe, Sousa's concerns are so ridiculous on their face that they hardly need refuting. Echoing the words of Edgard Varèse from a half century before, which I quoted at the outset of this chapter, Chadabe argues that "the electronic musical instrument, in its myriad forms, may turn out to be the *most* beneficial to humans and the *most* enjoyable, rewarding, and expressive instrument that has ever existed."[3]

I would like to plant myself firmly on the side of John Philip Sousa in this debate. The idea that electronic music technology is *more* "beneficial to humans" than all other music is absurd, whereas Sousa's question about whether children will be put to sleep by machines points right to the heart

of the issue of how human beings and their increasingly complex technology are going to coexist.

This, in the end, is the issue with which all of my work described in this chapter is engaged. I believe it is the fundamental issue of our time. We see it everywhere, from the smallest scale where we struggle to not be overwhelmed by our cell phones, iPods, and laptops, to a larger scale where we struggle to contain the unprecedented power of transnational corporations whose vast holdings and operations are made possible only by equally vast arrays of networked computers, and where we confront the enormously destructive power of weapons that are more and more readily available to smaller and smaller groups of people, to the truly global scale of world climate change. If art that makes intensive use of the latest technology is to be relevant in such a time, it must begin from here: how the tense and difficult confrontation of humans and their machines is reshaping and threatening our world.

Living Cinema Manifesto

Cowritten with Pierre Hébert.

■ ■ ■

We insist that for a "performance" to be meaningful, it must involve the human body.

We all live in human bodies, all day, every day of our lives. We struggle to make them do the things we want them to do. We have aches and pains. We all know the joy of using our bodies in an expressive and wonderful way, the frustrations of failing, and what it was like to learn whatever physical skills we have: swimming, dancing, riding a bike, playing a sport, anything. It is one thing absolutely every person has in common. The body is the fundamental bond between the performer and the audience, and the basis for "performance." Since we are interested in technology, our performances always involve putting technology and bodies together.

We believe that the meeting of the machine and the body is an uneasy one.

In the realm of performance, this uneasiness is reflected in the fact that, as technology has grown more and more sophisticated, the successful design of "instruments" that can be manipulated during performance with anything like the fluidity and intuition of conventional musical instruments has remained elusive. We do not attribute this failure, however, to a lack of imagination on the part of artists. Rather, we see it as a reflection in art of the uneasiness of the meeting of machine and body throughout culture today,

which can be seen in every human activity: war, work, play, reproduction, and so on. How machines and bodies will coexist is thus not a problem to be "solved," but the central tension of our time in human history, and a compelling terrain in which to locate art.

If forays into this terrain are going to go farther than mere advertising for technology, the tensions and difficulties of the body/machine relationship must not be ignored, swept under the rug, glossed over, or hidden by tricks and gadgets, but brought to front and center, highlighted, magnified, and investigated.

Finally, we believe that the uneasy relationship between human bodies and machines is merely one instance of a much bigger uneasiness between machines and life on our planet. This too must not be hidden in the shadows, but illuminated. For example, the exponentially increasing power of computers is something we find extraordinary and we choose to explore this in our art. However, exponentially accumulating piles of garbage are a necessary and integral part of constantly increasing power of computers. They are two sides of the same coin. Art that investigates the bright side and not the dark side ultimately can only become yet more props for an increasingly oppressive technological culture we wish to challenge.

Pierre Hébert shatters the mirror on which he has been drawing during a performance of *Between Science and Garbage*.

Human Bodies, Computer Music

An earlier version of this essay was published in the Leonardo Music Journal, *vol. 12, 2002.*

■ ■ ■

Pierre Hébert, a frequent collaborator of mine, says the measure of art is whether one can sense the presence of the artist's body in the art. If yes, then it is successful, and if no, it's a failure.

I think this is an important insight. It is closely related to the issue of virtuosity. Virtuosity has been out of fashion for years now, sidelined by conceptual art, punk rock, and other artistic movements that emphasize idea over execution, and by the increasingly common use of machines in performance (beginning with the primary locus of acting moving from the stage to the screen). But virtuosity refuses to go away. It is a necessary element of almost any performance.

I am not speaking here of the narrow notion of virtuosity as represented by, for example, a master violinist, but something much larger, encompassing more than formal technique. There are punk rockers who can barely play their instruments but whose performances are virtuosic in the sense I am proposing. This larger notion of virtuosity refers to what happens when someone acquires such facility with an instrument, or paintbrush, or with anything, really, that an intelligence and creativity is actually written into their muscles and bones and blood and skin and hair. It stops residing solely in their brain and goes to their fingers and muscles and arms and legs.

We all live in human bodies. We may be separated by race, class, gender, religion, geography, and time, but our bodies are a shared experience from which we cannot escape. We all know pain and pleasure, we know the extraordinary things the body is capable of, and the insurmountable limits it imposes. So when you give a performance that takes your body out of the mundane and into something extraordinary through art, this has a profound appeal, and it is the foundation of all performance.

I think most musicians working with electronics are probably not very satisfied with the state of electronic music today, and the crucial missing element is the body. Many of us have been trying to solve this problem for years, but we have been notoriously unsuccessful at it. How to get your body into art that is as technologically mediated as electronic music, or anything with so much technology between your physical body and the final outcome, is a thorny problem.

. . .

I got into electronic music in the mid-1970s, playing analog synthesizers that were just becoming available for personal use outside of research institutions. "Computer music" was still confined to crude programs run on mainframe computers at universities.[4] The thinking at the time was that these electronic instruments were so new and so different—their entire methodology and pedagogy seemed unique—that they would lead to the creation of a new kind of music. We eagerly searched for the outline of this new music no one had ever heard.

Today we actually do have a new kind of music that came directly from electronics, and specifically from computers: electronic dance music. Throughout the whole history of music prior to computers, no rhythm was absolutely perfectly timed due to the limits of human accuracy. This was a good thing, however, as the nuanced irregularities in how the beat was actually played was one of the crucial things giving distinctive character to different traditions of music. The perfectly timed beat was a sort of ideal grid that everyone kept in their mind but never actually played. With the evolution of jazz, the discrepancy between the ideal grid and what people actually played came to be known as swing, but there is no music in the world that didn't have *some* bit of swing. With computer dance music, the precise mental grid that had been lurking unheard for thousands of years behind the irregularities of human performance was pushed out front and made audible. This was a natural outgrowth of using computers with sound. When playing music with bodies, even approaching electronically precise timing requires years of practice; with computers this is turned upside down—electronically precise timing is the simplest method, and the introduction of irregularity requires more thought and effort.

That's revolutionary. It is a kind of music that could not exist without computers and thus meets the criteria for the music we thought must be coming but could not see in the 1970s, though it is not what anyone back then was expecting. In fact, many of us absolutely detest it. But if we step back for a minute, we can see it is not surprising that this is what developed, since we never found a way to get our bodies into electronic music.

I remember when the first MIDI sequencers (easily manageable composition software for personal computers) became available and everyone said, "Well, that's cool, but it sounds so machinelike no one will ever listen to it." And software engineers busied themselves trying to figure out how to make MIDI sequencers sound human. But before they could make much headway,

a new generation had come up who *liked* the machinelike quality. Apparently our tastes acclimate faster than our ability to technologically innovate.

Or at least the tastes of young people. Reaction to music with an electronically precise beat is the most generational thing I have ever seen in music, or any other art for that matter. I cannot think of a person who, in their youth and early adulthood, listened only to humans playing rhythm who now enjoys it. And I know very few people who listened to machines playing rhythms in those formative years who find it problematic.

Much of this music one hears today solves electronic music's problem with performance by making music the secondary event to whatever else is happening. People don't miss the performance, because it is not what they are paying attention to. They are dancing, or chatting at the bar, or taking drugs, or *something*, but they are not focused on the performance. In fact, people who make electronic dance music go to great lengths to divert people's attention from their actual presence, putting up screens, light shows, smoke-screens, showing film and video, and so on.

But more importantly, I think it is no coincidence that as computer music moved from research institutions to a major pop form it became primarily a dance music, for this is a back-door way for bodies—and virtuosity in the broad sense in which I am using it—back into the music. The physical bond of performance moves from the stage to the dance floor, while the "performers" (those monitoring the machines that are making the music) hide behind a light show or a fog machine. In this light, one can see the trajectory of recent musical history in three parts:

- Part one: people sit attentively in audience, watching performances in which people use their bodies to make music;
- Part two: an awkward transitional phase in which people sit attentively in audience, watching people sitting equally attentively onstage managing machines that make music. The awkwardness comes from the absence of the body, of performance;
- Part three: people sit attentively onstage managing machines making music, while everyone else dances, performing with their bodies.

Of course, the idea of people dancing to music is nothing new. The trajectory I am trying to highlight begins in Western concert music, which had an enshrined tradition of audiences sitting in rapt attention. In the twentieth century, composers in this tradition began to experiment with using machines to make sound, but these endeavors were never able to sustain a concert tradition. Electronic music machines were meanwhile being enthusi-

astically embraced in the rock and, to a lesser extent, jazz worlds, which had evolved their own concert formats of seated audiences. But when automatic music machines finally found a niche in which they appeared as indigenous inhabitants instead of foreigners being adapted to alien surroundings, it was in a musical form in which dancing was the whole point.

It is very rare for anyone to listen to this music without dancing, even its most fervent aficionados. The only home this music has found outside the dance club is in advertising: its utter vacuousness, combined with its vague references to youth and parties, makes it an ideal audio backdrop to the televised sales pitch.

■ ■ ■

The project of integrating the human body into the performance of music in which the sound is generated by machines thus remains quite problematic. This should come as no surprise. It is a fundamentally new problem: before the advent of machines that could automate sophisticated processes, there was no performance *without* the body. Since the body could not be gotten out, no one had to worry about how to get it back in.

More importantly, the whole problem is just one particular manifestation of the tension between the human body and the machine, which is at the very core of modern life. It finds expression in every aspect of our existence: work, play, health, reproduction, war, love, sex, and art. It is what structures our time and civilization. The fact that musicians have not resolved this tension indicates no failure of imagination on their part. It cannot be *solved* in the sense of a solution that can make a problem disappear. It can only be *experienced* in different ways. This makes it a fertile terrain for art, in particular for artists who work from an aesthetic like mine, which prioritizes struggle and tension. But negotiating this terrain requires that art that uses machines must do so critically, neither celebrating nor rejecting technology, but questioning and probing it, examining its problematic nature, illuminating or clarifying tensions between technology and the body, and thus offering the kinds of insights only art can provide concerning the nature of life at the dawn of the third millennium.

■ ■ ■

[*Note: Given the broad range of subjects I am addressing in this book, I have tried to write in such a way that each section will be of interest to readers who are not specialists in whatever topic is under immediate discussion. The remainder of this section may depart from this standard. I include it because I think*

there will be a significant number of readers who are sufficiently knowledgeable in the details of the subject matter to find the discussion useful. Others may wish to skip to the following section.]

Most of the earliest electronic music was musique concrète, compositions made from collages of sounds recorded on magnetic tape. In general, these were studio works first and last: painstakingly assembled by cutting up pieces of recording tape with razor blades and splicing them back together. "Performance" of these works consisted of playing back the final tape. In the late 1970s I made some attempts to move tape manipulation out of the studio and onto the stage by building contraptions of multiple tape recorders I could crudely manipulate during performance, but this idea was a little far-fetched.

Instead of using recorded sound, analog synthesizers generated voltages that oscillated at audio frequencies and thus could be heard as sound when amplified and sent to loudspeakers. One way to "play" these synthesizers was to control the shape, amplitude, and frequency of these audio signals with other voltage sources that were changing at a rate slow enough for the changes to be perceived as distinct events instead of sound. This was a very enticing idea: since both the shape of the sound and the shape of a composition could be controlled in the same world of automated voltages, complex and surprising systems could be set up within the synthesizer itself, which produced music that was startlingly new and different. "Composing" in this situation meant setting up the connections and parameters of the synthesizer so as to set in motion a specific set of processes, and "playing" the composition involved listening to the output and intervening in the evolution of the process by fine-tuning parameters and connections as things progressed.

This was the focus of my work in the 1970s. But whereas most others working along these lines did so alone or with other synthesizer players, I moved to New York and immersed myself in the downtown improvised music scene, trying to develop the skill necessary to set up processes in my synthesizer and then intervene to change them as quickly and accurately as collaborators like John Zorn (saxophone) or Fred Frith (guitar) could with their instruments.

A completely different way to play the synthesizer that also evolved during this time involved rigging a conventional instrument to generate voltages that could control synthesized sound. Keyboards were designed that translated the depression of the keys to a voltage the synthesizer could accept. Less successful experiments were made using guitars, drums, and other instruments as the "controller," or input device.

Many people, including myself, thought the use of keyboards and such a dead-end, for it meant using a lot of technology to play music that could be readily played with a piano or a guitar. When confronted with a row of keys that look like a piano and are laid out in a pattern of twelve unique notes in an octave, most people understandably start to think like piano players, and to think in conventional terms of harmony and melody. But the situation is even worse than that, for acoustic instruments never sound two notes in exactly the same way. There are too many variables in how one's fingers or breath actually produce the sound. Just as small variations in the beat turned out to be a critical nuance that shaped different traditions of music, small changes in sound from note to note turned out to be crucial to the vitality of musical sound (at least to the ears of those of us who grew up listening to acoustic instruments). It is impossible to get that kind of note-by-note variation from a synthesizer, and this is what gives conventional music played on a synthesizer its characteristic flat, machinelike feel.

Thus, while keyboards and guitars attached to synthesizers could be incorporated into conventional music in an often cheesy way, synthesizers seemed to hold the potential for something much more radical. Exploring in that direction meant throwing out the keyboards and learning to "play" the complex internal processes that seemed to be idiomatically indigenous to these new instruments.

Digital technology soon developed to the point that all the processes that synthesizers did with voltages, computers could do with bits, and do so more accurately, more flexibly, and less expensively. Digital synthesizers and samplers replaced tape recorders and analog synthesizers, but the dichotomy between conventional music played mechanically on the one hand, and more unorthodox process-oriented music on the other, moved from the synthesizer to the laptop fully intact.

The problem was and still is how to get one's body into the unorthodox kind of performance we are talking about. It had been problematic enough with a synthesizer: sitting onstage and carefully moving a knob a fraction of an inch, disconnecting a patch cord here and reconnecting it over there, and none of it correlating with a direct change in the sound the audience might perceive. With the emergence of the laptop as instrument, the physical aspect of the performance has been further reduced to sitting onstage and moving a mouse an inch or two, or dragging one's finger across a track pad.

Among instrument designers and programmers this is often conceived as a problem of "controllers"—that what are needed are new kinds of physical devices, the manipulation of which would integrate more appropriately

into this kind of performance than a keyboard, guitar, or knob or button. For years there has been a lot of experimentation with "alternative controllers" at research studios around the world. I have tried many myself: infrared wands, drawing tablets, joysticks and game pads, video frames—anything I can get my hands on.

But despite years of research and experimentation, there is still no new instrument sufficiently sophisticated to allow anyone to develop even a rudimentary virtuosity. This failure is rooted in the very premise that the problem lies in inadequate controllers. The bigger problem is this: what exactly are we going to control with these instruments/controllers we would like to invent? The performance software I have made doesn't require lots of data input to play. On the contrary, it requires very little. I might spend a whole performance making changes of very fine gradation to just a few variables.

If I had some really wild controller that doesn't exist now but I could dream up—a big ball of mud that I could stick my hands in and squeeze and stretch and throw against the wall and wrap around my head, and that puts out many parameter streams that can be seamlessly digitized and fed to a computer—I wouldn't know how to use it. I don't have any software that could use all that data, and I don't think anyone else does, either. The problem is inherent in the very concept of the music: if we are "playing" music by intervening in automated machine processes, then there is a lot going on that requires no input from the performer, and subtle changes that redirect the flow of the automated process are more likely than dramatic gestures to give compositional coherence to the result.

■ ■ ■

There were, however, some early electronic instruments that integrated the body differently. The theremin, designed by Léon Thérémin in 1919, and Maurice Martenot's 1928 ondes Martenot both produced sound by means of the beat or difference effect using two oscillators of inaudible radio frequency to produce an audible difference tone controlled by changing electrical capacitance. With the ondes Martenot this was done by moving an electrode, with the theremin by moving one's hands around an antenna.

These instruments were very limited. They could play one timbre, and that was pretty much it. Since the performer had control over only volume and pitch, their application was limited to performing fairly conventional music, and over the years the theremin eventually found a niche making spooky effects for sci-fi movies. However, they do stand as possibly the only electronic musical instruments on which one could become a virtuoso. Clara Rockmore,

in particular, became a bona fide theremin virtuoso by any definition of the word and performed on the instrument in concert music settings.

The reason for this possibility of virtuosity is that the physical capacitance of the player's hands directly shaped the pitch and amplitude of the sound. There were thus fewer layers of technology between body and sound than in most other electronic instruments. Another factor was that these were conceptually complete instruments that did not undergo a constant series of revisions, redesigns, and "upgrades." The way the sound is generated and the way it is controlled are an integrated package that one can literally stick one's fingers right into. And one can devote years to learning to play it without worrying that all that hard work will become useless every six months by an "upgrade" that changes everything.

But the most successful electronic instrument to date by far is the electric guitar. This is not even a "pure" electronic instrument, in the sense that the sound is not generated electronically but physically by a vibrating string, which is then amplified electronically. Within academia it is not typically even included within the realm of electronic music, identified as it is with blues and rock. It took the genius of Jimi Hendrix to blow the lid off the conventional use of this instrument and point the direction to a whole new way of playing a whole new kind of instrument. Hendrix's crucial innovation was to notice that by playing at high volume and standing close to the speaker, he could get feedback that he could control in an extremely nuanced way with the position and angle of the guitar, the weight and position of his fingers on the strings, even the exact position of his entire body.

At his most experimental, Hendrix made probably the most successful electronic music to date. It is music that would be impossible to make, even impossible to imagine, without electronics, and it is hard to imagine a musician on any instrument in any genre integrating his or her body into the performance as totally as Hendrix did. Watching films of him now is a revelation; his guitar and his body appear as one, and it seems like everything from his toes to his hair is involved in shaping the sound.

The radical element in Hendrix's work has been subsequently developed by Keith Rowe and Fred Frith, among others. These two approached the electric guitar much more explicitly conscious of leaving the entire tradition of the acoustic guitar behind and starting from scratch with the idea that they were dealing not with a guitar per se, but with amplified vibrating strings stretched over a resonant body, and that by using amplification, even tiny disturbances to the string could be made into musically useful sound.

Interestingly enough, electronic modification of the sound is not central

to the work of any of these three musicians. Hendrix used a wah-wah pedal, which is just a very crude filter. When I first started playing with Fred Frith, he was using no electronic modification of the sound at all. And while at subsequent times he could be seen with many foot pedals that electronically manipulate the string sound in various ways, physical control of the vibration of the strings was always at the center of his work.

In addition to the electric guitar, the turntable has also emerged as an interesting hybrid instrument, pioneered by Christian Marclay and now the focus of intense experimentation by an entire generation of DJs. Here again, we have a sound that is generated physically: the vibrations of a stylus as it is dragged across different surfaces. Once again, the crucial element that the electronics provide is the amplification, which makes subtle variations in the use of the stylus musically meaningful. Any further electronic processing done to the sound is just icing on the cake. Here again, we have a development that was missed entirely by electronic music research institutions, coming instead from popular culture. People like Marclay and the Invisibl Skratch Piklz have developed substantial skills that require very fine control and techniques, something like virtuosity.

Opposed to all this, the approach favored in electronic music research facilities has been to electronically process conventional instruments—say, a clarinetist performing with a second musician who sits at a computer that is recording the clarinet sound and manipulating it in various ways. With some exceptions, this direction of work has produced stunningly uninteresting results. Music that uses electronically generated sound from synthesizers or computers suffers from the problem that one cannot actually get one's fingers into the generation of the sound. Hybrid instruments like the electric guitar solve this problem by using sound sources controlled with the body and amplifying them. But acoustic/electronic collaborations, such as have been the rage in academic computer music, make the problem even worse by dividing up the tasks of generation and control of the sound and giving them to two different people. The sound might be generated by an extremely skilled instrumentalist with masterful control over the instrument, but this is often all but irrelevant since the final output is determined by someone sitting at a computer.

■ ■ ■

What follows is a brief synopsis of the instruments and controllers I have used over the years.

From the mid-1970s to 1982, my main ax was a synthesizer designed by

Serge Modular Music Systems. With no keyboard or other controller, it just had a large array of knobs and buttons, with brightly colored patch cords for connecting the many inputs and outputs. This can be heard on *Fall Mountain* (1979), *Voice of America* (1982), and Anthony Braxton's *Creative Orchestra (Köln) 1978* (recorded in 1978, released in 1998).

The destruction of the Serge in a technical mishap in London in 1981 sealed my departure from music for Central American politics for the following years. When I returned at the end of the decade, I began working with a sampler manufactured by Ensoniq. This sampler had a keyboard with polyphonic aftertouch, meaning that each key gave its own continuous pressure reading. One could thus control a separate variable with the finger pressure on each key. This made for a surprisingly effective controller, as the keys could be used as a very large collection of well-arranged potentiometers that one could quickly move with one's fingers. If you were smart about how you routed this data to the sampler's parameters, this became a powerful tool. I used this sampler on numerous recordings, including *Attention Span* (1990), *Sooner or Later* (1991), *Burns Like Fire* (1992), *All the Rage* (1993), and *Twins!* (1996). *Like a Melody, No Bitterness* (1997) was recorded as a document of my improvising on the instrument before finally moving on after ten years.

Both of these instruments had all the problems discussed above: I played them by setting up ongoing mechanical processes and intervening in them by moving a knob, poking a button, changing a patch cord, or pressing down on a key. Much of my movement was too subtle for the audience to see, and tiny changes in parameters could result in huge changes in sound, which audiences could find disconcerting. With both instruments I initially felt quite naked onstage. Moving knobs and patch cords is not generally considered a very stageworthy activity. When I got the sampler I made a conscious decision not to learn anything about "keyboard playing," because I did not want to start thinking like a keyboard player, but sitting onstage at a keyboard and not being a keyboard player can be uncomfortable.

In each case, however, after playing the instrument for a number of years I lost that naked feeling. Not that I developed any virtuosity in the sense that I have used here, but I did manage to become confident enough in my "playing" that I was able to relax my body into the performance and feel like it belonged there. I believe that audiences accepted that, as well, and performances became more credible.

In part this increase in credibility was due to the fact that there was at least some sort of physical interface between myself and the instrument. The synthesizer had real knobs and buttons, not virtual ones, and I managed to

put a little more bodily control into the performance by triggering some of its processes with a contact microphone I kept clenched between my teeth, which I would gnaw on during the performance. And manipulating the pressure of the keys on the sampler required a certain amount of elbow grease.

More importantly, I played each of these instruments for years. This would be a ridiculous claim in the world of conventional instruments, where mastery requires a lifetime, but in the world of electronic instruments even the ten years I spent with the sampler is rare. In general, people are in such a rush to keep up with the stream of technological innovation that they never stick with one instrument long enough to learn to play it in any meaningful way.

Why Computer Music Is So Awful

In 1996 I was invited to be a member of the computer music jury at the Ars Electronica festival in Austria. This is an extremely well-funded computer arts festival that gives prizes of significant sums of money in various computer-arts fields. I had never been on a jury before in my life. What's more, I was completely out of touch with the world of academic computer music, from which most submissions to the contest came. I accepted the invitation, looking forward to the chance to hear the latest works from Stanford, the IRCAM center in Paris, and other bastions of official Computer Music. However, once I heard the music that was submitted, I was stunned at how utterly awful most of it was.

The festival asked me to write an essay about my experience for the book they publish after each year's festival, and I wrote the following.

∎ ∎ ∎

Back in the early days of electronic music, the tools that were available were quite primitive, yet the range of music that was attempted was staggering, and a freewheeling spirit of adventure was prevalent. Today, we have computers with technical capabilities inconceivable to previous generations, yet as the technical capabilities have expanded, the range of musical possibilities that are being explored has become increasingly restricted.

Similarly, in the "old days" access to the electronic music-making technology was limited to a handful of individuals working in a few research institutions. Today, computers are ubiquitous in music. There is almost no recorded music that does not involve the use of a computer somehow or other, and the decreasing cost of the technology means that a bona fide home computer music studio is within the means of any member of the middle class

of the Western world, or even any middle-class teenager. Yet just as computers' presence in music has mushroomed from nearly invisible to downright unavoidable, the range of music considered to be Computer Music has become increasingly fixed and rigid. Why this contradictory evolution, which seems to impose social restrictions as fast as technology seems to offer new freedom? Why this emergence of Computer Music, instead of an openness to all the musics that computers make possible?

The emergence of Computer Music as a thing isolated off on its own, for which advanced academic degrees are conferred, ponderous journals and conferences are organized, and prizes awarded, is of course intimately linked to the careers, salaries, and prestige of the individuals and institutions that benefit. Here the logic of the inverse development of the broadening use of computers in music against the narrowing of the concerns of Computer Music at least has a clear and rational basis in the self-interest of those involved. In fact, it is a phenomenon seen time and time again in academia: the more an area of knowledge becomes general public knowledge, the louder become the claims of those within the tower to exclusive expertise in the field, and the narrower become the criteria for determining who the "experts" actually are.

The cul-de-sac these trends have led Computer Music into is a considerably less enjoyable place to tarry due to a technological barrier that is becoming increasingly obvious: despite the vastly increased power of the technology involved, the sophistication of the most cutting-edge technology is not significantly greater than that of the most mundane and commonplace systems. In fact, after listening to the 287 pieces submitted to the Ars Electronica computer music jury, I would venture to say that the pieces created with today's cutting-edge technology (spectral resynthesis, sophisticated phase vocoder schemes, and so on) have an even greater uniformity (not to say monotony) of sound among them than the pieces done on MIDI modules available in any music store serving the popular music market. This fact was highlighted during the jury session when it was discovered that a piece whose timbral novelty was noted by the jury as being exceptional and fresh was discovered to have been created largely with predigital synthesizers thirty years old.

To put the matter in its bluntest form, it appears that the more technology is thrown at the problem, the more boring the results. Composers may begin with a musical idea but get lost along the way in the writing of the code, the troubleshooting of the systems, and the funding to make the whole thing possible, then fail to notice that the results do not justify the effort. It is interesting to note that the jury for computer animation found an opposite

result: in animation, at least, the difference in quality between work done with cutting-edge versus commonplace technology is immediately apparent to even the untrained observer. Even, in fact, to an eight-year-old. Thus the success of *Toy Story*. (*Toy Story* won the Ars Electronica prize in animation that year, much to the consternation of many involved in the festival.)

In Computer Music, on the other hand, the merits of the works done with cutting-edge versus commonplace technology are certainly opaque to the uninitiated, and often discernible only to those who have invested time and effort in acquiring expertise in the very same technology. (It must be said, however, that due to the enormous financial returns that hinge on visual innovation, the resources thrown at computer animation dwarf those involved in even the most high-end music systems. Who knows what might result if the resources put into developing the two hours of *Toy Story* animation were put into two hours of music.)

If, however, we leave the confines of the Computer Music tower and look at what is happening outside in the rest of world, what do we see? Computers are revolutionizing the way music is made. In electronic dance music we have genre upon subgenre upon microgenre of music that is based almost entirely upon, and impossible to conceive of without, the absolute regularity of tempo that computers are capable of producing. Automated mixing consoles and digital effects processors have brought a sea change in the subtlety and nuance possible in the mixing of recorded music, as immediately becomes apparent upon comparing recordings made before and after their emergence. This has opened up a whole new range of studio artistry. Or to go to a different extreme, the drum machine extravaganzas of Ikue Mori, with their almost absurdly complex tempo and meter juxtapositions, usually determined on the fly, are unthinkable without computers.

All these developments and more are cases in which the introduction of computers has profoundly changed the way music is conceived, played, recorded, and appreciated, creating new genres, new fields of expertise, new forms of experiencing a performance, and so on. All of it is unimaginable without computers. And none of it is Computer Music.

And we have not even mentioned sampling. Of all the ways that computers have been applied to music, sampling has had the most radical impact. Sampling has taken musique concrète, blown it open, and showered the debris down on the entire musical world. New genres have been spawned and existing ones changed forever. New terrains of collaboration and appropriation have been opened. Fundamental notions of authorship and artistic

ownership have been shattered, leaving for the moment no clear heir in their place. It may not even be an exaggeration to say that the entire " postmodern" aesthetic has been shaped in important ways by this technology.

Yet sampling is not Computer Music. Why? Precisely because sampling is everywhere. If sampling is the legitimate domain of any teenager working on the family Macintosh, no one can claim a monopoly on its knowledge. Thus it falls from the rarefied heights of Computer Music, its vast impact and consequences notwithstanding.

I wish to be very clear here: I am not arguing that the market in which popular music is bought and sold is a valid arbiter of artistic excellence. As a composer who worked for years with no institutional connection or support, surviving on the fringes of the music market, I am acutely aware of how the market imposes its own constraints and discourages the kinds of creativity that interest me the most. It is the weight of these very market constraints that make it so important that those musical arenas that operate according to nonmarket criteria be as open and flexible as possible.

The very existence of all those kids messing around with sampling on a home computer has helped to stir an interest in novel musical approaches in general, and music made with computers in particular, that is broader than ever. Isn't it ironic? On the one hand we find market constraints squeezing popular music with an unprecedented vigor, and on the other hand we have a public with an equally unprecedented fascination with computers and their possibilities. And yet Computer Music can find no audience beyond those who make it.

conclusion

The Professional Suicide of a Recording Musician

In March 2006 I posted all my recordings to which I had the rights on the Web for free download. One year later I wrote the following essay, which was published jointly on AlterNet.org and QuestionCopyright.org, in April 2007.

■ ■ ■

In March 2006, I posted all my recordings to which I have the rights on the Web for free download. This included numerous LPs and CDs created over twenty-eight years.[1] I explained my motivations in a statement I posted on my Web site:

> I have decided to make all my recordings to which I have the rights freely available as digital downloads from my web site.
>
> This will make my music far more accessible to people around the globe, but my principal interest is not in music distribution per se, but in the free exchange of information and ideas. "Free" exchange is of course a tricky concept; more precisely, I mean the exchange of ideas that is not regulated, taxed, and ultimately controlled by some of the world's most powerful corporations.
>
> I do have serious reservations about this step, however, but they have nothing to do with money. My music is made for sustained, concentrated listening. This kind of listening is increasingly rare in our busy, caffeine-driven, media-drenched, networked world. I suspect it is even rarer for music that was downloaded for free, broken up and shuffled through fleeting "playlists," and not objectified in a disc that one can hold in one's hand, file on the shelf, or

give to a friend. But ultimately this concern has nothing to do with whether we charge money to hear recorded music, and everything to do with how we live in a culture in which there is a surplus of information and a scarcity of time to pay attention.[2]

One year later, I continue to be amazed at how few other musicians have chosen this route, though the reasons to do so are more compelling than ever. Why do musicians remain so invested in a system of legal rights that clearly does not benefit them?

When record companies first appeared, their services were required in order for people to listen to recorded music. Making and selling records was a major undertaking. Recording studios and record manufacturing plants had to be built, recording technology and techniques developed. Records not only had to be manufactured, but also distributed and advertised. Record executives may have been crooked in their business practices, callous about music, and racist in their treatment of artists, but the services the companies provided were at least useful in the sense that recorded music could not be heard without them. Making recorded music available to the general public required a significant outlay of capital, which in turn required a legal structure that would provide a return on the required investment.

The contrast with the World Wide Web today could not be more striking. Instant, worldwide distribution of text, image, and sound has become automatic, an artifact of production in the digital realm. I start a blog, I type a paragraph: instant, global "distribution" is a simple artifact of the process of typing. Putting twenty-eight years of recordings up on my Web site for free download was a simple procedure involving a few hours of effort yet resulting in the same instant, free, worldwide distribution. It makes no difference if ten people download a song or ten thousand, or if they live on my block or in Kuala Lumpur: it all happens at no cost to either them or me other than access to a computer and an Internet connection.

So much for distribution. What about production? Almost none of my releases were recorded in a recording studio provided by a record company. They were recorded onstage, in schools or radio stations, or in living rooms, bedrooms, and garages with whatever technology I could cobble together. They are made either by myself alone or with a small handful of close collaborators. In one sense this is atypical, because I intentionally developed an approach to recording that was premised on never needing substantial resources, with the explicit goal of maintaining maximum artistic autonomy. While this approach may have been unusual twenty years ago, it is less and

less so today as digital technology has drastically reduced the cost of recording. There are very few recording projects today that actually require the resources of the sort of high-end recording studios record companies put their artists in (and for which the artists then pay exorbitantly—bills that must be paid off before the musicians see any royalties from their recordings). Just as the Web has changed the character of music distribution, laptops loaded with the hardware and software necessary for high-quality sound recording and editing have changed the character of music production.

Record companies are not necessary for any of this, yet the legal structure that developed during the time when their services were useful remains. Record companies used to charge a fee for making it *possible* for people to listen to recorded music. Now their main function is to *prohibit* people from listening to music unless they pay off these corporations.

Or to put it slightly differently, they used to provide you with the tools you needed to hear recorded music. Now they charge you for permission to use tools you already have, that they did not provide, that in fact you paid someone else for. Really what they are doing is imposing a "listening tax."

Like all taxes, if you don't pay, you are breaking the law. You are a criminal! Armed agents of the state have shown up at private residences and taken teenagers away in handcuffs for failure to pay this corporate tax. It is worth noting how draconian state coercion has been in this field in comparison to many others. For example, almost everyone I know (including myself) has an unpaid copy of Microsoft Word on their computer. I am certain that some kids who have run into legal trouble for sharing music without paying the corporate tax also had unpaid copies of Microsoft Word on the very same hard disks that were taken as "evidence" of their musical crimes. Yet no state agents are knocking on the doors of our houses to see if we have pirated software. Music alone is singled out for this special treatment.

You would think that musicians would be leading the rebellion against this insanity, but most musicians remain firmly committed to the idea of charging fees for the right to listen to their recorded music. For rock stars at the top of the food chain, this makes sense economically (if not politically). The entire structure of the record industry is built around their interests, which for all their protesting to the contrary dovetails fairly well with those of the giant record companies.

But the very same factors that make the structure of the record business favor the interests of the sharks at the top of the food chain work against the interests of the minnows at the bottom, who constitute the vast majority of people actually making and recording music. Most records, in fact, produce

good money for corporations and little or none for the musicians. This is because the recording studios and engineers, art departments, advertising departments, A&R departments, legal departments, limo services, tour agencies, caterers, and distribution networks that swallow up the sales revenue for all but the big hits are owned by these very same corporations. Records that sell tens of thousands don't "break even" not because no money comes in, but because all the money goes to keeping the corporation in the black. Revenue for the corporation starts coming in with the first CD sold; royalties for artists don't kick in until every part of the bloated corporate beast is adequately fed.

What exactly are these corporations? To begin with, we should note that the major "record companies" are not actually record companies at all but huge media conglomerates. Most "independent" labels are owned by a corporate label. Each "major" is in turn owned by an even bigger corporation, and so on up the food chain. At the top of the chain sit a tiny handful of media giants: Time Warner, Disney, Rupert Murdoch's News Corporation, Bertelsmann of Germany, Viacom (formerly CBS), and General Electric. These corporations are among the world's largest. All are listed in *Fortune* magazine's "Global 500" largest corporations in the world. They have integrated both horizontally (owning lots of record labels, lots of newspapers, or lots of radio stations) and vertically (controlling newspapers, magazines, book publishing houses, and movie and TV production studios, as well as print distribution systems, cable and broadcast TV networks, radio stations, telephone lines, satellite systems, Web portals, billboards, and more).

This incredible concentration of power over news, entertainment, advertising, music, and media of all kinds is a recent phenomenon and is fueled by the very same digital technology that has made the Web and the recording-studio-in-the-bedroom possible. In 1983, fifty corporations dominated U.S. mass media, and the biggest media merger in history was a $340 million deal. By 1997, the fifty had shrunk to ten, one of which was created in the $19 billion merger of Disney and ABC. Just three years later, the end of the century saw the ten shrink to just five amid the *$350 billion* merger of AOL and Time Warner, a deal more than a thousand times larger than "the biggest deal in history" just seventeen years before. As Ben Bagdikian, author of the classic study *The New Media Monopoly,* noted, "In 1983, the men and women who headed the first mass media corporations that dominated American audiences could have fit comfortably in a modest hotel ballroom . . . By 2003, [they] could fit in a generous phone booth."[3]

These companies own the most powerful ideology-manufacturing appa-

ratus in the history of the world. It is no wonder they have convinced most musicians, and most everyone else, that the entire endeavor of human music making would come to a screeching halt if people were allowed to listen to recorded music without first paying a fee—to these corporations. I know many musicians for whom making records in an environment dominated by corporate giants has been an exhausting and thankless task from which they have derived little or no gain. Yet they remain convinced that taking advantage of the free global distribution offered by the Internet would constitute some sort of professional suicide.

Here is how the structure of this industry ruins the aspirations of independent-minded musicians and labels. Mainstream CDs sell in large numbers for only a short window of time, usually while songs from the CD are on the radio. Unless those CDs are on the shelves of stores while the songs are on the air, potential sales are lost. In order to get stores to order large numbers of CDs in advance, the industry evolved with the norm that stores can return unsold CDs at any time. If your company sells pants, or toasters, or bicycles, retailers cannot do this, but record shops can. As a result, record labels must have more money in the bank per unit sales—be more capitalized—than other kinds of companies.

Unfortunately, with almost all independent labels, this is far from the case. Most are started by music fans driven into the business by their passion for the music they love. They operate on a shoestring. They send out a bunch of records and hope for the best. Sales might look good at first, but at some later point they get swamped with returns and they have a cash-flow crisis. To survive the crisis they engage in creative bookkeeping, telling themselves it is okay because they are really doing this in the interest of the artists, and when things improve everything will get sorted out. But things only get worse, until they collapse or they get bought by a bigger company with more capital. If they collapse, artists don't get paid and there is a storm of mutual recrimination. If they get bought, the company that buys them is generally interested only in the top-selling artists in the catalog and may well take all the other titles out of print. I know one artist who had ten years of his recordings vanish into the vault of a big label that bought the little label he recorded for. He approached his new corporate master and *asked to buy back the rights to his own work and was refused.* In the company's view, his work did not have sufficient market potential to justify releasing it and putting corporate market muscle behind promoting it, but neither did they want his work released by anyone else to compete with the products they did release. From their perspective, it was a better bet to just lock it up.

I could relate many more anecdotes here, or delve deeper into the structure of the industry, but I think what has been said so far should suffice. Among people in my immediate social circle of musicians, John Zorn, Mike Patton, and Fred Frith have, over the years, sold CDs in sufficient quantity to actually make money. For all the rest of us, selling recordings in whatever format has been a break-even proposition at best. Not only have we not made any money, for most people in the world our music is unavailable. My works provide an excellent example.

- My first LP, with the Fall Mountain ensemble, was released on Parachute, a small label run by Eugene Chadbourne, which folded long ago, and the music has been unavailable ever since.
- My *Getting A Head* and *Voice of America* were released on Rift, a small label run by Fred Frith, which suffered the same fate. They remained unavailable until I put them online for free.
- My *Attention Span, Sooner or Later, Burns Like Fire,* and *Say No More* were released on RecRec in Switzerland, a label launched by a music fan that went through exactly the trajectory typical of small labels I described above. By the time I and other artists recording for the label discovered that we were being cheated out of our royalties, the label was already collapsing. Here again, all this music remained unavailable until I put it online for free. Since then, several thousand people have heard it.

I could continue this list, but there are a lot of CDs and the stories would become dully repetitive. Of course, my music is pretty far off the beaten path. But if I had instead spent the last decades playing in rock bands that had released a series of recordings that each sold in the tens of thousands, the details would be different but the result would be the same. This is the structure of music distribution it is allegedly in the interests of musicians to defend.

There is now a very simple alternative, which is to post your music on the Web. No, you won't make any money from it, but the odds are overwhelming that you would never make any money from it anyway, even if you charged for it. And by posting your music on the Web, a remarkable thing happens. People all over the world can actually hear it. When my music was available only for sale on CD, I would often hear from people who had spent years unsuccessfully trying to find a copy of a particular CD, and these were hardcore listeners who put a lot of their free time into finding recordings of

music that was important to them. Now anyone with even a passing interest can find my music easily and hear it.

People have actually been convinced that if it were not possible to charge fees for listening to recorded music, there would be no "incentive" to play music. It's time to take a step back and see the big picture. As recently as sixty years ago, most people who made their livelihood from music viewed the recording industry as a *threat* to their livelihood, not the basis of it. Given the mountains of money that big stars have made during the intervening decades, this fear has generally been viewed in retrospect as hopelessly naive. But consider the following: a few years ago I performed in the cultural festival organized by the Sydney Gay and Lesbian Mardi Gras and witnessed the parade and dance party that is this festival's culminating event. The parade brought roughly half a million people into the streets, including participants and observers. It took hours for the parade to slowly move through its course. Every contingent in the parade had its own choreography and music. The participants danced through the streets, and many spectators danced alongside. So that's half a million people dancing in the street for several hours. The parade ended in a twelve-hour dance party attended by over twenty thousand, featuring seven different pavilions with nonstop music in each. Before the era of recording, the number of musicians required to keep half a million people dancing for six hours, and then twenty thousand dancing for twelve hours more, would have easily run into the thousands. At the event I attended, the musicians involved numbered exactly one. No contingent in the parade included a live musician—all were dancing to recordings. All the music at the dance party was recorded, as well. In the largest pavilion, at the climax of the party, an actual live singer, Chaka Kahn, emerged in a blaze of fireworks and lights to sing a short medley of her hits—to recorded accompaniment.

Humans have walked this earth for about 200,000 years. We don't know exactly when music emerged, but it was certainly a very long time ago, long before recorded history. There is evidence that music may have been integral to the evolution of the human brain, that music and language developed in tandem. The first recording device was invented just 129 years ago. The first mass-produced record appeared just 110 years ago. The idea that selling permission to listen to recorded music is the foundation of the possibility of earning one's livelihood from music is at most 50 years old, and it is a myth. The fact that most musicians today believe in this myth is for corporate power an ideological triumph of breathtaking proportions.

The issues involved here are hardly limited to music but extend outward to a legal and corporate structure that shapes our culture so profoundly its importance can hardly be exaggerated. Music is no longer just music but a small subset of a corporation's properties. Property rights have become so absurdly swollen that they now constitute a smokescreen hiding a corporate power grab on a scale rivaling that of the great robber barons of the nineteenth century. Instead of grabbing land or oil, today's corporate barons are seizing control of culture. They are using the legal construct of property to extend the reach of corporate power into parts of our lives that were previously beyond their grasp.

There are so many shocking anecdotes one could relate in this regard; here is one from my own recent experience. It has been my privilege to have John Cooney as a student. John is young, bright, enthusiastic, politically engaged, and artistically gifted. During his freshman year at college, he made a short animation about global warming that won the Flash Contest prize from Citizens for Global Solutions and the Environmental Award of the Media That Matters Film Festival. He also made a computer game that he put online for free, and that was listed as a "Top Free Online Game" by Freeonlinegames .com, a "Game of the Week" by ActionFlash.com, and a "Featured Game" by Addicting Games. John's game also made the "Flash Player Top Games List" and was even the subject of a story on BBC World News.

Not bad for an eighteen-year-old college freshman. But both his projects resulted in cease-and-desist letters from corporate lawyers, including one from Tolkien Enterprises demanding that he not refer to an animated character in a game he was offering online for no charge as a "hobbit." None of this involved high stakes or dire consequences. John's game no longer features a "hobbit." This case is trivial compared to parents getting sued for vast sums because their kids are downloading pop songs, or the unhappy plight of *Eyes on the Prize,* a film that beautifully documents the civil rights movement in the United States yet was withdrawn from circulation because its makers could not afford to renew all the necessary permissions on the incidental music that "leaked" into the film via documentary footage (which included a substantial payment to the copyright holders of the "happy birthday" song as the film shows Martin Luther King Jr.'s family at home celebrating the civil rights leader's birthday).

But John's experience is important precisely because it did not involve important people or high-profile issues. Even though there was no realistic possibility that anyone would think Tolkien Enterprises had somehow endorsed or been involved in John's project, the mere fact that someone,

somewhere was making new, independent culture using Tolkien Enterprises' copyrighted character was enough to set the corporate reflexes in motion. The key thing here is the convergence of corporate power with the growth of the World Wide Web. If John had just shown his game in class and not put it on the Web, Tolkien Enterprises would never have known or cared. If his animation had not won an award, there would likely have been no legal threats. Together, the episodes offer a concise demonstration of how copyright law punishes success and deters creative use of the World Wide Web.

Anything on the Web is available to anyone, which is of course both its promise and its peril. Corporate legal departments can write automated programs that crawl through the Web 24-7 searching for copyrighted works. The "hits" then generate threatening letters that intimidate anyone who doesn't have deep pockets and a lot of time on their hands. The cost to the sender is almost nil; the cost to society is, in a literal sense, immeasurable.

Getting a threatening letter from a corporate legal department is not a pleasant experience for anyone, least of all an eighteen-year-old kid. Keep in mind that more and more students turn in homework assignments via the Web, and not just in college but in high school, too. All of that work is now exposed to the corporate vultures.

Bob Ostertag in Bologna. Courtesy of Massimo Golfieri.

"Property rights" have bloated to the point where they can dictate the content of freshman art projects. But that is not all. Altogether more and more of what we do in our lives passes through the Web. People invite friends to parties, view art, listen to music, play games, have political discussions, date and fall in love, post their family photo albums, share their dreams, and play out sexual fantasies—all online. Since corporate legal departments claim their copyright privileges extend to anything on the Web, the result is a huge extension of corporate power into private lives and social networks.

But that is just the beginning of the story, for the accelerating rate of technological change continues to push digital technology further and further into our lives in just about any direction you might look. To pick just one example, boundaries between our bodies and minds and our technology are blurring. Cochlear implants, for instance, now allow deaf people to hear via computer chips, loaded with copyrighted software, which are implanted in their skulls and in response to which their brains reconfigure, growing new synapses while unused synapses fade. Cochlear implants are wirelessly networked to hardware worn outside the body that usually connects to a mic, thus allowing the deaf to hear the sound environment around them. But the external hardware can just as easily be plugged into a laptop's audio output for a direct audio tap into the Web.

When the Web extends into chips in our skulls, where is the boundary between language that is carved up into words that are corporately owned and language that is free for the thinking?

I don't wish to be sensationalist. We are not all about to turn into corporately owned cyborgs. But I *do* wish to point out that the issues around turning culture into property are urgent and far-reaching. Society is not well served if we treat specific matters like downloading music on the Web as isolated problems instead of one manifestation of a much bigger struggle in which much more is at stake.

notes

Introduction

1. Photographs of Gelitin's balcony off the World Trade Center are published in Gelitin, *The B-Thing* (Cologne: Walther König, 2001).

2. Don DeLillo, *Mao II* (New York: Penguin, 1991), 156.

3. Of course there are exceptions. Chilean *nueva canción,* for example, which emerged in Chile in the years leading up to and during the Allende era, performed the role of offering people engaged in a struggle a moment of respite where they could celebrate their common commitment, yet it outlasted the political movement in which it emerged and continued as concert music with a broadly international audience.

4. The Serge synthesizer was designed by composer Serge Tcherepnin. In the 1970s, synthesizers were so costly that in general they could be found only in academic institutions or in the hands of rock stars. Serge had the idea of making a synthesizer in the form of a kit, which dropped the price considerably. There was no compromise in quality, however. Serge synthesizers were exceedingly well engineered and creatively designed.

5. Anthony Braxton, "Introduction to Catalog of Works," in Christoph Cox and Daniel Warner, eds., *Audio Culture: Readings in Modern Music* (New York: Continuum, 2004).

6. The true scope of Braxton's work is, sadly, not widely appreciated and requires some study just to grasp the outlines. Mike Heffly published a comprehensive book, *The Music Of Anthony Braxton* (Westport, Conn.: Greenwood, 1996). Unfortunately, the list price of this book is an absurd $125. More affordable is Graham Lock's *Forces in Motion: The Music and Thoughts of Anthony Braxton* (New York: Da Capo, 1989).

Many of Braxton's own writings can be found at www.wesleyan.edu/music/braxton/tricentric.html, while others may be purchased from Frog Peak Music.

7. The pet store basement came to be known as Studio Henry. The band White Noise (Wayne Horvitz, Robin Holcomb, Dave Sewelson, Carolyn Romberg, and Mark Miller) jointly rented it as a rehearsal space and soon were putting on informal concerts. Members dropped in and out until the space became a site for underground performances of all kinds, run by Mark Miller and Mark Lutwak of Theater for Your Mother.

Chapter 1: Central America

1. Mark Danner, *The Massacre at El Mozote* (New York: Vintage, 1994); Mark Danner, "The Truth of El Mozote," *The New Yorker*, December 6, 1993.

2. Danner, "The Truth of El Mozote."

Chapter 2: The Balkans

1. Franjo Tudjman was the leader of Croatia during the Yugoslav civil war. Given Croatia's historic ties with the West and Serbia's historic ties with Russia, Western media generally portrayed Milosevic as the baddest of the bad guys who led Yugoslavia to ruin. There is little to support this version of events; Tudjman matched Milosevic step for step in the Yugoslav disaster.

Chapter 3: Queers

1. Edward Lucie-Smith, *Flora: Gardens and Plants in Art and Literature* (New York: Watson-Guptill, 2001). See also Annabel Livermore, *Journey of Death as Seen through the Eyes of the Rancher's Wife* (El Paso Museum of Modern Art, 2007).

Chapter 4: Music and Machines

1. Edgard Varèse, "The Liberation of Sound," in Christoph Cox and Daniel Warner, eds., *Audio Culture: Readings in Modern Music* (New York: Continuum, 2004).

2. *The Last Whole Earth Catalog: Access to Tools* (Menlo Park, Calif.: Portola Institute, 1971).

3. Joel Chadabe, *Electronic Sound: The Past and Present of Electronic Music* (Upper Saddle River, N.J.: Prentice Hall, 1997).

4. My first experience using computers to make music involved punching computer code on little cards that were fed into a card reader connected to the mainframe computer in the basement of the library of Oberlin College. The computer would run the code overnight, and you could hear the sounds that resulted from your code the following day.

Conclusion

1. The original recording titles include *Early Fall; Getting A Head; Voice of America; Sooner or Later; Burns Like Fire; Fear No Love; PantyChrist; Like a Melody, No Bitterness; DJ of the Month; Say No More; Say No More in Person; Verbatim;* and *Verbatim Flesh and Blood.*

2. www.bobostertag.com

3. Ben H. Bagdikian, *The New Media Monopoly* (Boston: Beacon, 2004).

biography

1957

Born in Albuquerque, New Mexico, USA.

1972–75

High school in Ft. Collins, Colorado. Vaguely wanting to be an orchestra conductor, learned a different instrument every year (flute, violin, percussion) but mostly played electric guitar. Formed an ensemble to perform my compositions, with two electronically modified trumpets, oboe, English horn, piano, trap set, percussion, electric bass, and electric guitar. The group rehearsed for two years, but there was nowhere for us to play.

1976

Began a contentious stay at the Oberlin College and Conservatory of Music. Dropped the guitar and instead built and played a Serge synthesizer. Formed the Fall Mountain ensemble with Ned Rothenberg (reeds) and Jim Katzin (violin).

1978–79

Dropped out of Oberlin to tour Europe with Anthony Braxton's Creative Music Orchestra. Twenty years later, the orchestra's concert in Köln was released as a two-CD set on hatART, *Creative Orchestra (Köln) 1978*. Settled in New York City's East Village after the tour and joined the scene of young, unknown musicians including John Zorn, Eugene Chadbourne, Wayne Horvitz, and Fred Frith (who had just moved to New York City from London).

Fall Mountain released an LP, *Early Fall*, on Eugene Chadbourne's tiny Parachute label.

Spent an increasing amount of time as an organizer in the movement to stop construction of nuclear power plants being built on the eastern coast, in Long Island, New York, and Seabrook, New Hampshire. Organized an antinuclear benefit concert with John Cage, Fred Frith, and myself.

1980

Released *Getting A Head*, with Fred Frith and Charles K. Noyes, on Fred's Rift label. The record featured an instrument/invention consisting of three modified reel-to-reel tape recorders linked together with helium balloons. One of the first, and to this day one of the only, times that tape manipulation techniques developed by electronic composers for use in the studio were adapted for live performance and improvisation.

Concert at The Kitchen in New York City, where I presented both the tape invention with Charles K. Noyes and an improvisation on my Serge. The first "real gig" for an East Village upstart.

Zoo Festival, a weeklong improvisation extravaganza at Giorgio Gomelsky's Zu Theater organized by Chadbourne and Zorn. The festival was timed to coincide with, and basically in opposition to, the well-heeled New Music, New York Festival at The Kitchen. Though the New Music, New York Festival (which later metamorphosed into New Music America) was supposed to showcase all the new music in New York City, no one from the East Village crowd was invited to participate. The Zoo Festival's final "big band" concert featured Zorn's first large-ensemble game composition, *Archery*, and Eugene Chadbourne's *The English Channel*, which was then released as an LP. Chadbourne's composition was based on zany juxtapositions of brief fragments of musical styles, pioneering a compositional direction later popularized by Zorn and now ubiquitous in all kinds of contemporary music.

Spent less and less time at music, and more and more opposing construction of nuclear power plants. Planned protests; camped out near nuclear construction sites; trained activists; dealt with police clubs, horses, mace, and tear gas; and sat in jail.

Had a life-changing experience in Nicaragua, where the Sandinista movement had just overthrown the Somoza dictatorship. Went with the idea of recording Nicaraguan music for the Rift label, which I was now running together with Frith. Returned to New York City and nearly abandoned music. Raised money and did public speaking on behalf of the guerrilla movement in El Salvador.

Ended the year returning to The Kitchen to perform *Hospital General*, which featured the text of a *TV Guide* article about the efforts of a soap opera star to save stray cats, intercut with news reports of the atrocities of Somoza's National Guard in Nicaragua. Accompanied by Jim Katzin's violin.

1981

The new year began with Ronald Reagan's inauguration as U.S. president, the Super Bowl football match, and the American hostages returning home from the U.S. embassy in Tehran, which all combined to produce a shockingly ugly outburst of American nationalism. This sort of thing has now become the norm in the United States, but this was the end of the 1970s, and the sense of a dire change for the worse was profound. Somewhere I got access to a television and made audio recordings of much of it.

Performed a duo with Frith the next weekend. The first set was *Hospital General,* with Fred taking the place of Jim Katzin. The second set was improvised. I used my synthesizer and tapes. But instead of open-reel decks and helium balloons, I employed a pile of telephone answering-machine cassette loops of varying lengths, which I shuffled among several cheap cassette players, each modified to malfunction a different way. I used this setup to manipulate my television recordings, as well as recordings I had made on my travels to Nicaragua, and also Fred's live guitar playing.

Later that year, Fred and I traveled to London for a festival gig at the ICA. During the setup, my synthesizer was destroyed in a technical mishap, and I was left with only my cassette decks, some noisemaking toys I had brought, and a contact mic. I told Fred that I couldn't perform with this rig and that he should play solo. Fred suggested we get a third. His friend Phil Minton, an extraordinary vocalist, was in the audience, and we asked if he would sing. He said he would if we got him a shot of whiskey. This was arranged, and we did a very stripped-down set of broken cassette recorders, contact mic, Fred playing a "guitar" that was really just a piece of scrap wood with some guitar strings stretched over a pickup, and Phil. It was magical.

Rift released the New York and London concerts as the LP *Voice of America.* Coming years before the invention of the sampler, *Voice of America* introduced techniques that would later become commonplace with the use of digital technology.

With no money to replace my wrecked synthesizer, the accident severed my last ties to the music world and I immersed myself for the rest of the 1980s in the Salvadoran revolution.

1982–88

Up to my ears in the political crisis in Central America. Went from raising money for the refugee community to organizing national demonstrations and traveling the East Coast organizing support committees. Eventually became a writer for a diverse range of publications, including *Pensamiento Propio* (Nicaragua), *Pensamiento Critico* (Puerto Rico), *The Guardian* (London), *PrensaLatina* (Peru), the *Weekly Mail* (South Africa), *Mother Jones,* and the NACLA *Report on the Americas* (United States), and *AMPO* (Japan). Alternated my time in Central America with organizing and public speaking in the United States, giving lectures at Harvard, Yale, Princeton, Rutgers, and many other schools and institutions.

As the 1980s wore on, found myself in increasingly profound disagreement with the rebel movement in El Salvador and the Central America left in general.

1988

Returned to music, a turn of events made possible by Fred Frith, who had remained a close friend throughout the decade and who now invited me to tour with his new band, Keep the Dog. Having paid no attention to developments in music technology in the intervening years, I had never heard of samplers or MIDI. Rushed to the store to find an instrument to play and returned home with a sampler and a bunch of manuals. In New York City a few weeks later rehearsing with the band.

1989

Toured extensively with Frith and resumed my own musical work, as well. The sampler replaced my old Serge synthesizer and the tape recorders as primary instrument.

First NYC appearance in nearly a decade at the Knitting Factory, playing one set duo with Frith and another set duo with John Zorn.

1990

Continued touring with Frith. Released my first recording in nine years, *Attention Span,* with Fred Frith and John Zorn.

1991

Released *Sooner or Later,* a musical response to my years in El Salvador. The composition is made using only a recording of a Salvadoran boy burying his father and a short sample of Frith's guitar work.

Began a long collaboration with Quebecois filmmaker Pierre Hébert. Performed extensively solo and also in duo with Frith or Hébert.

1992

Recorded a riot for gay rights in San Francisco. Composed *All the Rage* by transcribing the sounds of the riot into parts for string quartet and adding a text by poet Sara Miles. World premiere by the Kronos Quartet at Lincoln Center. Kronos then toured the composition extensively.

1993

Kronos released *All the Rage* as a CD of the same title on the Nonesuch label, and for the first and only time my recorded work was distributed with the backing of a corporate record company.

I had originally conceived *All the Rage* as a collaboration with writer/painter/pho-tographer/filmmaker David Wojnarowicz, but David was ill with AIDS. When David died before the collaboration could take place, I made a second, solo piece from the riot recordings, *Burns Like Fire,* and dedicated it to him. The work was released as a CD, and I performed it live using gestures in space with infrared wands designed by synthesizer pioneer Don Buchla.

Formed my performance ensemble, Say No More, with Mark Dresser (contrabass), Gerry Hemingway (percussion), and Phil Minton (voice). The project was based on a compositional process of taking recordings of the members' improvisations, both separately and as an ensemble, as the source material for musique concrète computer pieces, which in turn become the basis of scores for the group's live performances. The group released the first of what would become four CDs over the next few years, titled *Say No More,* and toured in the United States, Europe, and Canada.

1994

Composed *Spiral,* another work dedicated to David Wojnarowicz, this time using David's last text as the libretto. David's text used the metaphor of being transformed into glass to describe the experience of dying. Working with instrument builder Oli-ver DiCicco and Pierre Hébert, *Spiral* was a concert-length work for actor, electron-ics, film, and a chamber ensemble of specially constructed glass instruments (harp, drums, marimba, and more, all made from glass). Hébert's films were projected on suspended sheets of glass that doubled as percussion instruments.

Spiral world premiere in San Francisco as part of the national "What About AIDS?" art show. Performances at the Walker Center in Minneapolis, in Brussels, and in Freiburg (Switzerland) followed, before the glass instruments were largely destroyed in transit by airlines, effectively ending the brief life of the work before it could be recorded or even performed much.

Say No More's second CD, and first CD as a live chamber ensemble, *Say No More in Person,* released by the Kunstradio program of the ORF (Austrian State Radio).

1995

Just as in the late 1970s I felt torn between political activism and musical work in downtown New York City, in the 1990s a similar tension arose between my musical world, where my colleagues were all straight, and my social world, where my friends were generally queer. When Zorn asked me to make a CD for a series he was curating by asking composers to do something completely different from what they normally do, I decided that the most different thing I could do would be to make a pop record, an opportunity I could use to bring my straight and queer friends together on one project, *Fear No Love.* Collaborators include rock star Mike Patton, dyke punk rocker Lynn Breedlove, Trevor Dunn of Mr. Bungle, drag queen Justin Bond, Fred Frith, queer novelist Christian Huygen, percussion virtuoso William Winant, actor Philip

Horvitz, and many more. Unfortunately, no one seemed to get the joke. Some critics actually thought I was trying to become a pop musician. BMI reclassified me as a pop artist, which meant I would no longer receive royalties from the performance of my music. No one bought the CD. Total flop.

1996

Released *Verbatim,* the third CD by the Say No More quartet, and *Twins!,* a collaboration with turntablist Otomo Yoshihide. Toured Japan with Yoshihide, and Europe with Frith. In Australia, made a commissioned work for *The Listening Room* of Australian Radio (ABC), *Hunting Crows,* featuring the voice of Phil Minton and an instructional recording from the 1940s on how to shoot crows.

Asked to be a member of the music jury of the Ars Electronica festival in Linz, Austria. Ars Electronica is the richest computer art festival in the world, with prizes in digital music, art, animation, Web, and so on. The invitation was surprising given my distance from the academic computer music that was the usual festival fare. Each year the festival published a hardcover book featuring an essay by one member of each jury, and they asked me to write the essay from the music jury. I wrote a harsh critique of the music submitted to the jury and of academic computer music in general ("Why Computer Music Is So Awful," included as an essay in this book). I was not invited back to Ars Electronica, but the essay was reprinted widely (first in *Resonance,* the journal of the London Musicians Collective) and eventually translated into several languages.

Launched the House of Discipline and House of Splendor projects at a gig in San Francisco. Both groups featured myself and Otomo Yoshihide. House of Discipline added vocalist Mike Patton, while House of Splendor added drag queen Justin Bond. The gig resulted in a House of Splendor record contract with Naut Humon's Asphodel label.

1997

Toured Italy and eastern Europe with violinist Jon Rose, with whom I produced a one-hour radio work, *Crows,* for Italian state radio in Rome. The Say No More quartet toured Europe. *Spiral* premiered in Europe at the Belluard-Bolwerk festival in Switzerland. And House of Discipline, with Yoshihide and Patton, played an intense set to an oversold house at the Angelica Festival in Bologna. The set was recorded and released by the festival on a compilation of festival performances (the only recording of House of Discipline available).

Working as an artist-in-residence at the STEIM electronic music studio in Amsterdam, I built the Window, an instrument consisting of a video camera·and a suspended sheet of edge-lit Plexiglas. The instrument is played on a dark stage by drawing shapes with one's fingers on the Plexiglas, while the video camera feeds the image to a com-

puter that generates musical data from the shapes. The instrument was premiered at the Paradiso in Amsterdam in a duo performance with Pierre Hébert.

1998

Made my first trip to South America as a musician instead of a journalist, with a solo performance in Buenos Aires. The Say No More quartet toured in Japan and Europe.

Made a new multimedia version of *Hunting Crows* that substitutes crow sounds with toy instruments played onstage, and audio manipulation of their sounds made with gestures in space with the toys. The image of the gestures was recorded by a video camera and fed to a computer for analysis. Premiere in Berlin to a sold-out house.

Worked with students at a UNESCO-affiliated high school in Köln to create a commissioned work for German radio (WDR) to commemorate the fiftieth anniversary of the United Nations Universal Declaration of Human Rights. Students ranged from fairly accomplished teenagers to kids with no musical experience. We created *Dear Prime Minister*, which was broadcast on WDR and released as a limited-edition CD by the radio and the school. Students banged rocks together in rhythms derived from the names of atrocity victims at Auschwitz, Srebrenica (Bosnia-Herzegovina), and El Mozote (El Salvador). Others played rhythms using sandpaper and hammers on wood. Those with musical skills played fragments of klezmer music, gypsy music, and more. Meanwhile, students took turns reading letters they had written to heads of states on behalf of specific prisoners of conscience.

The House of Splendor CD hit an expected roadblock when some employees of the Asphodel label threatened to resign if the label released the recording. Apparently they were offended by the drag/queer content. Lengthy negotiations ensued.

1999

Returned to Australia, this time as a guest artist of the Sydney Gay and Lesbian Mardi Gras Festival.

After ten years working with the same commercially produced sampler, I switched to a laptop computer and began writing my own performance software created with the Max programming language and used joysticks, game pads, and drawing tablets to control the sound. Released my last improvisations on the old sampler under the title *Like a Melody, No Bitterness: Solo Improvisations Volume One*, to document a decade spent mastering the instrument, before abandoning it for the laptop.

Endless label woes seemed finally resolved in a deal with Seeland, the label run by the media guerrilla group Negativland. *Like a Melody* was the first Seeland release, followed by the controversial House of Splendor recording refused by Asphodel, rechristened as *PantyChrist*. The release was followed by a *PantyChrist* European tour.

Back as artist-in-residence at the STEIM studio in Amsterdam when the NATO bombing of Yugoslavia began. In response, I worked with lighting designer Richard Board to create *Yugoslavia Suite,* a multimedia work for hand choreography and digitally manipulated sound and video. Just weeks after the bombing ended, Richard and I toured the work in the Balkans, including Beograd and Novi Sad in Serbia.

2000

Began work with Pierre Hébert and Salvadoran actor and playwright Baltazar López on a full-scale multimedia and theater work, *Entre Basura y Ciencia* (Between Science and Garbage), which was premiered in San Francisco in February.

2001

Returning to notes-on-staff-paper composition for the first time since working with the Kronos Quartet, wrote *Desert Boy on a Stick,* a concert-length work for cello and text. The texts were the titles of the art works of Texas-based artist Jim Magee. The cellist was Joan Jeanrenaud, who had just left the Kronos Quartet after twenty years with the group. Premiered at Colorado College, which commissioned the piece along with the Colorado Springs Arts Center.

Pierre Hébert and I formed Living Cinema, developing the software and performance techniques necessary to make cinema a live performance event. Living Cinema performed a substantially revised *Between Science and Garbage* in Europe, Canada, and the United States.

2002

Released *DJ of the Month: Solo Improvisations Volume 2* on Seeland, documenting my work on my laptop-based sampler/synthesizer.

Many more Living Cinema concerts, which was now my principal performance vehicle.

2003

Living Cinema tour of Japan, where we developed a new piece, *Portrait of Buddha.*

Living Cinema tour of Europe. In Porto, Portugal, we premiered *Homage to Francis Bacon* as part of a major exhibition of the paintings of Francis Bacon and began our collaboration with vocalist Theo Bleckmann.

2004

Living Cinema released *Between Science and Garbage,* both as a DVD on Zorn's Tzadik label, and as a film distributed by Videographe. The film version began to appear in film festivals.

Living Cinema tour of Europe. Many unusual gigs, such as in Casares, Spain, a tiny mountain village in Andalusia.

Returned to composing words instead of sounds, and coauthored *The Yes Men: The True Story of the End of the World Trade Organization,* published by Disinformation Press. The Yes Men are a couple of friends who go around the world speaking on behalf of corporate criminals.

Began teaching in the Technocultural Studies program at the University of California at Davis.

2005

Living Cinema premiere of *Endangered Species.*

Living Cinema premiere of *The Statue of Giordano Bruno,* which is also released on film by Videographe.

Extensive touring of Living Cinema.

2006

People's Movements, People's Press: The Journalism of Social Justice Movements published by Beacon Press. The book examines the history of activist journalism in America. Showing how reliance on the printed word fundamentally shaped what we now know as social movements, the book raised the question of how social movements will change as they move from print to the Internet as their primary means of communication.

Increasingly angry at the corporate power grab taking place under the rubric of "intellectual property rights," I posted all my recordings to which I have the rights on the Web for free download.

2007

Living Cinema created *Special Forces,* a new work using images of the Israeli invasion of Lebanon that summer. World premiere of the work in Beirut, though I myself could not attend due to a passport fiasco. Pierre Hébert arrived in Beirut alone and performed by himself using audio I sent him over the Internet. United States premiere of *Special Forces* at the Museum of Modern Art in San Francisco.

Published *The Professional Suicide of a Recording Musician,* explaining why I gave all my music away.

Released *w00t,* my first release of music that skipped the CD phase entirely and went straight to the Internet for free download. *w00t* was created entirely from fragments of computer game music and included artwork by computer game designer John Cooney, made from fragments of the art of many computer games.

sources

Discography

Most of these works can be downloaded for free from www.bobostertag
.com.

w00t (2007). Concert-length work created from fragments of computer game music.
First Internet-only release.

DJ of the Month: Bob Ostertag Solo Volume 2 (2002). Solo improvisations using game-
pad controllers and custom-made software. [Seeland 526]

Say No More project CDs 1 and 2 (2002). Originally released separately as *Say No
More* (1993) and *Say No More in Person* (1994). Reissued in MVORL limited edition
in 2002. With Joey Baron (percussion), Mark Dresser (bass), Gerry Hemingway
(percussion), and Phil Minton (voice). First and second CDs in the *Say No More*
project. [Seeland 521]

Say No More project CDs 3 and 4 (2002). Originally released separately as *Verbatim*
(1996) and *Verbatim Flesh & Blood* (2000). Reissued in MVORL limited edition in
2002. With Gerry Hemingway (percussion), Mark Dresser (bass), and Phil Minton
(voice). Third and fourth CDs in the *Say No More* project. [Seeland 522]

Verbatim Flesh & Blood (2000). With Gerry Hemingway (percussion), Mark Dresser
(bass), and Phil Minton (voice). Fourth and final CD in the *Say No More* proj-
ect. Live ensemble performance of the compositions created on computer for the
Verbatim CD. Recorded live in at the Kunstencentrum Vooruit in Gent, Belgium.
[Seeland 512]

PantyChrist (1999). With Otomo Yoshihide (DJ) and Justin Bond (vocal). No way to
describe this one. [Seeland 510]

Dear Prime Minister (1998). With the students of the Hansa Gymnasium. WDR/
Hansa Special. Special release through the Hans Gymnasium and WDR.

Like a Melody, No Bitterness: Bob Ostertag Solo Volume 1 (1997). Solo improvisation using an Esoniq ASR-10 sampling keyboard. Reissued in MVORL limited edition in 2001. [Seeland 508]

Verbatim (1996). With Gerry Hemingway (percussion), Mark Dresser (bass), and Phil Minton (voice). Third CD in the *Say No More* project. Composition created on the computer from fragments of the live performances documented on the *Say No More in Person* CD. [Rastascan 29]

Twins! (1996). With Otomo Yoshihide (DJ). Resampled "twins" of parent tracks by Herb Robertson, Chris Cutler, and Yagi Michiyo. [Creativeman 0030]

Fear No Love (1995). Queer pop songs. With Mike Patton, Fred Frith, Justin Bond, Lynn Breedlove, fifteen others. [Avant 041]

Say No More in Person (1994). With Mark Dresser (bass), Gerry Hemingway (percussion), and Phil Minton (voice). Second CD in the *Say No More* project. Live ensemble performance of the compositions created on computer for the *Say No More* CD. Released by ORF Radio, Vienna. [Transit 444444]

Say No More (1993). With Joey Baron (percussion), Mark Dresser (bass), Gerry Hemingway (percussion), and Phil Minton (voice). First CD in the *Say No More* project. Assembled on computer from fragments of solo improvisations. [RecDec 59]

All the Rage (1993). Kronos Quartet plays Ostertag's transcriptions of gay riots in San Francisco. Libretto by Sara Miles. [Elektra-Nonesuch 79332–2]

Burns Like Fire (1992). Riots, country and western, and gospel. Companion piece to *All the Rage*. Reissued in MVORL limited edition in 2001.

Sooner or Later (1991). Solo. Based on a recording of a Salvadoran boy burying his father. RecRec Music (RecDec 37). Reissued on MVORL/Seeland in limited edition in 2001. [Seeland 514]

Attention Span (1990). With John Zorn (alto sax) and Fred Frith (guitar). Rift Records (Rift 14) and RecRec Music (RecDec 33). Reissued in MVORL limited edition in 2001.

Voice of America (1982). With Fred Frith (guitar) and Phil Minton (voice). Recorded in concert in London and New York City. RecRec Music (RecDec 907). Reissued in MVORL limited edition in 2001.

Getting A Head (1980). With Charles K. Noyes (percussion) and Fred Frith (guitar). Uses unorthodox instrument built from tape recorders and helium balloons. Rift Records. Reissued in MVORL limited edition in 2001. [Seeland 516]

Fall Mountain: Early Fall (1979). With Ned Rothenberg (wind instruments) and Jim Katzin (violin). Recorded at the Oberlin Conservatory of Music. [Parachute]

PERFORMING THE WORKS OF OTHER COMPOSERS

Fred Frith/Keep the Dog: *That House We Lived In* (2003). Two-CD set of concert recordings of Frith's ensemble from the 1990s. [Recommended Records FRA 3]

Anthony Braxton: *Creative Orchestra (Köln) 1978* (1995). Live performance from 1978 released as two-CD set in 1995. [hatART 2–6171]

John Zorn: *Pool* (1979). One of John Zorn's earliest game pieces. Originally released by Parachute. Re-released by Tzadik in 2003. [Tzadik 73163]

Eugene Chadbourne: *The English Channel* (1978). Large ensemble including many East Village improvisers. [Parachute]

COMPILATIONS

House of Discipline (with Mike Patton and Otomo Yoshihide). Included on AngelicA 1997, a compilation of performances at the Angelica music festival in Bologna, Italy, 1997. [I dischi di angelica 3]

Improvisations with John Zorn and Fred Frith. Included on AngelicA 1994, a compilation of performances at the Angelica music festival in Bologna, Italy, 1994. [I dischi di angelica 1]

John Zorn: *The Parachute Years* (1997). Multi-CD set of Zorn's early game pieces. [Tzadik 7316–7]

Filmography

Living Cinema Presents Between Science and Garbage. On film: released by Le Vidéographe (Montreal), 2004. On DVD: released by Tzadik (New York), 2004.

The Statue of Giordano Bruno. On film: released by the National Film Board of Canada (Montreal), 2005. On DVD: released as part of the collection *Pierre Hébert: The Science of Moving Image,* National Film Board of Canada, (Montreal), 2007.

Books

People's Movements, People's Press: The Journalism of Social Justice Movements. Boston: Beacon Press, 2006.

The Yes Men: The True Story of the End of the World Trade Organization. New York: Disinformation Press, 2004. (Published anonymously as the Yes Men, co-authored with Mike Bonano and Andy Bichlbaum.)

credits

An early version of "Art and Politics after September 11" was published in German under the title "Kunst und Politik: Nach dem Elften September" in *MusikTexte,* number 100, February 2004.

"Absolute Diabolical Terror" is coauthored by Sara Miles and was originally published in the April 1989 issue of *Mother Jones.*

"Power Outage" is coauthored by Sara Miles and was originally published in the October/November 1990 issue of *Mother Jones.* For more on the writing of Sara Miles, see www.SaraMiles.net.

Excerpts from "Balkan Journal" were published under the title "War Games in Hell" in the February 2001 issue of *The Wire.*

Some portions of the "All the Rage" were first published in *Arcana: Musicians on Music,* edited by J. Zorn, New York: Granary Books, 2000.

"Why I Work with Drag Queens" was originally published in German under the title "Gender Improvisieren" in the March 1999 issue of the Swiss newspaper *WOZ.*

"Desert Boy on a Stick" began as a radio portrait of Jim Magee and Annabel Livermore commissioned by the Kunstradio program of ORF Radio, Vienna, which was broadcast on June 8, 2002.

The title of the art work beginning with the words "Then tell me Jerusalem" is used with the permission of Jim Magee.

"Spiral" is used with the permission of the estate of David Wojnarowicz.

An earlier version of "Why Computer Music Is So Awful" was published under the title "At a Dead End?" in *Prix Ars Electronic 1996,* edited by H. Leopoldseder and C. Schopf, Vienna: Springer, 1996.

An earlier version of "Human Bodies, Computer Music" was published in the journal *Leonardo,* vol. 12, 2002.

"The Professional Suicide of a Recording Musician" was originally published jointly on *AlterNet.org* and *QuestionCopyright.org,* in April 2007.

"Living Cinema Manifesto" is coauthored by Pierre Hébert.

index

BOB OSTERTAG is a composer, performer, historian, instrument builder, journalist, and activist. He is a professor of technocultural studies and music at the University of California at Davis and the author of *People's Movements, People's Press: The Journalism of Social Justice Movements*. He has performed at music, film, and multimedia festivals around the globe. His radically diverse collaborators include the Kronos Quartet, avant-garder John Zorn, heavy-metal star Mike Patton, jazz great Anthony Braxton, dyke punk rocker Lynn Breedlove, drag diva Justin Bond, Quebecois filmmaker Pierre Hébert, and others. His writings on contemporary politics have been published on every continent and in many languages. Electronic instruments of his own design are at the cutting edge of both music and video performance technology.

The University of Illinois Press
is a founding member of the
Association of American University Presses.

Composed in 10.5/13 Adobe Minion Pro
with Frutiger LT Std display
at the University of Illinois Press
Manufactured by Thomson-Shore, Inc.

University of Illinois Press
1325 South Oak Street
Champaign, IL 61820-6903
www.press.uillinois.edu